Drawing and Painting the Landscape

A course of 50 lessons

Philip Tyler

D1341406

THE CROWOOD PRESS

First published in 2017 by
The Crowood Press Ltd
Ramsbury, Marlborough
Wiltshire SN8 2HR

www.crowood.com

© Philip Tyler 2017

All rights reserved. No part of this publication may be reproduced or transmitted in any form or by any means, electronic or mechanical, including photocopy, recording, or any information storage and retrieval system, without permission in writing from the publishers.

British Library Cataloguing-in-Publication Data
A catalogue record for this book is available from the British Library.

ISBN 978 1 78500 324 0

Frontispiece: *Brancaster Staithe Tears*, acrylic on board.

Graphic design and layout by Peggy & Co. Design Inc.
Printed and bound in India by Parksons Graphics

Contents

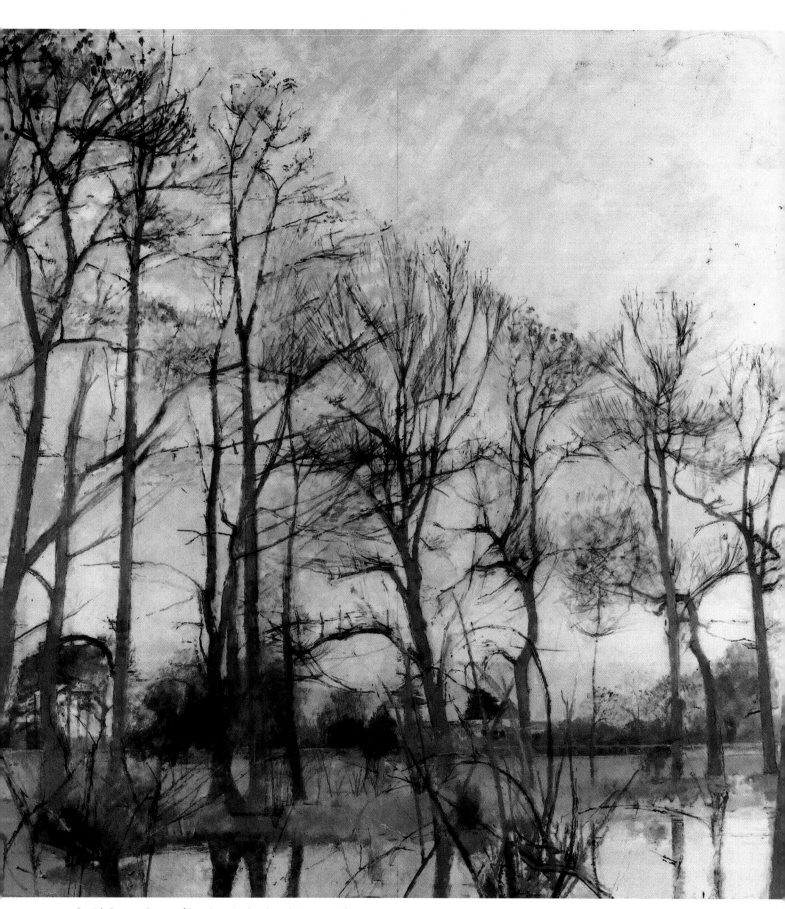

Patrick George, *Curtain of Trees* (2000), oil on board. (Courtesy of Browse and Darby Gallery)

Preface

The day had started promptly enough. A light scraping of ice on the windscreen. A car full of the things I would need to interview Patrick George: a camera, my phone to record the interview and a few gifts too. Five or six turns of the car key confirmed that my car was dead and a faltering battery was indeed not fit for much else. An hour or so later, the AA man was on his way; for what would be a busy day, I set off on my journey. As I drove through West Sussex, my thermometer hit -8°C at one point, but the landscape did not seem that cold, bathed as it was in a golden light. Driving through Essex, the countryside became an altogether different vista; heavy cloud created a muted space, a subdued series of colour patches, a flat pattern of shapes. As I entered Suffolk, the space seemed to stretch away from me but formed a thinner, more compressed landscape. The air began to lift and colour began to seep in, permeating the landscape, bringing it back from grey.

As I entered Patrick's house, greeted warmly by both Patrick and Susan, and the fresh soup and bread that Susan had made that morning, I saw that his house seemed to have light coming in from all sides. On the walls were fellow comrades in arms, a Tony Eyton, a William Coldstream, a Craigie Aitchison, and a Jeffery Camp, each one quietly exuding their presence on the space. After this delicious fare, I began to talk with Patrick and he began to interview me.

Why paint landscape? His eyes looked straight at me, making me justify my own responses to the North Norfolk coast and the Sussex Downs. I discussed the emotions and recollection one had in front of a particular space. At that moment, I wished my phone were on record; his thoughts sparkled in the room, which seemed to light up in front of me. Eventually, my phone switched on and our conversation developed over the next hour. We talked about us both growing up in an urban environment, he Manchester, me London, and the notion that the landscape may have offered us both an escape, a chance to look into the far distance rather than at one's feet. We talked about drawing, about colour and more than anything about really looking.

As the interview developed, the light seemed to grow in luminosity, moving across the floor and gradually riding up over Patrick himself. His face became bathed in the most glorious intensity; the loaf, soup bowls and coffee cups became magical and luminescent. Every so often, Patrick would look away from me, and stare out of the window into his garden. I knew what he was thinking, he was probably waiting for the moment when he could paint that view. His oil paints and easel already there in preparation for the moment.

You tend to think of great paintings in galleries, private collections or museum walls. You don't expect to see paintings that you have grown to love, stacked up against the wall with their backs turned. Susan later unveiled each in turn, a view of Hickbush, a Saxham tree, the facade of a building; paintings I have grown to love since my first encounter with a George back in the mid 1980s at the hard won image show. What touched me then was this simple idea: paint what you see, discover the extraordinary in the everyday. That painting with its electrical pylon rooted itself in my psyche. Its flatness, a configuration of shapes and colours, a mutable landscape, Patrick had revisited the same spot over and over again. Finding that the space had changed, he simply recorded his new experience, trying to make sense of his visual experience.

Within a year of that show I was studying in America, experiencing a light I had never seen before, a magical light, intense, clear and richly saturated. Everything seemed to be in sharp focus, and it was during that time I saw my first Richard Diebenkorn.

Patrick George, *Winter Landscape, Hickbush*, late 1970s. (Courtesy of Browse and Darby Gallery)

Whilst I never made the connection back then, as I looked again at these Patrick George paintings in the flesh I saw parallels, the often-rectilinear movements of the landscape punctuated by diagonals, the evidence of contemplation, the need to get to some kind of truth that could only be arrived at over time by dedication, questioning and transformation. Would this colour work? How could one capture the experience of light falling on that leaf? I was rather interested in Patrick discussing his choice of Suffolk. Somehow there were fewer leaves on the trees here, less obstacles to deal with, yet his paintings are full of the problems he has set himself to solve. When I asked him about what aspect of landscape he was trying to convey, he simply said that he just wanted 'to do the best he can.' Like a bird resting lightly on a branch, Patrick's touch is a delicate one, barely breathing the paint on the surface of the support. His paint tubes, and there were many greens, are testament to time some seemed to hark back to an earlier age.

It was once said that Coldstream's brushes were perfectly clean and free from pigment, cleaned constantly in the process of making a mark, his indecision becoming a nervous set of ticks. I'm not sure if George is so bogged down by measurement, his canvases have a decisiveness and breadth of mark, that suggests he is not anchored by measurement, but they are full of contemplation. The loaded gestural attack of Bomberg or Auerbach, the trail of the hand not part of George's oeuvre. Instead, his luminous canvases are full of light and air. Again I am reminded of Diebenkorn and his Ocean Park paintings, whilst the saturation of Diebenkorn's paintings are permeated with Californian light; they have the same touch. They say you should never meet your heroes. Whilst I never met Richard Diebenkorn, I have a handwritten letter from him. When I received this in the mid 1980s, I was touched by the humanity of the man. He was honoured and flattered that I had so forthrightly engaged with his paintings, and I felt the same kind of connection with

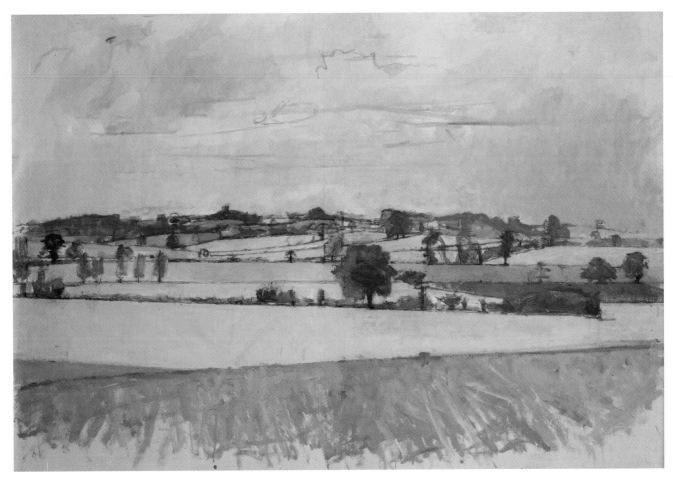

Patrick George, *Hickbush, Extensive Landscape from the Oaks*, 1961. (Courtesy of Browse and Darby Gallery)

Patrick, a man of exacting visual intelligence, conviction but also humility. I came away from his house and before I got into my car, I realized that I was surrounded by the subjects of his paintings. Those trees in a field, that branch and roof; everywhere I looked I saw another of his paintings. On my way to Suffolk, I reflected on all those landscapes I had seen and how many Patrick George paintings could be made. On my way home I had a similar experience, every view seemed filled with the light in his work.

Postscript

Three months after I interviewed Patrick, I received an email from his gallery, Browse and Darby, that he had sadly passed away on the weekend.

Richard Diebenkorn, Untitled No. 10.

Introduction

*T**here is something beautiful about a melancholic cloud hovering in the sky, a moment when the light breaks through, giving clarity to a feature in the landscape. One takes a breath, looks across the distant view and stares in awe at the immensity of the space, the notion of self, disappearing into the distance. To capture that feeling, to put down on paper or canvas that emotional response to the landscape, to encapsulate all those memories and moments of experience and somehow make that concrete in paint, that is the challenge for the artists deciding to explore landscape as their motif.*

What do you think of when you look at the title, *Drawing and Painting the Landscape*? Do you think of Constable (1776–1837) or Turner (1775–1851), Gainsborough (1727–1788) or Corot (1796–1875), Monet (1840–1926) or Pissarro (1830–1903) or do you delve back further to Rembrandt (1606–1669), Rubens (1577–1640) or Joachim Patinir (1480–1524)?

The history of landscape painting is a long one and within an eastern tradition, even longer. The Chinese scroll paintings made over a thousand years ago create a sense of majesty and awe in the viewer; a place of contemplation and wonder, yet made with an economy of means that deny the skill and mastery of the medium. The Chinese said that a painting was made with the eye, the hand and the heart.

Within a European tradition (the word landscape itself did not appear in the English language until the early seventeenth century) early Gothic landscape started off as a backdrop to a staged drama, acting out some biblical narrative. These imagined places simply create a place for the action, but eventually the landscape would become more

A painting made when I was fifteen, one of my first landscapes. Gouache on paper with airbrushed sky.

Mirroring the world in paint is my major preoccupation, but landscape and the bodies that inhabit it is my main subject.

– NICK BODIMEADE

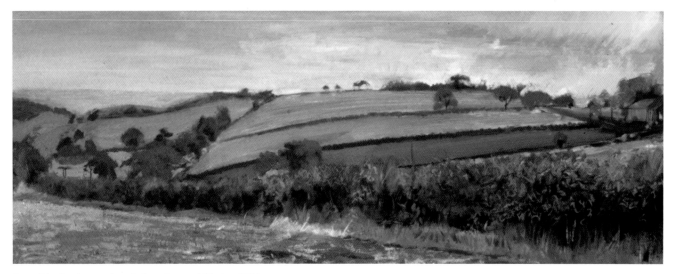

One of the landscapes I made from Beacon Hill, circa 1984.

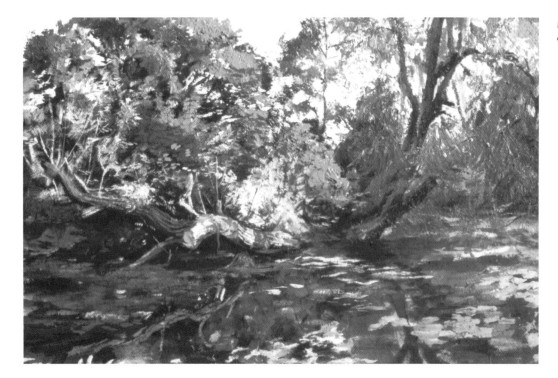

My first *plein air* painting, circa 1984.

than just generic trees and hills, the location would become imbued with character and meaning.

After the Reformation, the subject of landscape painting became a genre of its own. Artists throughout the centuries have wrestled with the problem of describing space, light, atmosphere and differing weather conditions. Some found within landscape a vehicle to convey much more than a scenic inspiration. John Martin (1789–1854) could demonstrate the hand of God, Turner the tumultuous sea and Constable

the notion of heritage and place. It is interesting to note that landscape became increasingly popular during the industrial revolution. As Tim Barringer said, 'As Britain became predominantly urban, images of the countryside came to stand as emblems of the nation itself.'

While cities rose, and country folk left behind their past, skills and way of life, the middle classes created this idyllic notion of the landscape. Trains tore a hole through the landscape, the country became smaller and remote locations

became places of spiritual solace. Ruskin found beauty in the landscape and tried to capture it in exacting detail. The Pre-Raphaelites would take their canvases onto location to work directly from the landscape and their counterparts in France were doing the same. The notion of *plein air* painting might be one that we take for granted, but it was born at the end of the nineteenth century. It is important to remember that Constable worked directly in the landscape to produce oil sketches that would have never seen a gallery wall in his day. Constable's paintings were looked on as too vulgar, too true to nature to a public used to looking at the landscape though a blackened piece of glass.

Today, in a contemporary art world full of photography, video sound and performance, why do some artists still want to put pen or brush to paper or canvas? Of course, context is everything and in a small number of high spec museum galleries, there is a lively engagement with rhetoric and theory, and art works become objects of enquiry, exploring new media, new technology, new thinking. But in a large number of commercial galleries, run by people who have their own visions of the art world (one that doesn't necessarily resemble this bubble), private collectors buy paintings for their homes and artists struggle with the alchemical process of turning mud into place, line into distance, colour into space.

Many of the artists contained in this book are people I know personally, either through direct contact or through my experience of their work. For me, there is something quite magical about the transformation of base materials into image, which leave behind the mark of the artist who made it. The first time I saw a Rembrandt in the flesh, I was struck by the physicality of the paint. One could feel the hand that made the mark. The same can be said of a David Atkins or a Louise Balaam. So I am drawn to those artists who exhibit a certain kind of physicality in their paint application and who convey something of the majesty and emotion of the landscape of their work.

There is a romantic idea about the artist striding through the landscape, painting materials in hand, to find some magnificent vista and then transcribe it to canvas.

For the amateur artist, the idea of a painting holiday, travelling to some beautiful location, brushes and canvas in tow, holds considerable excitement, but painting landscape presents many technical as well as philosophical challenges.

My relationship with landscape painting has been a long and circuitous one. Growing up in an urban environment meant that I knew little of the horizon as a child. Surrounded by tower blocks, their monumentality had a visual impact upon me. Studying at Loughborough College of Art and

Landscape is a major preoccupation and it was the first thing that I really got excited by painting, and being involved with. It wasn't until I moved to the country that I started to look at other subjects; having been born in the city, I kind of missed city life so I started to explore that as well, but I have always been fascinated by the interpretation of landscape and what landscape stands for in terms of how it moves you and touches your soul. It can stand for very deep held feelings that come through myself as a human being and I think that landscape is the one thing that takes your breath away; it reaches a depth in me and touches something that's beyond words and that's what started my interest in landscape. From very early on I was encouraged to go for walks in parks and woods in London. It was those that I really found I responded to in a physical and spiritual way that linked itself as a subject that was appropriate for me or inspiring for me as a painter.

– DAVID ATKINS

Design meant that I saw deep space for the first time. I attempted *plein air* painting, had my eyes opened to negative space by early Mondrian, but it was a student exchange to America that introduced me to the work of Richard Diebenkorn who was to have a more profound effect on me.

In the early 1990s, my mother and father-in-law John and Joan Dixon, both keen amateur artists, had moved to Norfolk, very close to the north Norfolk coast. Every holiday was spent with them and my wife and eventually our children, long days on the beach at Brancaster, enjoying the vast expanse of sand, the low horizon and those skies. John introduced me to Edward Seago, his economy with watercolour and his grandeur with scale. I spent many hours drawing and painting the views and as our children grew up, Norfolk became their playground.

My first gallery dealer was based in Norfolk, not far from where the Dixons lived. Iris Birtwistle was an amazing woman; nearly blind, an art dealer working out of a caravan, she had an immeasurable passion for her artist. Whilst her vision was diminished, she had an amazing eye and could tell good from bad. She could be forthright in her opinion and demanded the best work from me but she was an essential part of my journey to become an artist.

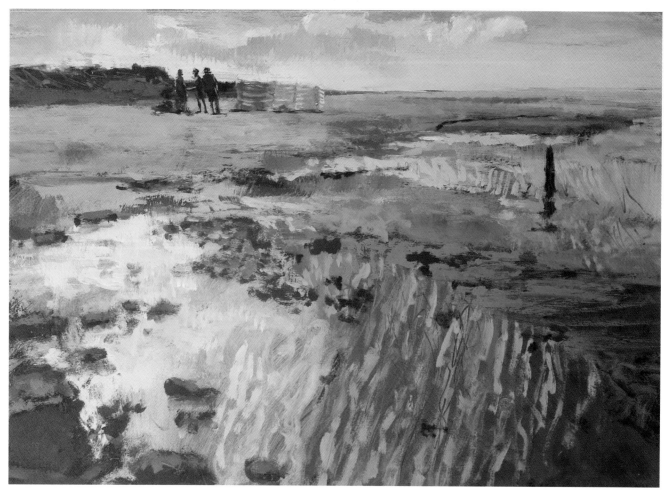

Brancaster Beach, acrylic on paper, circa 1996.

In recent times, the landscape has become my dominant obsession, in particular the terrain where I live in West Sussex, the Downs, and the effects of the weather have become important vehicles to express emotion, particularly since the death of my father. Landscape can be melancholic, brooding, uplifting and even spiritual at times, and to a certain extent I have allowed it to swallow me up. Some artists choose landscape as their major preoccupation, others as part of a much larger oeuvre. I work in a serial way, focusing on a motif and exploring that for a long period of time before moving onto another motif, rather like Nick Bodimeade.

Following on from my first book, *Drawing and Painting the Nude*, I would like to guide you through some of the technical and theoretical challenges that landscape presents.

Over the next fifty lessons, I will cover materials, techniques and approaches supported along the way by words and images of other artists who interpret the landscape in their own way.

In so doing, I hope to give you a much greater insight into how you can interpret the landscape and find your own voice in painting or drawing it.

Mirroring the world in paint is my major preoccupation, but landscape and the bodies that inhabit it is my main subject.

 – Nick Bodimeade

Landscape is a major preoccupation and it was the first thing that I really got excited by painting, and being involved with. It wasn't until I moved to the country that I started to look at other subjects; having been born in the city, I kind of missed city life so I started to explore that as well, but I have always been fascinated by the interpretation of landscape and what landscape stands for in terms of how it moves you and touches your soul. It can stand for very deep held feelings that come through myself as a human being and I think that landscape is the one thing that takes your breath away; it reaches a depth in me and touches something that's beyond words and that's what started my interest in landscape. From very early on I was encouraged to go for walks in parks and woods in London. It was those that I really found I responded to in a physical and spiritual way that linked itself as a subject that was appropriate for me or inspiring for me as a painter.'

 – David Atkins

The urge is to rise to the challenge and understand pictorially what I am responding to. Sometimes it's hard to know until you're in the process and it feels right to try and make sense of it. In a sense you possess it somehow and as a result experience it deeper by seeing it.

 – Julian Vilarrubi

For the past thirty years I have lived in the rolling countryside of the Oak Ridges Moraine, an ancient land form located just north of Lake Ontario. I roam this unique place in all seasons, and document my impressions. It seems very important to record both the appearance of places, and the nature of my response to them. And I have to do this on a daily basis, almost as if a record needs to be kept. I walk to locations every day and this slow process of looking reveals the character of the places I visit. I paint the landscape because it is where I see the most richness, complexity, and meaning. I love and need this beautiful place … the paintings come out of that.

 – Harry Stooshinoff

Landscape could convey everything I wanted to communicate, with a power and mysterious subtlety that continues to challenge and excite me.

 – James Naughton

Because it's universal. It speaks to you, landscape speaks to you, doesn't it? It's full of emotion.

 – Piers Ottey

I find there's nothing like being outside – the changes in the weather, the sky and the light are endlessly fascinating and engaging for me. I love the idea of a multi-sensory experience – being extra-aware of smells, texture, sometimes the taste of salt on the breeze, as well as sound and sight, all coming together as part of that particular place. I aim to communicate these different aspects somehow in my paintings.

 – Louise Balaam

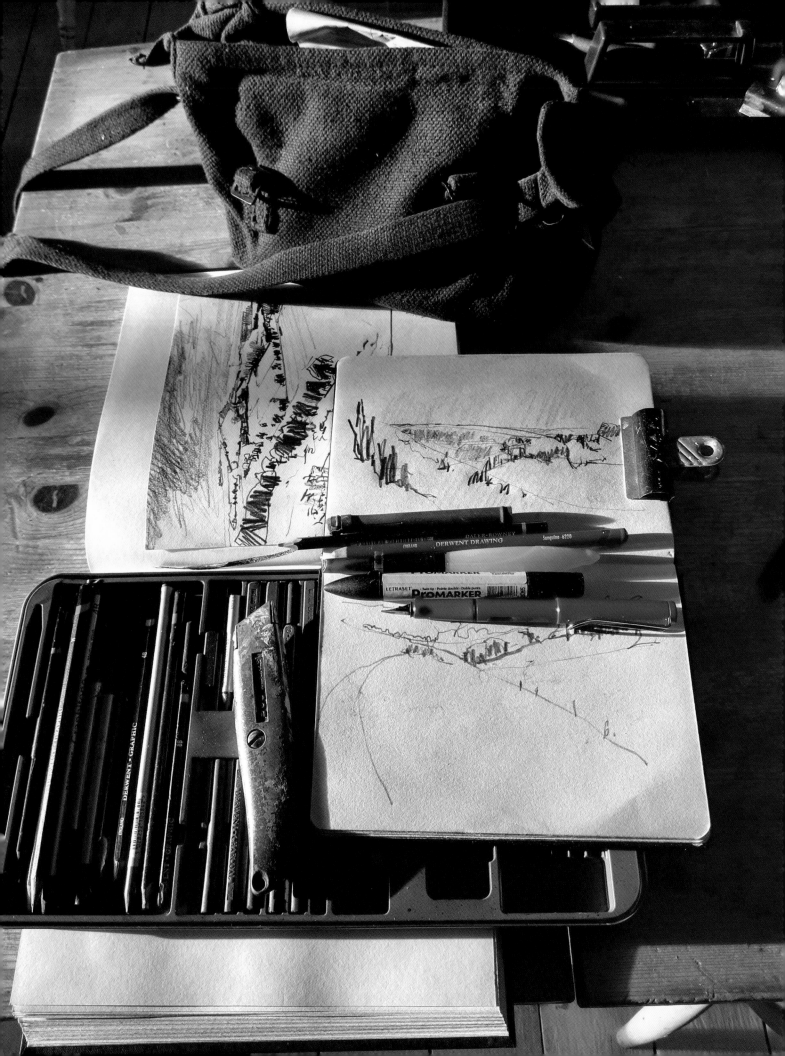

Materials

A *s one stands at some high promontory, and looks across at this vast space, at the tiny markers of human existence, the ant-like cars catching the light as they trail through country lanes, a bale of hay in a field. One ponders the problem of how one can do justice to all this space and light with a sketchbook and some simple drawing materials.*

Many things are capable of making a mark on paper and can be used to respond to the landscape. There is an intimate relationship between the artist, the material, the support and the scale they work. You will find that one medium is better for the kind of drawing you want to make, but one needs to play with media to know how it can be used and what it can be used for. Only by challenging what you do already will you grow as an artist and become familiar with the unknown.

DRAWING TOOL KIT

A small sketchbook, preferably one that is fairly cheap (so that you do not feel under pressure when you use it) is an absolute essential part of your basic drawing tool kit. Expensive sketchbooks can be really intimidating, so a cheap sketchbook is a great start. A scrapbook is a good idea too as they are usually made of coloured sugar paper, has a lovely texture suitable for charcoal, pencil, graphite and watercolour, as well as pastel drawing and coloured pencil

studies. This will help you make coloured studies of the landscape and are also cheap. An A3 hard backed landscape format sketchbook is a great buy as they will last a very long time and will enable you to approach the landscape in lots of different ways and in a variety of different media.

Eventually it will pay dividends to buy a sketchbook of pastel paper and a watercolour pad. Look at the texture of the paper before you buy. Some pastel papers can have quite an artificial grain, which you may or may not like and some may come in a colour range that is too strong, or is not heavy enough for your needs.

Photocopy paper is useful as well as this is excellent for basic monoprint, relief prints, pen and ink, biro and compressed charcoal studies. It is good for making quick studies and great for practising mark making and experimental work. Buy yourself some fine line pens, a dip pen, a brush pen, a long clear plastic ruler and a metal rule is essential for cutting paper or card. These are usually much cheaper from a DIY store than an art shop. Biros are inexpensive, can come in a variety of basic colours to draw and are great to work with. Alcohol markers can be very effective for sketching (Promarkers come in a wide range of colour) and increasingly watercolour markers that are now available, which give you versatility of a marker with the ability to modify the colour with a brush. (Spectrum Aqua and Windsor and Newton). A small set of watercolours, soft chalk pastels, graphite, oil pastel, a range of pencils and a plastic rubber are also essential purchases.

A range of basic drawing tools and two sketchbooks of different sizes. Note the bull dog clip to stop the pages flapping around in the wind.

If you intend to make larger studies in acrylic or oil, A1 sheets of 220gsm acid free cartridge paper makes for a good standard and T.N. Lawrence do a huge range of handmade and mould made papers. 220gsm is a great paper for painting as it is less likely to cockle (deform) when wet and you can get heavier papers for watercolour. You can buy individual sheets as needed from your local art shop or you could order a pack. A cheap alternative is a roll of lining paper from your local DIY store (the heaviest weight you can). These will need sticking down to a board with masking tape or gummed tape (another must if you intend to do a lot of watercolour). A craft knife is invaluable too and it is best to buy one with a retractable blade. Some knives have one long continuous blade running along its body, which can be snapped off to a sharper blade when it has gone blunt. Some have spare double-ended blades, which fit inside the metal body of the handle so that when the blade goes blunt, you open the handle, turn it around and use the other end, before disposing of the blade entirely. This type of craft knife is better and stands the test of time. Blades are used for cutting paper, card, thin board and sharpening pencils. A scalpel is also great for collage and fine cutting. If you are going to use a scalpel, it is a good idea to save a cork from a bottle of wine to put your blade into when you have finished using it, as this reduces the risk of accidentally stabbing yourself. Alternatively, some scalpels also have a retractable blade. Although a cutting mat is a luxury, it will prolong the life of your blades and makes cutting safer so it is a good buy too.

Do not be put off by this list and feel intimidated to go out and spend a fortune on materials. Look at each exercise and buy what you need as you go along but eventually you may need to buy some more specialized drawing and painting media to suit your intentions and ambition.

Charcoal

Wood that is put in a sealed container and placed in the centre of a fire, cooks and blackens. This carbonized wood is charcoal and comes in the thin and thick varieties according to the part of the branch that has been used. Commonly used is willow or vine. Charcoal can produce a wide variety of tones. One of the common mistakes is to use it like a pencil. It can be easily moved around and removed so the drawing can transform and grow in a much more organic way. The potential of charcoal is limitless, from the atmospheric gestural landscapes of Peter Prendergast to the decorative mark making of David Hockney's drawings of Yorskhire.

Compressed Charcoal

Mixing crushed charcoal and gum arabic produces compressed charcoal. Charcoal pencils use compressed charcoal at their centres. They have different grades of hardness, uniform in their shape and behave like pastels. They can produce

Two identical clutch pencils, one with compressed charcoal and one with graphite.

A set of Derwent compressed charcoal sticks of varying grades.

a very strong black, which sticks to a wide variety of paper including smooth. The pigment is bound with gum arabic, which is the same binder as gouache and watercolour. It can be used with water to produce washes. Compressed charcoal can yield dark and emotive landscapes and light and airy ones too. It is difficult to erase and when held in the hand, transfers itself easily onto your skin.

Compressed charcoal comes in a variety of tones from black through to white where you can produce a lighter tone without needing to dilute. This works particularly well when you are drawing the landscape on toned or coloured paper. Because of its glue content, it is less likely to need fixing than normal charcoal. It can also be rubbed onto the back of photocopy paper to make transfer paper and be bought in a range of hues, and the earth palette its particularly useful.

Clutch Pencil

These are a mechanical lead holder, holding graphite or compressed charcoal into a handle. They come in a variety of sizes, weights and costs. The very thin leads can break easily and are only really capable of very fine lines, delicate hatching and controlled detailed drawing. Ones that hold a thicker lead will allow you to make a more expansive range of marks, which gives you greater scope to render the landscape. The weight of the tool and how it feels in the hand is an important part of the drawing symbiosis. Your mark making can be expressive, frenetic or delicate, giving a more diverse range of approaches. You can change leads easily which means that you can draw with a range of media, but it will always have the same weight and feel in your hand.

A set of water-soluble Neocolour crayons.

Conte

Rather like compressed charcoal, it is a combination of pigment and gums with some waxes too, which makes it harder and easier to sharpen. Conte comes in a wide range of colours and can also be used with water. Sanguine closely resembles red chalk, which was a mined red oxide. It was used by artists such as Watteau and Rubens. Combined with black chalk, it is possible to produce a wide range of subtle tones. Look at Rembrandt's red chalk drawings as well as Fragonard.

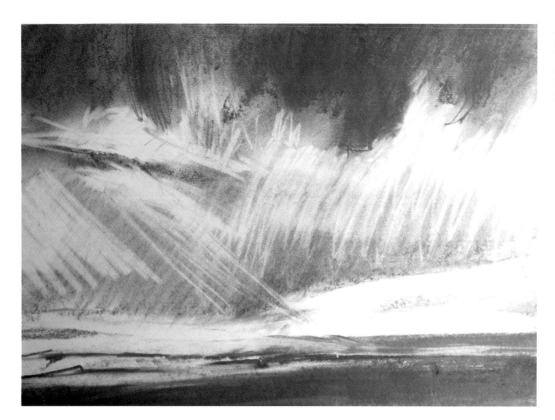

A graphite stick drawing made on grey pastel paper. They were easy to erase too, enabling the light to be formed in the clouds. Study for *Murmur*.

Crayon

Wax crayons are a combination of wax and pigment. The pigment loading tends to mean that colours tend to lack in vibrancy, but chunky crayons are really good for frottage and wax resist, especially when combined with an ink wash. Using photocopy paper, experiment with capturing some of the textures in the landscape by making rubbings. These sheets can then be used for wax resist by laying a wash over the paper. The wax repels the wash, leaving the colour of the crayon and the texture. These can then be used as collage elements in your drawing.

John Piper's (1903–1992) bombed out buildings made during the Second World War are great examples of this technique. Pencil crayons come in a much wider and richer variety of hues, and some are water-soluble. The better known brands, Caran d'Ache, Derwent, Staedtler, offer a rich and diverse range of hues with excellent pigmentation. New products continue to emerge: Inktense, pastel pencils as well as various coloured Art bars and solid watercolour.

Eraser

The eraser can be both a destructive and constructive tool, not just removing unwanted drawing but creating images. Paper can be covered with a layer of charcoal and smudged in with a rag or the back of your hand to create an overall grey. The light tones can then be erased out of the grey, making the drawing rather like a bistre study, before further tones are added to make the darks.

Bread

A humble slice of bread can be kneaded into a small ball. Stale bread is best. This can be used as a rubber too. A Putty Rubber is a soft kneadable rubber, which can be manipulated to erase small detailed areas as well as larger expanses. You can also get electronic rubbers, which work a bit like an electric toothbrush, rotating a small rubber tip to allow fine detailed erasing.

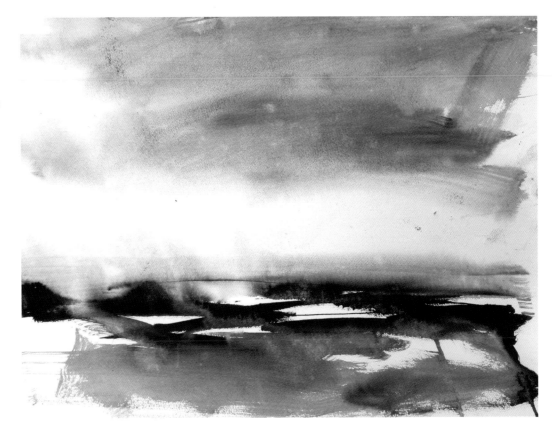

This quickly executed ink drawing tried to create the atmosphere of an oncoming storm with looming clouds overhead but intense light filtered through the veils of rain in the distance.

Graphite

This is found in pencils and the degree to which it is combined with clay creates the various tones available (B for black and H for hard). Graphite can also come in stick or pencil form. Soft pencils are great for immediate and tonal landscape drawing. Graphite sticks make it easier to create large areas of a drawing more economically, but are also good for fast drawings capturing the energy and dynamism of the landscape. Pencil is one of the most widely used mediums of the world and having a broad range of pencil grades extends its scope, softer Bs can yield rich blacks and a broad range of tones. Harder H pencils can yield crisp lines, which are perfect in conjunction with watercolour.

Indian Ink

Indian ink is made by combining soot with shellac and it is the blackest of the inks. When dry, Indian ink is waterproof and lends itself to line and wash drawing which can produce luminous landscapes. It can also be used in conjunction with a stick or a reed pen where you can make expressive drawings and mark making studies. Van Gogh demonstrated the potential of thinking across the various textures of the landscape, translating that into reed pen marks, of dot, line and dash. Indian ink is diluted with water, although the texts suggest that you use distilled water (if you have a condenser tumble drier at home you will have a lot of distilled water) as normal water causes the pigment to break down and scatter into the wash. Indian ink was a standard medium for illustrators using a dip pen at the turn of the century. Coloured inks are made with soluble dyes mixed with shellac so they are often very bright, transparent and water-resistant once dry.

Iron Gall Ink

An ink used in the Renaissance, which is made from crushed oak galls, rainwater and rust with a little vinegar. It produces an ink, which gradually darkens with age, becoming a blue black.

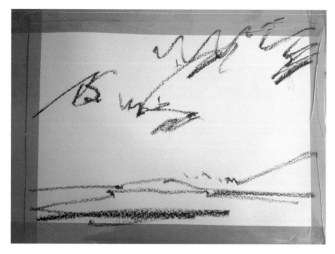

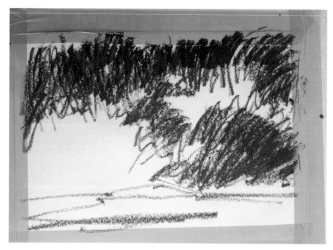

Whilst oil bar has similar qualities to oil pastel, it is a much more fluid medium. Once the surface of the paper is covered, you can continue to build up and manipulate layers of colour to create incredible richness and painterly effects. This drawing started off on grey paper with a series of linear marks to describe the main areas of the large storm cloud as well as the landscape structures.

In this drawing, Raw Umber and blue were applied, building the dark cloud masses overhead, as well as the leaving areas of paper for the intense light that would break through these clouds.

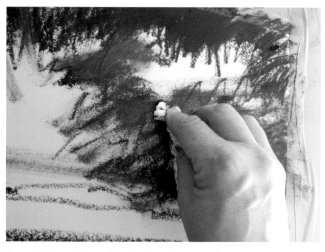

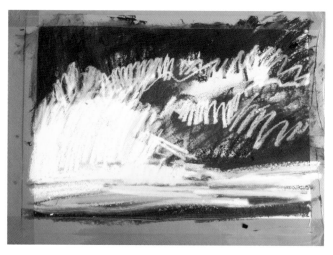

Some kitchen roll (as well as the thumb) was used to move the oil bar, blending the colours together, moving the material as one would do with painting, creating a much greater variety of texture and form both soft and hard. This is much easier to achieve than with oil pastel.

More colour has been added, introducing white into the equation as well as bright strokes of yellow and green. A limited range of all bars have to be experimented with to yield the right range of colour. At the moment, the drawing is still quite coarse, keeping the weave of the paper open.

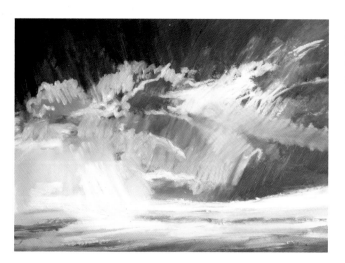

In the final stage, much more layering has taken place: working blues into Raw Umber, manipulating subtle areas of colour into the whites, establishing the main drives of the foreground landscape which was shrouded in a rain nest but which also had this incredible luminosity.

Oil Bar

Rather like an oil pastel but somewhat larger, the oil bar leaves a wet mark on the support, which can be worked like oil paint with a brush and solvent. This can lead to exciting gestural and painterly marks, which lean toward a more expressive interpretation of the landscape. An oil bar is halfway between oil pastel and oil paint, and it comes in thick tubes, like an overlarge pastel but it has a very soft, fluid touch. The bar tends to form an outer skin much like oil paint when it dries. This has to be broken and can be done with a knife to create a finer edge.

It can be useful to store these in a takeaway plastic tray once opened, as they can spread everywhere.

Oil Pastel

The combination of pigment and oil. Oil Pastel comes in small stick form, which is usually covered in paper, making it easier to handle. The variety of colours can be quite widespread depending on the brand and they can vary in consistency too. They can be mixed with white spirit or turpentine to produce more painterly effects, but equally they can be used either flat, blended or mixed using hatching, cross-hatching or stippling. The range of the medium and the scope for its manipulation can yield a wide range of land-scape interpretations. As with all pastels, you can go larger, working on bigger paper, especially coloured paper which gives you more scope to build up detail and subtle rendering of form and colour nuances.

Paper

Paper can be made from many materials but commonly it can be made from either wood (pulp) or cotton (rag). Paper made from wood has an acidic content which eventually causes the fibres of the paper to rot and discolour, becoming brittle with age (think an old paperback book). Paper made from rag does not have this acid content and therefore does not deteriorate with age (acid free). Archival work, water-colours, gouaches, drawing and prints should be made on acid free paper in order to secure their longevity. Paper has a texture depending on how it has been processed. Paper also has a size (glue) content, which holds the fibres of the paper together. A waterleaf paper has no size, making it very absorbent. The same is true of blotting paper, making it soak

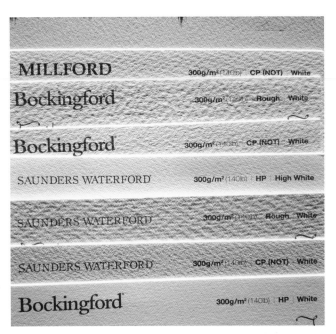

A range of free watercolour paper samples which came from one edition of the *Artists and Illustrators* magazine.

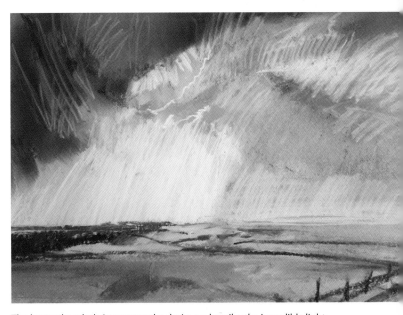

The key to the whole image was the desire to describe the incredible light in the scene. Pastel was used in layers and built up on a coloured ground.

up moisture. The greater the size content, the less absorbent it becomes, making colour sit on the surface. Etching paper will have little size, ensuring that it has the flexibility and absorbency to remove the ink from the etched line, whereas watercolour paper will have a lot of size in it. These are of course personal choices, but it is important to explore the

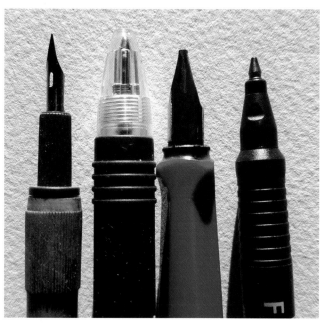

From L-R, a dip pen, a biro, an italic nibbed Lamy fountain pen and a fine line pen.

A five tone promarker study of storm clouds.

variables to help you achieve the results you want. Some paper manufacturers sell offcuts of sample packs. These can at least give you an affordable, easy way of trying out approaches.

Pastel

Chalk pastel is pigment mixed with gum acacia and is dry and powdery to touch. Chalk pastel can be blended or mixed together using hatching, cross-hatching, or by rubbing the pigments together. Unlike oil pastel, chalk pastel can be erased, which means that they can be transformed much more easily than oil pastel. Like oil pastel, the scope of chalk pastel is immense. Degas demonstrates the true mastery of the medium and it is worthy of note that pastels are often referred to as paintings (have a look at James Crittenden's pastels too). As with most dry media, colours are mixed through layering, either blended together on the paper support, or optically mixed. It is important to retain the integrity of the paper surface for as long as possible. Keeping the weave of the drawing as open as possible will retain its vivacity of hue. Build up your layers and remember that your drawing has to be fixed or mounted behind glass.

Pens

Before the creation of the fountain pen, a dip pen was the most prevalent form of writing implement. These are incredibly sensitive tools, made from steel. They have a small split end, connected to a reservoir, which will hold ink, food colouring, bleach and other fluid media. They are pressure sensitive, so you can make a variety of line widths as well as more gestural mark making, and the opportunity to create different dilutions to dip into and a sense of space in your landscapes.

A biro or ballpoint pen was an invention of the late nineteenth century and has a greasy viscous ink that is transferred onto the paper with a steel ball. A fibre tip pen and felt tip pen transfer a more solvent-based ink through capillary action (the ink is drawn through the fibre or fabric, which dries quickly.

A fountain pen can make a beautiful addition to your drawing and you can choose from a variety of nibs to suit your hand, but a fine point can be used to produce eloquent hatching and cross-hatching.

Some use a bladder, which means that you refill your pen by immersing it in ink and squeezing it. Some use a plastic cartridge that will allow you to draw for quite some time without the need to refill. The ink used in fountain pens tends to be a water-soluble ink, which means that after an initial drawing is made, the ink can be lifted with water to create washes.

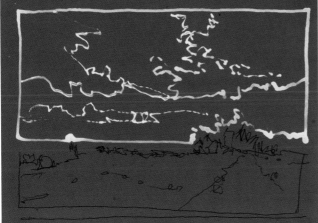

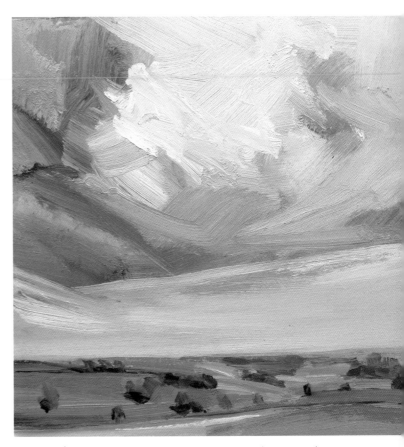

This is an acrylic painting of the Downs, trying to capture the space and the dynamic movement of clouds.

Using a Tipp-Ex pen to make a drawing. The pen handle is flexible and is squeezed to release the Tipp-Ex. The varying width of line makes it somewhat ambiguous as to what is the landscape and what is the sky. Invert the image and it reads as another landscape.

The language of pen and ink resembles that of hard ground etching and it is worth looking at some fine examples by Whistler or Rembrandt, in particular at how line is manipulated to describe space and form.

Quink Ink

Quink is a brand of ink, which is used with fountain pens. It is trichromatic ink, which means that it is made up of colour. Diluted in water, these colours reveal themselves when the ink pools. The combination of the line and the dispersion of colour into water from the black makes for sumptuous and evocative landscapes. The ink can also be bleached so areas of a drawing can be blocked in and worked back into with bleach applied with stick, dip pen or brush. It works well with wax resist and can also be combined with other water-soluble media. The nature of its solvent base means that it will come through layers of paint.

Tipp-Ex

Tipp-Ex is a brand name for a correction fluid, which was originally developed to correct errors in typing when manual typewriters were commonly used. This white opaque medium can be used to cover over errors in pen and ink drawings, as well as for drawing purposes. It comes as a bottle with a sponge brush applicator, which can be mixed with oil pastel to produce delicate pale colours, and in a pen form. The pen can be used to make drawings on coloured paper.

Wire Brush

Used on the surface of the paper or board, the wire brush can create rough textural effects. These alterations of surface can be used prior to the application of media, or after to reveal previous layers. Craft knifes, sandpaper and scourers can also be used in the same way.

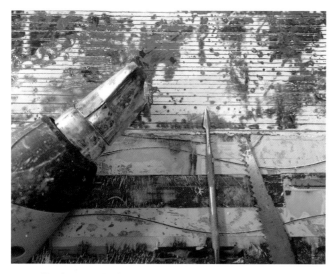

Wax pellets being melted into a tray to be decanted into tins with oil paint. (Courtesy of David Hayward)

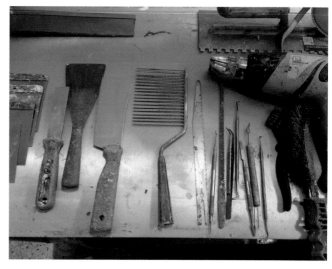

Some of the tools used to manipulate an encaustic painting. (Courtesy of David Hayward)

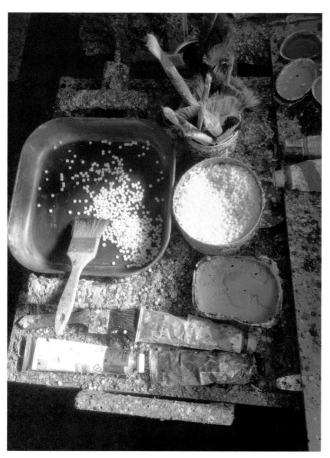

A wide variety of painting tools. (Courtesy of David Hayward)

PAINTING MATERIALS

All paints are effectively made of three constituent parts: pigment (material which gives the paint a colour) whiting (which gives the paint opacity) and binder, the material that causes the paint to adhere to the support. Not all pigments work with different binders, so subsequently the range of hues available in oil paint differ from those in acrylic and watercolour. The combination of pure pigment and the binder gum arabic – or gum acacia – forms watercolour. Watercolour is the purest of the paints and the best quality watercolour is in pan form as this is the purest combination of pigment and binder. Tube watercolour will have other things mixed into it to reduce the possibility of drying in the tube; this can include things like honey, which will reduce the quality. Tube watercolour can go off, especially if the lid is left off the tube. Pan colour will last a long time and will go a long way, but it is more difficult to create large expensive watercolours just by using pans.

Pigment mixed with gum acacia and whiting produces gouache, poster paint and powder colour. These paints are effectively the same; the differences between them will be in the choice of pigment (you will find that the better quality pigments are in gouache) Gouache is ground to a much finer consistency than poster paint or powder paint. The amount of whiting involved will also vary between types (cheaper paints will use more of it). Whiting is unbleached chalk and is relatively cheap, so the more whiting in your paint, the more opaque your paint but also the more chalky the paint can appear.

Pigment and whiting mixed with acrylic resin produces acrylic paint; pigment and whiting combined with linseed oil will produce oil paint; mixed with egg yolk: egg tempera painting; and combining pigment whiting and wax will produce encaustic.

Encaustic

Encaustic can come into main types, hot or cold. With hot encaustic, beeswax is melted in tins, using a hot plate (a camping stove works) and the liquid molten wax is added to the paint, which dries as soon as it cools. This means that colour mixing has to be done on the hot plate or in different tins sitting on the hot plate (used canned food containers are great for this).

When pigment and whiting are added to rabbit skin glue size (which is usually heated in a double boiler) this produces distemper, which also dries really quickly. All water-soluble paints are inter-mixable. Oil paint can be painted on top of egg, tempera and acrylic paintings, which mean that these mediums can be used for underpainting, with the advantage of faster drying, a lot of colour blocking, and drawing and tonal balancing can be done before more refined oil blending can be applied on top. Acrylic cannot be painted on top of oil, the constantly shrinking surface causes the acrylic paintings to peel off. However, egg tempera can be painted over wet oil painting.

Acrylic

Acrylic has a bad reputation, this is partly due to it being relatively new, as it was only really being used by artists from the 1970s onwards. It is also partly because of some of the poor performance of some of these paintings in terms of conservation. There were some issues with David Hockney's work from that period, where Hockney modified the medium to try to slow the drying time down. It was these modifications that later caused problems with the longevity of the paintings. However, according to the experts, the chemists state that acrylic is probably one of the most durable paints available to artists today and certainly should last equally as long as oil paint.

To a certain extent, you get what you pay for. Some cheap acrylics tend to be very poor indeed, watery, lacking quality

WORKING IN ENCAUSTIC

David Hayward works in encaustic and writes:

Encaustic is an ancient medium used by the Egyptians and Romans. It re-emerged early in the twentieth century and was used by artists such as James Ensor, Diego Rivera and Jasper Johns. The process involves dissolving pigment into molten wax (most often oil paint into beeswax). Other oils and resins can be added to alter consistency, luminosity and surface finish. Some artists include other materials encased in the wax to create mixed-media images. Wax and oil colours are mixed using a hot plate or electric palette and are then applied quickly to the painting surface (usually board). The medium cools and sets almost immediately which allows more layers to be applied without waiting for the underpainting to 'dry'. If necessary, a hot air gun can be used to soften the surface and various tools can be used to manipulate textural qualities, apply detail or remove unwanted layers.

I work mainly in encaustic – a very physical, often messy process of dissolving oil paint in heated beeswax – it is a medium that tolerates trial, error and change. Encaustic surfaces can be manipulated in various ways – sometimes by burning, cutting and scraping away layers to reveal underpainting or by embedding discarded fragments from earlier work into a painting's surface. These acts of burying and excavating, revealing and embedding offer a kind of parallel to the way landscape contains geological and archaeological evidence of its own past.

pigment and so on, and the cheaper brands tend to dry to a more plastic finish. Spending a bit more money will certainly yield better quality pigment, greater opacity and coverage as well as a more matte finish. Winsor and Newton, Lascaux, Golden all do acrylic ranges for both the student and the artist.

Daler-Rowney's Cryla has one of the densest pigment loading and has a thick buttery consistency which lends well to impasto approaches, but can also be watered down to produce delicate glazes. Daler-Rowney also has the System 3 range, which is a much more affordable paint coming in a range of sizes. The 500ml tubs are useful if you intend to do a lot of painting or work on a larger scale. They are flow formula, which means that they have a softer feel and can

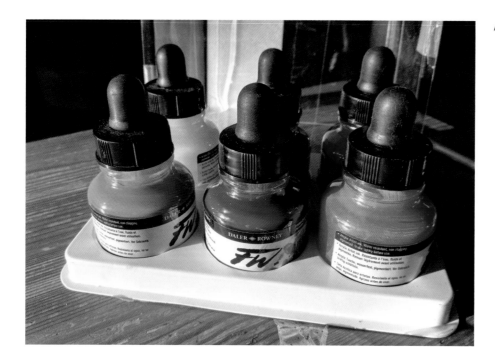

A set of six Daler-Rowney FW acrylic inks.

be used to create larger expanses of colour, used in an air-brush, diluted more readily and can also be combined with mediums that can transform them into screen printing or relief printing ink. The medium slows the drying time down, allowing time to pass through the screen or be inked on the block without drying out first. Other mediums can be added to acrylic to aid glazing or stiffen the paint as well as altering the surface (matte, gloss). System 3 also has a heavy bodied version, which is certainly denser than normal System 3, but is nowhere near as dense as Cryla. A good compromise which is certainly more economical is to buy System 3 colour but to use it in conjunction with Cryla white.

Acrylic paint is a water-soluble material, which dries to become waterproof. Acrylic medium is rather like PVA, white when wet, but becomes transparent and waterproof when dry. This means that when you paint, your colour changes as it dries, often darkening in hue. More expensive artist quality acrylics do not tend to do this as much. Its flexibility means that it is an excellent paint if you are trying to paint using impasto, but it can also be thinned down to produce delicate glazes. Although one can use water to do this, you stand the risk of undermining the paint's adhesion to the ground, meaning that colour can be lifted off.

Recently acrylics have been created which have slower drying times, enabling them to be manipulated more like oil paint. These are sometimes referred to as open or interactive ranges. Additionally, the drying time of acrylic can be slowed by keeping the surface of the paint damp with the use of a water spray.

Acrylic can be a fantastic medium. It is fast drying which means you can paint quickly in lots of layers, perfect for *plein air* painting when the weather changes constantly. You can break all the rules associated with oils and can combine many techniques in the same image. It is capable of a broad range of approaches from expressive and gestural studies to meticulous rendering of the landscape.

Acrylic Ink

Daler-Rowney produce the FW range, which are acrylic mixed to a very fluid state. They come in small jars with an eyedropper, which makes them easy to dispense and allows for greater consistency of colour mixing. Their fluidity makes them perfect for dip pen and mapping pen usage, running through an airbrush or used like watercolour.

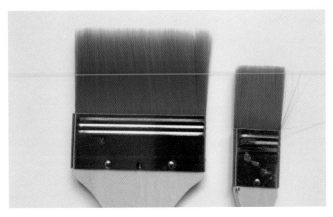

A flat is square ended, producing a blunt blocky mark. The Glasgow boys and some of the coastal painters around Staithes, Newlyn and Dorset advocated the use of the square brush technique.

Three different sized rounds.

A bright is like a tapered flat.

A fan brush is shaped like a fan and was traditionally used as a blending tool to mix together adjacent colours, producing a subtle mix, but can also be used in a landscape painting to create tree and branch textures (*See* Chapter 5, Mark making).

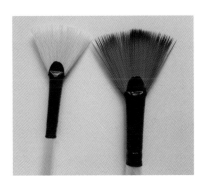

Alkyd

Alkyd is an oil paint, which has been modified with the use of resins to enable it to dry much more quickly than traditional oil paint. The resin in the paint means that it handles pretty much the same way that oil behaves, however, coming out of the tube, it is somewhat softer in feel. Alkyd can be particularly useful when working *plein air*, where the increased drying time can be advantageous. Both Alkyd and traditional oil can be mixed, so it is sometimes useful to mix an Alkyd white with traditional oils as this will often speed up the drying time of the oils.

Brushes

You can spend a lot of money on brushes, but equally some inexpensive brushes can do the same job that expensive ones can do. You need a brush, which has resistance, so that you are not fighting against the paint. If your paint is stiff and buttery you need a stiff brush. If you want to work with more fluid paint, then you need to use softer brushes, but you still need that tension in the bristles. Large brushes can hold a small point and can give you a good reservoir of paint, but a small brush cannot yield a big mark. So it is better to aim for larger brushes, when selecting them. DIY stores can be a real solution for very large brushes and the choice and quality of bristle can vary considerably.

Brushes are described according to their shape and the type of hair used in their construction.

A brush can be made out of different fibres: hog, sable, squirrel hairs as well as synthetic nylon ones.

It is true to say that different brushes work best with different paints and techniques. You need to experiment to find out how to use these tools, understand the variables to begin to discover for yourself what works.

Piers Ottey once said that he never made an oil painting with less than thirteen brushes. It's better to have a large number of brushes dedicated to different puddles of colour than frequent visits to the sink to clean one brush. Keeping your colour fresh is easy if you know how.

Gesso

Gesso is the traditional way of priming boards for oil painting. The combination of whiting (unbleached chalk) and

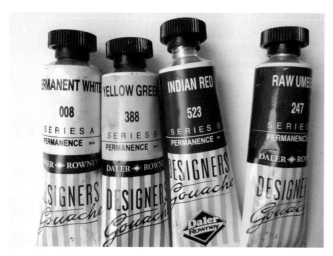

Four tubes of designer's gouache. These will enable you to produce a very flat colour. They are opaque and use the best quality pigments, which is why they are very expensive. Cheaper versions do not have the same covering power or feel. Have a look at Mike Hernandez's gouache landscapes to give you some idea of the medium's vibrancy.

Liquin is an alkyd medium which increases the drying time of oil paint by 50 per cent. It can come in a variety of different viscosities: original, fine detail, Oleopasto, each of which creates different painting textures from transparent glazes to richly impastoed. Lucas number 5 is another painting medium and there are many on the market, and many that can be made by the artists to suit their individual needs.

rabbit skin glue size. Pellets or size are dissolved in water overnight and then heated in a bain-marie to make it more fluid. Whiting is then added to this hot size to form a creamy gesso, which is then applied to the panel. This is usually done over time, sanding between each successive layer with wet and dry, forming a sealed smooth surface. In recent times this has been largely replaced with acrylic gesso, where whiting is added to acrylic resin and applied to the board. As the acrylic gesso is more flexible than traditional gesso, it can also be used to prime canvas as well.

Oil Paint

The history of oil painting is long and well documented, dating back as far as the fifteenth century in Europe, but it was during the Renaissance that the medium came into its own. The fact that it is slow drying means colour is workable for many hours/days, which allows for seamless transitions of colour and tone, particularly when the surface of the damp painting is feathered, blending damp paint patches together. They say the oil painting was developed to paint flesh but its flexibility and longevity demonstrates that a wide variety of pictorial surfaces can be created using it. One of the basic working processes of oil paint can be summarized in the phrase fat over lean. This essentially means that initial painting layers should be relatively oil-free, and subsequent layers should have increasing amounts of oil content. So initially,

painting starts with oil paint mixed with turpentine applied thinly, rather like a series of washes, new layers might have more tube consistency and as more layers go on top of that, you might begin to add oil content to your paint, creating more flexible paint films. Following this principle will also reveal that each layer will have a different drying rate. The lean solventy turps layer will dry fairly quickly, making it useful for *imprimatura* (a thin transparent staining layer of the primed canvas to give it a coloured ground), and can be used for underpainting (*grisaille*, *verdaccio* or *bistre*). More oil paint added to the turps will create a more creamy paint, which will take longer to dry. Less solvent but adding mediums will increase the drying time and medium rich, oily glazes form the final top layers. There are numerous mediums that can be made which combine oils, solvents, resins and waxes. Each medium will have their own properties and will feel different on the brush. Only experience will give you insight into your preferred medium of choice. Liquin is a very popular alkyd based medium which speeds up the drying time of oil. It comes in a variety of viscosities which enables you to make both thick impasto and thin transparent glazes or fine detail.

Depending on the scale of the work, a medium size painting can take anywhere between two to four hours to construct if one is working *alla prima*. A small oil study could take about an hour to an hour and a half so the nature of the scene needs to have this taken into consideration.

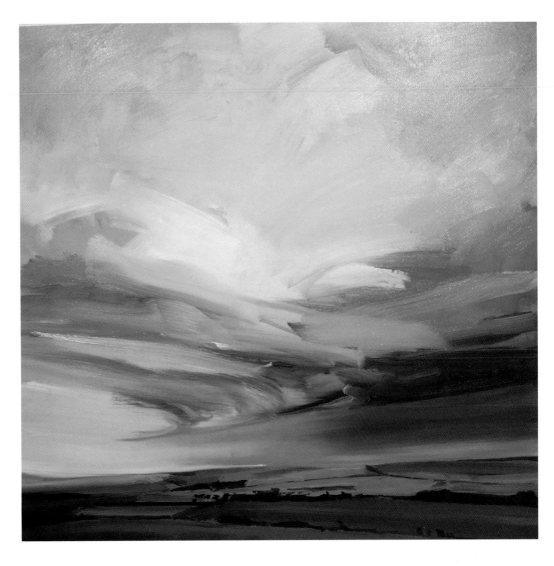

Fold, oil on canvas, 100 × 100cm. *Alla Prima* painting which attempted to capture the drama of an oncoming storm.

Medium

Oil paint and acrylic paint can be modified with the addition of different painting mediums. Turpentine will act as both a solvent and a medium. Thinly applied oil paint (lean) would generally have a high degree of turpentine, which quickly evaporates, making it a quick drying solution to underpainting. Linseed oil is another slowing the drying time down and is used generally for creating glazes. Mixing turpentine and linseed oil together with the addition of damar varnish can also create another medium and there are various different permutations and combinations of solvent oils and waxes. Liquin is an alkyd medium which increases the drying time of oil paint by 50 per cent. Liquin can come in a variety of different viscosities, each of which create different painting textures from semi-transparent glazes to richly impastoed. Lucas number 5 is another painting medium and there are many on the market.

Palette

A palette should be the size of your painting. A large painting requires a large amount of space to place your paints, brushes and solvents, leaving you sufficient room to mix your colour. Your palette should be non-absorbent, its colour should relate to the colour of the ground that you are working on and it should be easy to clean. You can buy off the shelf palettes, which are often well type; these are suitable for watery paint like gouache and watercolour, where you need to hold the watery material in one place. They are not so useful for working with acrylic or oil painting, unless you want to mix up large quantities (Albert Irvin used old food cans for his colours).

Plastic trays that come with some takeaways, are really handy for mixing big washes applied with large brushes. Plastic egg boxes can also be used as an improvised palette for watery paints. The fact that some of these palettes can be discarded quickly and replaced is quite convenient when

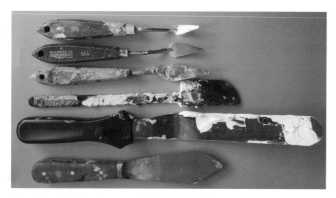

The palette knife and painting knife are incredibly useful tools to have in the studio. The painting knife is usually shaped like a triangle and comes in a variety of sizes. A palette knife is usually more like a rounded blade and can be straight or cranked.

A few years ago, shapers were introduced which were like rubberized palette knives on a brush handle. Their popularity waned and they can be picked up in art shops quite cheaply, but these can be used to apply or manipulate paint like a flexible palette knife. They can also be used for other jobs (see masking fluid and watercolour).

you're working on location. Just make sure that you don't throw your rubbish away in the landscape and recycle where you can.

Tear off pallets are available; made from a thick greaseproof paper, these are useful as once they are covered with paint mixtures, they can be thrown away and replaced with a fresh sheet. Tin foil or a roll of cellophane offer a practical solution when you need to make a very large palette. A small amount of moisture under the cellophane will cause it to adhere to a melamine top, keeping it in place while you are painting. As cellophane is transparent, paper can be painted up to the same colour as the ground you are working on and placed underneath. Tin foil can be taped down with masking tape again once the palette is full of colour, it can be thrown away and freshly replaced.

Palettes for Acrylic

Whilst cellophane provides a very practical solution to a painting palette, it should only be used for fresh acrylic. The nature of this fast drying medium means that the paint forms a skin on the surface of the cellophane, which slides and mixes with your colour.

It is better if you have a flat palette made of MDF or marine ply. These can be sealed with varnish if you intend to use them for a long time. As acrylic dries quickly, you end up getting quite a heavy build-up of dried paint. Large plastic trays or plastic plates are quite useful too. Air causes acrylic to dry, so at the end of a painting session, you can cover your acrylic with cling film as this will keep the paint wet for days rather than hours. You can use a large Tupperware box or a stay wet palette, which both have sealable lids to keep the air out, but this can cause the acrylic to smell.

Palette Knife

The palette knife is used to apply paint to the palette when the paint comes in a tin, as well as scrape up the residue paint from the palette to aid cleaning. It helps to mix colour cleanly and can be used to make a painting. Colour is best mixed up on a flat palette and applied directly to the board or canvas to establish a plane of colour. Painting knives come in a variety of sizes and can enable you to make broad sweeping gestures or small patches of colour. Acrylic dries quickly, so layers can be applied on top of each other. A rich textural surface can be created and scrapped away. The point of the painting blade can be used to create sgraffito effects. The same can be done with oil, but because of the increased drying time, the technique used must be more affirmative, making a direct statement without too much subsequent reworking, otherwise the result will become muddy. Wall paper scrapers, kitchen spatulas, old credit cards and offcuts of card can all be used as makeshift painting implements.

Watercolour

With the highest concentration of pigment, watercolour is applied as a thin wash and colour can be manipulated through subsequent glazes. If too many are applied, the colour becomes muddy as subsequent layers will mix together. Although the basic watercolour sets seem relatively simple, watercolour is one of the hardest mediums to perfect because you cannot cover up your mistakes. Watercolour can be used broadly to document the transitory light conditions, the subtleties of cloud, mist, rain, as well as the intensity of light. The potential of the medium can be beautifully demonstrated in the studies of Turner, Leslie Worth, Ian Pots and the highly resolved paintings by William Holman Hunt.

Whilst traditional watercolour relies on transparency and white paper, a derivation of this medium is body colour. Body colour is the addition of white gouache or Chinese white into the mix, which allows you the possibility of both transparency and opacity with your techniques.

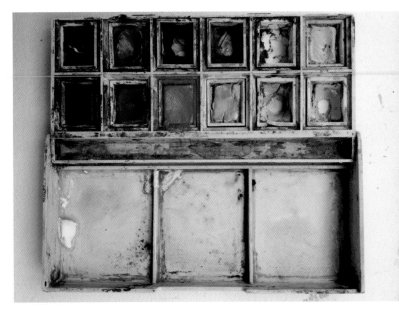

If you are using watercolour, the box has its own built-in palette. This is perfectly adequate for most painting on the spot, but if you are working in the studio on larger studies, it is useful to supplement this with a well palette.

Gouache

Gouache is ground to a very fine consistency, which enables you to achieve a very flat result, however, it can also be thinned down to become a wash. You will find that the luminosity of this colour is not the same as a watercolour. Gouache can also be used through an airbrush and a wide range of painting techniques can be used with it, from washes, dabs, dashes, dry brush and scumbling, all of which will be discussed later on in Chapter 7.

As a point of note, on a bright summer's day, light reflects off the white paper shining directly into your eyes. This can cause some damage to your eyesight. Be careful and consider the use of polarized sunglasses; whilst this may alter your perception of colour, it would be much better to protect your sight or consider the use of coloured paper which will be less harmful to your eyes as it will not reflect as much light back into them.

Water-soluble Oil Paint

In recent years, particularly with the growing awareness of health and safety and the impact that solvent can have on the body, water-soluble oil paint has become readily available. Whilst it is still oil paint, the chemists have altered the chemical structure of the oil to make it accept water, which means that the paints can be thinned with water (or turps) and brushes can be cleaned with soap and water. By removing the need for solvent, there is a dramatic reduction in the hazards associated with the use of white spirit and turpentine, which include irritation of eyes, headaches, nausea and developing dermatitis. If you have a studio with good ventilation and you reduce your exposure to these materials by using surgical gloves, many of these problems can be reduced, but if you have a small studio in your home, then the smell and proximity of these materials can become quite problematic. Water-soluble paints provide an excellent substitute. There is little difference between the handling properties of water-soluble oil paint, however, it is true to say that it is not as widely available as traditional oils and does not have the full range of pigments that traditional oil paint has. Water-soluble can be mixed with traditional oil paint quite successfully and mediums intended for oil paint too, as long as you are not introducing water into the thinning of the paint. Once you do this, you have to treat the paint like traditional oils and you will also have to clean your brushes with solvent.

Hardboard. Here, the textured side is shown.

Canvas. In the early history of easel painting, oils were made on wooden panels (sometime a number joined together to make larger panels). Canvas was developed to enable artists to make larger paintings, which were not so heavy.

CLEANING

For cleaning purposes, it is really useful to use a brush cleaning kit from a local DIY store. There are a few different designs, but essentially they perform the same task. Brushes are held in a bath of solvent and raised above the floor of the container so that the sludge of paint falls off the bristles.

Because of the different viscosity of material, the solvent sits on top of this sludge and can be poured through coffee filter paper, cleaning it further so that it can be reused and the resultant sludge removed with kitchen roll and disposed of safely. It is therefore useful to have a lot of brushes when working in oil.

SUPPORTS

Board

There are lots of different types of board you can paint on, though Chipboard is not a suitable wood for painting. Cardboard is readily available and is generally free (and you can get quite big sheets of it). Depending on the number of corrugated layers, it can give you a more substantial surface to paint on, but it is very absorbent. It can be primed with acrylic or household emulsion but this will cause the board to warp, so painting a large cross on the back of the board should even out the tension. If not enough primer is applied, the surface of the painting will become patchy.

Greyboard

Greyboard is an inexpensive card support and it is a fairly good surface to work on directly with acrylic but it does have an acidic content. This is OK if you are experimenting but not great if you intend to sell your work as it will become brittle and yellow with age.

Mountboard

Mountboard is used for mounting up artwork and comes in large sheet sizes, generally A1 in most art shops but can be purchased larger from some art suppliers. It comes in a number of colours which are lightfast but it is more expensive as it is a soft material and can be easily damaged, especially the corners. Many framing shops often sell their offcuts as these tend to be the bits of card cut out of window mounts.

Hardboard

In America it is called Masonite. Its cost and widespread availability means that it makes it much less intimidating to paint on as a support. Hardboard is made from layers of paper compressed together. It comes in sheets 120 × 240cm, but some stores only sell boards half that size. Some wood yards will cut your boards to size using an industrial machine cutter which can take a matter of minutes, but you will pay extra for every cut. So, one sheet of wood could give you eighteen 40 × 40cm boards to paint on, coming in at approximately £1.00 per sheet. Hardboard comes in 5mm thickness

and has both a textured and smooth side. The textured side can be painted on but the surface is quite coarse and artificial with a strong grain pattern, but it can suit more scumbled dry brush techniques as this side is much more absorbent than the verso side. This opposite side is very smooth and paint has a tendency to slide off it, which can be useful for initial underpainting. This is improved, however, with priming, especially if one uses a gesso ground. Hardboard can be trimmed down with a sharp craft knife and a steel edge.

Canvas

In the early history of easel painting, oils were made on wooden panels (sometimes a number joined together to make larger panels). Canvas was developed to enable artists to make larger paintings, which were not so heavy. Oil paint eventually rots canvas, so it has to be prepared with primer to allow the paint to sit on the surface of the painting away from the support. Loose canvas needs to be stretched over a wooden frame to create a flat surface to work on. This framework is called a stretcher or a strainer, depending on whether the corners can be pushed outward to restretch the canvas (if it goes saggy) or whether its dimensions are fixed. You can buy ready-made canvases that are already primed. They do vary considerably in quality and some of the cheapest are more primer than fabric. The cheap ones are usually very lightweight and can warp and break easily on the larger scale. The artist's quality ones are usually better made with heavier wood and denser canvas or linen. Some stretchers are made of aluminium rather than wood, which are more or less museum quality and do not warp. Alustretch produce stretchers for some of the top artists in the world.

Linen

This is a much finer fabric and is often used in portrait painting but equally it is more expensive than cotton duck canvas.

Canvas bought on the roll can have a certain amount of resistance to priming. Which means that the primer sits on top of the canvas rather than integrating into it. This can be alleviated by washing the canvas first, but care has to be taken that the canvas does not become creased. The best way to do this is to place canvas into a bath of water and then hang it out to dry. This not only reduces the starch and makes the canvas more readily absorb the primer, it also causes the canvas to shrink a little. Warped canvases are often caused by

MDF (medium density fibreboard) has many of the properties of hardboard although it has a matte surface on both sides.

too much tension on the stretcher due to the shrinkage of the canvas. When making your own canvases, ensure that your canvas is approximately 25cm bigger in both dimensions than your stretcher or strainer. This will allow for enough room to pull the canvas over the stretcher bars on the other side.

Rabbit skin glue size is the traditional preparation of canvas, which causes the canvas to shrink. Acrylic gesso and acrylic can also be used on canvas, but do not use household emulsion paint as this will crack due to the flexibility of canvas and the brittleness of the paint.

MDF

Medium density fibreboard (MDF) comes in a variety of thickness; 3mm is a good thickness in that it is very similar to card in terms of weight and how much space it will take up in the studio but has the added advantage that if it does warp, it can be easily bent back into shape when framed. Thicker boards are available but they are much more difficult to bend back into shape once bowed, so they need to be cradled on the back to prevent them warping. This involves gluing and screwing (or using panel pins) a wooden frame like a strainer to the back of the board.

Paper

Most fibrous material can be beaten, liquidized and boiled in water to form a kind of soup.

Marine ply is an excellent support. The cross ply nature of the thin veneers of wood tends toward counter warping and it will be able to handle the moisture in the air. Blockboard can be used successfully as well.

Paper can be machine made, mould made or handmade. The edge will usually give you a clue to the origin. Cut clean edges machine made, deckled (thinning out) on two sides mould and on all four sides handmade.

A wooden frame (with a fine mesh stretched across) is immersed into this, collecting the assorted fibres, which knit themselves together. As the water content is removed by draining and pressing between absorbents' cloths, a sheet of paper is formed. The texture of the mesh has an impact on the surface of the paper but also how it is processed afterwards. Paper can be smooth (hot pressed), rough or semi textural (not). Some surfaces can feel heavy and artificial, others will take you drawing and painting media well; the rougher the paper, the more textural the result. A gouache stroke will become more fragmented. A watercolour wash will sit in the recessed texture, charcoal or chalk will slide off smooth paper. These are, of course, personal choices, but it is important to explore the variables to help you achieve the results you want.

2 × 1 are cut to length and a half lap joint has been made in each end.

Strainers

Strainers are fairly easy to make as long as you have some basic tools: a tape measure, a carpenter's square, a saw, a G clamp, a drill and bit, and some screws about 2cm deep.

2 × 1 inches of wood from the wood yard can be purchased although it is better if this is seasoned and planned as this will be less likely to warp. Green (new) wood can twist and bend, especially if it sits inside someone's centrally heated home. Depending on your woodworking skills, you can make mitre joints or a half lap joint. You will need to decide on the dimensions of your painting first and then cut two lengths of 2 × 1 to the shortest dimensions and two to the longest. Depending on the size of your strainer, you may

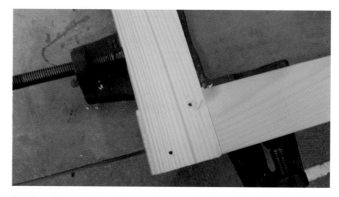

Two lengths are held at right angles to each other, and pilot holes drilled to stop the wood from splitting. These are then screwed together.

Cross bars are inserted into the middle of the frame away from the top edge. These were butt jointed and secured by drilling through the strainer bars into the cross bar and then screwed together.

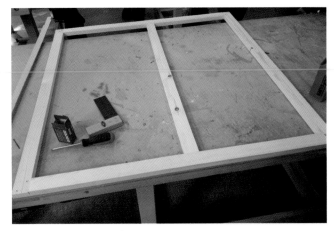

Care is taken to measure the diagonals to ensure that the strainer is square.

MDF sections are cut deeper than the depth of the strainer bars. This ensures that the canvas sits above the frame

You need to ensure that you do not overstretch your canvas as it will tighten anyway with the application of primer. Apply even pressure throughout the process otherwise you can cause the bars to shift out of square.

Start at the middle and place three staples through the canvas into the frame and repeat on the opposite side, pulling the canvas toward you. Then turn the stretcher through 90 degrees and repeat the exercise, pulling the canvas toward yourself as you do so, creating tension. Move to the opposite side and repeat, pulling the canvas toward you again and bringing it over the stretcher to create tension. You can use canvas pliers if you want as this levers over the stretcher bars to stretch the canvas, pulling the pliers away from you, or you can use your hand to do this but be careful with your knuckles as they can chafe against the canvas. Now move slightly to the left of your middle staples and do the same, then go to the point opposite side and repeat. After that, move to the right hand side of the middle staples and repeat and next turn to the adjacent side, gradually working from the middle outward toward the corners on all sides.

You can leave the staples approximately 10cm apart, leaving a gap of about 15cm away from the corners. Try to fold the canvas neatly around the edge of the canvas, pulling the corners out diagonally. Keeping any seams in line with the edge of the stretcher bar makes it easier to frame later as you do not have a bump in the canvas.

The colour of the ground can have a significant impact on the painting so experiment with the following: grey, Yellow Ochre, pink, blue, green and black grounds. Dirty muddy colours come to life on a black ground. Try to make two paintings at the same time with two radically different coloured grounds. When you make your mark on one painting, make the same mark on the other and see how the same colour appears to be quite different according to its background. The underlying colour of the ground creates a unifying effect, meshing your image together. Matthew Burrows swears by a half oiled ground, Piers Ottey on rabbit skin glue size and traditional gesso; each person wants something different and you will have to explore the permutations to find something that suits your needs.

need another one of two lengths for cross bars. This becomes more important when you are working on a strainer, which is more than 3ft across.

You can follow the old carpenter's rule: measure thrice, check twice, cut once to make sure that everything is the right size.

To establish the size of the cut, place an offcut of 2 × 1 at right angles to the end of the strainer bar. Mark off the width onto this wood, and mark off the mid-point of the wood's thickness. Cut the wood down to half its depth and then turn the wood end grain up and cut down this halfway to meet the first cut forming your lap joint. If you intend to make a lot of your own strainers, it is useful to purchase a mitre cutting saw, which holds the saw at specific angles to your wood. This will help you cut perfect 90 and 45 degree angles.

You can make a mitre joint which involves cutting the wood at 45 degrees. The wood has a tendency to split near the end so it is better to drill pilot holes for your screws. A couple of screws in each corner will suffice. Check that your two lengths are at right angles when you screw them together and measure the diagonals to ensure that these are the same size. It is a good idea to attach beading to the top outer edge of the strainer once it's made so that when you stretch your canvas, it is not in contact with the frame, otherwise you will get the impression of the stretcher bars on the painting.

Oil paint is detrimental to the canvas support so it needs to be primed. Once the canvas is stretched, it can be primed with acrylic primer, acrylic gesso, primer or rabbit skin glue size. Traditional gesso should not be put onto the canvas as the movement of the support will cause it to crack but acrylic gesso is more flexible. You can apply your primer with a stiff decorator's brush to ensure that you get the primer into the warp and weft of the canvas. Once covered, you can use a thin scraper to drag the gesso into the surface more, filling up the crevices and sanding in between coats to create a smoother surface if you wish. Alternatively, you might want to use a much coarser canvas for the texture. Painting on canvas can be really exciting, especially if working on a larger scale. However, the cost and effort that goes into making it can be quite intimidating as you will feel under pressure to do something good on it.

Marouflage is a technique where the canvas is glued to a wooden support, giving you the texture of canvas but the rigidity of board. PVA will adhere your canvas fairly well to the board and rabbit skin glue is used for oil painting. Instead of using canvas, muslin can also be applied to the board, creating the same effect.

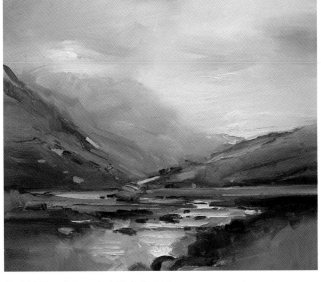

David Atkins. *Autumn Light Lake District*.

Stretcher Bars

Ready-made stretcher bars have tongue and groove joints which makes them easy to slot together, but it means that they are not permanently attached. Once stretched, if the painting loses tension, wedges can be pushed into the corners and hammered outward, increasing the tension. When piecing together the stretcher, you still need to make sure the joint is at right angles by resting the joint against a carpenter's square. As these can fall out of square as you stretch, it is a good idea to tack them together with a length of wood running diagonally across the strainer, holding the two corners at right angles. If you buy ready-made stretcher bars, these have a raised bevelled edge cut into them, which raises the canvas above the bars so that they are not left with the impression of the bar on the finished painting.

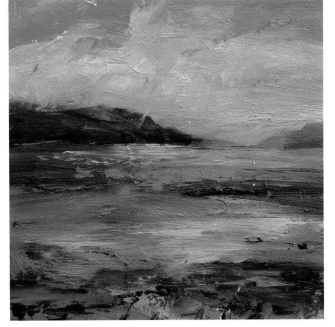

Louise Balaam. *Looking out to sea*, Ullapool.

Ground Colour

Once you have primed your canvas or board, you will need to consider the colour that your painting is going to be painting against. Do you use white? Would it be more appropriate to choose the dominant colour of the painting and colour your canvas or board that hue? The Impressionists would sometimes paint their landscapes on a red ground (the complimentary colour to the greens that they would be predominantly using).

Oiled paper can be bought which already has an oil content and an overall colour. Along with priming and sizing, the surface quality of the support has a massive impact on how the paint behaves once it's on there and the kind of marks you can make.

Your budget may be an important consideration but in many instances, you can buy one of two colours, look for offcuts, find materials that might be used for the purpose of painting and drawing. Nothing can exaggerate the importance of personal experience. All the things that go wrong along the way are vital parts of the learning process and help you on your way to true mastery of a medium.

Linear drawing

*W*alking into the woods, within a few moments the space closes in a series of tree lined tunnels; a break in the path and routes seem to offer themselves up, inviting inspection, but do you continue to travel that same well-trodden path, or venture into the unknown, getting lost, finding dead ends, but with the knowledge that if you do venture into the unknown, you will learn more about this mysterious place?

LINEAR DRAWING

Many people have a belief that the world is divided into those who can draw and those who cannot. Victorian ladies drew because they were all taught how to draw. Anyone can be taught to draw, you can learn in less than one day, sometimes in a matter of three or four drawings. Honing your drawing skills (once you have learned a few of the basic techniques) can take the amount of time it takes to drink a cup of coffee. Fifteen minutes is all you need, fifteen minutes a day, most days and your drawing skills will improve immeasurably. So the simple question then is do you have a spare fifteen minutes and the motivation to use that time?

Perception

We may take for granted the ability to use our eyes, but seldom do we consider how difficult a process seeing is. Each eye sees a slightly different view of the same landscape. The images appear at the back of the retina inverted and through a layer of blood vessels. The light sensitive cells deal either with colour (the cones) or light and dark (the rods), converting this information into electronic signals, which are sent to different parts of the brain. The left eye sends information to the right hemisphere of the brain and the right eye to the left. Each hemisphere has its own visual cortex, which translates the visual information into our understanding of what we are looking at. Did you know that you have a blind spot in each eye and that the brain, rather like the cloning tool in Photoshop, covers this up?

Reading Oliver Sachs's *The Man Who Mistook His Wife for a Hat* reveals many of the ways in which sight and brain do not always work together. In the essay 'Eye Right', someone failed to see the left hand side of things.

The problem of drawing is not a visual one, but it is to do with how we process visual information in our brains. If we can change the way we think about the subject of our drawing and focus on the idea of shape rather than object drawing, then our drawing will improve immeasurably.

Boats at Brancaster Staithe, pencil and ink on paper.

The evocation of memory

Materials

- Old postcard
- Sketchbook
- Charcoal
- Compressed charcoal
- Indian ink
- Tipp-Ex pen
- Large flat synthetic brush
- 2B and 4B pencil
- Pastel

See if you can find an old picture postcard of some holiday destination, a beautiful view. Look through old family photographs and see if you can find something similar. Tap the word landscape into a search engine and see what images pop up. Of these images, which has the greater emotional effect upon you? It should be an easy choice, the family photograph will take you back to the place, the time, the moment, the smell of the location; it acts like a memory substitute. Landscape is much more than just a view; it's filled with moments, recollections, feelings and aspirations.

Whilst it is quite possible to use any of these sources to work from, it would of course be much better if you worked from images that you have some connection to. Before you venture forth and go on location, a great deal can be considered beforehand with the use of photographic source material.

Choose an image which gives you as much information as you can find, something with plenty of detail, a landscape rather than a seascape, with trees, fields and clouds. This image could be in black and white or colour.

Invented landscapes

Draw a series of rectangles in your sketchbook. Place a very light horizontal line across one of the rectangle, about a third of the way down, using your 2B pencil. Underneath this line, draw another, quite close to the first, a few millimetres away. Draw another, this time a bit further away and apply a little bit more pressure, darkening the line. Each new line can vary off the horizontal, become a bit more meandering, but low in amplitude. Another line can be added, darker again with more height in the curves and changes of direction. As you reach the bottom of the rectangle, each line should get further apart, darker and more physical in its execution. It's surprising how even something this simple can evoke the idea of a landscape.

Once you have completed this first drawing, repeat the exercise, this time with a different medium. Try to understand the weight of the hand; the gesture of the arm can make tiny inflections and changes of mark. Play with the placement of the first horizontal. You might create a high horizon or a low one. Experiment with combining media, ink with Tipp-Ex over the top, pastel and water. When you begin to use the brush

Even the simplest of lines will evoke a landscape.

and ink, think about how the angle of attack and the opacity of the ink can yield different marks and tones.

Invented landscapes 2

Repeat the same exercise as before. As each line follows the next, allow the line to develop lumps and bumps. As each line progresses, see if you can enlarge these lumps and bumps, increasing the amplitude of the hills and troughs and also the distance the lines are apart, as well as their width. These drawings will not only create a sense of space, they will also imply forms, landmasses, rises and falls in the landscape.

These drawings can be worked into, using different line weights. Think about your pencil sharpened to a chisel point, so that you can get thin and thick lines in your drawing. Explore other media as well, constantly thinking about how you can make a linear mark.

Invented landscapes 3

Cut out a series of rectangles from your coloured paper. Make each of these the same width but vary the height. Place your ruler against an edge of your leftover paper and tear the paper toward yourself so that you can form a long thin strip. You will find it easier to tear the paper along its grain to achieve thin strips.

If you are not sure where the grain is, lightly push the two opposite sides of the paper together, and feel the tension in the paper. Turn the paper through 90 degrees and repeat and feel the tension again. Where the paper has less tension, the paper is being bent along the grain.

Experiment with different colours of paper, even the inside of business and bank envelopes can have interesting textures and colours. Now stack two of these rectangles on top of each other. Do this a few times, so that you have placed the horizon at different heights each time. Place these torn strips in parts of the lower region. Onto some of these images repeat the above exercises, drawing back over these with linear marks. Onto the top half, apply white chalk over some of the colour.

Your brain is hard wired to read all of these collage drawings as landscapes. It's an incredibly liberating thing to realize that you do not have to draw the landscape perfectly to create an image, which has the essence of it!

Use the side of your chalk so that you produce a broad set of marks. Experiment by placing tracing paper, greaseproof paper or parchment paper over some of these studies to see what happens when you begin to mute some of the colours creating misty landscapes.

Repeat the exercise, only this time tearing all edges without using a ruler. Try this with a number of colours of paper, placing one layer on top of the other. Once again, you can work into these collages if you wish with different marks and shapes of line.

Revealed landscape

Materials

- Photos of landscapes (a landscape postcard will do)
- Sketchbook
- 2B and 4B pencil
- Scalpel
- Ruler
- White photocopy paper
- Coloured card

If one's ability to measure a distance is inaccurate (we might give it a figure of ten per cent plus or minus either way) we can minimize the error margin if small distances are travelled in a drawing. Ten per cent of 1cm is much smaller than ten per cent of 30cm.

Take one of your photographs of a landscape and place your white paper over the majority of your landscape, revealing only the horizon. Think about how far down the rectangle this edge comes and try to draw the line that you see on a rectangle, which has the same proportion as your photograph.

Move the paper down a small amount; about the distance the lines were apart in the previous exercise. Now draw what you see above the paper. Repeat this process, moving the paper down toward the bottom of the image until you have completed the whole drawing.

Repeat this a few times, getting a sense of how close together some of the elements are nearest the horizon. If it helps, mark off a series of 5mm distances on your photograph and repeat these on your drawing to help you with scale and proportion.

Basic proportion

There are a number of different measuring techniques one can employ in landscape drawing and painting. Basic shape, sometimes called relational measurement, allows you to draw at any scale. By taking the shorter side and comparing that to the longer side, a sense of the proportion emerges. The drawing can then start with a box in the same proportion. One can think about the box as a derivation of the square, so care is taken to calculate the longer side in relationship to multiples or divisions of the square where the shorter side becomes the unit of measure.

Cover up the majority of your photographic source with a sheet of paper. Draw what you see above the paper. Repeat this process, moving the paper down toward the bottom of the image until you have completed the whole drawing.

Cut out a series of rectangles from your coloured card, creating a 3 × 3cm square (1:1), 3 × 6cm (1:2), 3 × 9cm (1:3) and 3 × 12cm (1:4) rectangles. You can create simple viewfinders that allow you to more accurately judge the placement of the landscape features within the rectangle.

Draw these rectangles in your sketchbook, the same proportion as your apertures. You can trace around the hole cut out if you like, or draw a new rectangle in the same proportion by either making one which shares the same diagonal, or has the relationship of the short side to the long side.

Now place the aperture over one of your landscape images vertically so that you see the view as if you had taken a slice through it. Translate what you see in the rectangle. Make a particular note of where the different parts of landscape line up to your vertical measurements. Move this aperture around your image and repeat the exercise, finding a series of compositions out of the same image. Once again, feel free to explore media and combine these together. You can also use your coloured paper as backgrounds for your drawing. Try the same exercise, turning the rectangle horizontally across the image and also consider different formats of rectangle.

Clouds

So far we've been thinking about the marks in the land. For this next exercise, find photographic source material of clouds. They come in a variety of shapes and sizes, what kind of line qualities should they have to describe their form and shape? Should you draw the cloud or the sky behind them? Experiment with your media, working on both white and coloured paper, experiment using soft and hard media. Treat these very much like informal plays – little tiny exercises to get you thinking about the nature of marks and how these marks could relate to the subject. After all, clouds are merely vapour, they're not solid at all. They can be soft and diffuse or can form large masses, which cast shadows over the land.

We will talk about the structure of clouds more fully in the chapter on perspective, where we will think a bit more carefully about how they recede into space, and how their form can be simplified into structural masses.

Blind drawing

Materials
- Photos of landscapes
- Sketchbook
- 2B and 4B pencil
- Fine line pen
- Coloured pencils
- Felt tips
- Pastel pencils
- Coloured paper

As babies, we learn to make sense of the world by placing objects inside our mouths, not just because we are teething and trying to bite our gums, but also because our most sensitive organ was our lips. We discovered the world by feeling the perimeters of objects and built a mental image of each. This manifests as a linear schematic description of the object in our mind.

Blind drawing is a very powerful tool in training the eye to really see. You are not looking at your paper but you are staring intently at your subject. You can work from a photographic image, from the computer screen or, as would be preferable, you could work directly from the landscape itself.

Most children draw in outline and create signs for the things they experience (up until the age of about nine). When people say they don't know how to draw, they mean that they don't have a sign or schema (Gombrich's term), which will provide them with a solution to the problem. As we've already identified, the schema for landscape is embedded in us. We can draw a single line through a rectangle and we will read that as a landscape. What you need to do now is train your eye to notice the particularity of landscape, the uniqueness of one tree against another. In order to do this, we need to slow down and take a great deal of care over the process of looking. To help us on this journey, to improve our observation of landscape, we are going to use blind drawing.

Begin with the horizon and work downwards, look very slowly. The key is to be slow enough so that you notice the subtleties of that line. If there is a change of direction, how great is that change, is it ever so slightly off the horizontal? Don't be tempted to look at your drawing, instead try to become completely engrossed in the qualities of the shape that you can see. Follow down the page, it doesn't matter if your line is not in the right place.

You are attempting to understand more fully the qualities and the idiosyncrasies of the landscape. Blind drawing can be a way of warming up, finding a way of getting into the landscape to discover how it might be drawn. Never underestimate the power of a blind drawing. A perfectly beautiful drawing can be made without looking at the paper. You have to trust in the process.

Make a series of blind drawings from your research, experimenting with linear media, using different colours of line. Also experiment by holding two different coloured media in your hand at the same time.

Many students look casually at the subject, taking on too much information at once, drawing chunks of the subject. Draw 1mm at a time, becoming lost in the minutiae. Visualize yourself as an ant, crawling across every crease and fold, every contour and change of plane in the landscape and your hand will follow the pathway of the ant.

Drawings should be built up over very small distances, gradually navigating across the landscape, rather than jumping big distances. By going the long way around, by drawing the creases and folds or changes of plane, one is also using a strategy to avert one's attention away from the object being drawn. To see it as a series of interconnecting shapes as opposed to an object means that you are more likely to draw it without your preconceptions imposing. This process of looking, taking time, noticing every change of direction, every inflection in the line will help train your eye and enable you to really understand the complexity and nuance of landscape drawing.

You have to become lost. Rather than drawing up and down a tree, you have to navigate across, trying to see how each small part connects to the whole. You have to think about this type of drawing rather like a jigsaw in that you start with a piece right in the centre and gradually work out which shape connects to that building outward until you eventually find the edges. Try not to cheat and look at your drawing, it is a good idea to use the cover of the sketchbook over your hand, so that you cannot accidentally look at your drawing.

Do not produce a line by making a series of short strokes, which join together, this is a sketchy line, and one which makes an assumption of the landscape by taking on too much information. You must draw really slowly, making one line instead of many, but pay real attention to the process of noticing all the detail that you can see.

Once you become familiar with the process, you will begin to feel that you can enjoy the process of really becoming engrossed in looking and you lose a sense of time, place and language. It's a wonderful place to be.

Practice makes perfect as the saying goes. In order to draw the landscape, you have to practice, but you also have to explore and try out different methods to find the best way of describing your experience. You need to find an approach that will suit your purpose. You can use these exercises to warm up, to get your eye in or simply explore new ways of drawing. You can be experimental, playful, descriptive, energetic or collected, but in all instances you are thinking about shape relationships and how these can be used to create or flatten space.

The beauty of the landscape is that you can throw a lot at it and it will take it. Unlike the figure, which requires a degree of exactitude in the drawing (to see the complexities of shape and proportion to get it right) the landscape can be interpretive. We easily see minor changes in the shape or proportion of the human figure, but every landscape is different and unique. Cezanne talked about the changes that occurred to the landscape when he moved a bit to the left or a bit to the right.

So your drawing session could begin with some quick drawing to give you a way in to creating a sense of place. Blind drawing can allow you the time to really look at the landscape and begin to understand the tiny changes in direction of form and space. Thinking across the landscape can improve your understanding of the landmasses, the rise and fall of the contour. All of these exercises are aimed at improving your perception of the place you are quoting from, to allow you to see it more expressively or intensely.

However, an important question to ask yourself is what are you going to draw from? Are you going to travel to a location and make drawings *in situ*? You need to consider where you are in the country, how far away are you from this location, how long does it take to get there, what will the weather be like and how much time will you have once you are there?

LESSON 4

Partial peek

Materials
- Landscape
- Sketchbook
- 2B and 4B pencil
- Fine line pen

What is the point of noticing all of this information with considerable attention, the exactitude of everything, if the outcome is that your lines don't quite meet up where they should be? The answer is a very simple one, look a little bit. If blind drawing enables you to focus absolutely on the process of looking at the motif, partial peek enables you to have the opportunity to glance back at your sketchbook and ensure that your lines are in the right place.

Of course, the landscape is forgiving and if you place a tree or a hill in the wrong place, it is not going to have such a significant impact.

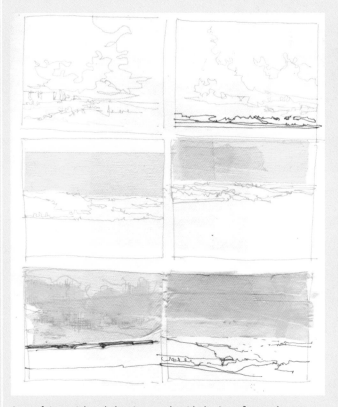

A set of six partial peek drawings made with the Aqua fine marker pens. The sky had a layer of masking tape applied to it to reduce the visual contrast of the line, making it recede.

Think about how long you look at the motif. You should ensure wherever possible that you spend longer at the landscape than at your sketchbook.

It might be that you start off by setting time limits on yourself, looking every ten seconds at your sketchbook, every five then every two. Compare the difference and see if you can find the optimum solution. You will discover that certain elements of the landscape lend themselves to more blind drawing. The line quality may be more evocative for a tree or a rolling hill. As you work towards the foreground, you might increase the detail, adding more information to it to create space. The most important thing to consider is this relationship between looking and drawing and in particular, the idea that you are drawing the landscape, not making a drawing about the process of making a drawing.

After four or five partial peek drawings in biro, experiment with drawing in colour. Felt tip pens can be really useful and so can coloured biros. Try painting panels of colour in your sketchbook with gouache, or use coloured paper. Consider a coloured line made with coloured pencils combined with other coloured media. You might also create some simple divisions of the rectangle with coloured collage first before weaving a partial peek drawing over the top.

Now that you have become familiar with partial peak drawing, experiment by using the same technique but swapping hands. Why do this? Although the drawings are difficult to make and the hands might wobble, you have to concentrate really hard on making the drawing. It lowers your expectations of producing a perfect drawing, which will have a significant impact on your work and produce really strong results.

It is easy to become complacent with drawing, and sometimes it is easy to make those automated marks which do not really mean anything. Changing hands really forces you to think about how you make every mark and that may yield some unpredictable results, which is always a very good thing to help you have new insights in front of the landscape.

LESSON 5
Measured drawing

Materials
- Landscape
- Sketchbook
- 2B and 4B pencil
- Fine line pen
- Thin card
- Thread
- Sewing needle
- Two plant labels
- Paper fastener
- Drawing board
- Travel easel
- A1 paper
- Bull dog clips

So far, we have discussed the idea of working from photographic source material for your landscape studies. Whilst this provides us with a useful resource to practice some of the basic approaches to drawing, it also avoids the problem of translating the physical experience of the landscape in three dimensions. These drawing activities give us some of the clues to the problem of drawing the landscape in line, but standing in it, experiencing the changing light, weather, heat, cold provide you with so much more.

Stand in the landscape and look at the view in front of you. Consider the amount of view you see when looking ahead. How much of it is to your left and to your right without

A feature in the landscape can be measured by the eye and captured on a pen or pencil. This can then be used as a unit of measure. So how many river widths get you to the next object in the landscape? Once a scale is arrived at, it is easy to plot the drawing.

Getting the scale right is easy. You can comfortably fit four pen widths into your cone of vision.

A sketchbook page is divided into four, giving you a scaled version of the pen width.

The drawing commences using this scale. So one uses the unit of measure in the landscape to plot points in the landscape.

As the drawing progresses, it becomes easier to see what lines up with these features, what is on the same horizontal or vertical plane and the drawing is built from the inside outward.

The completed measured drawing of Lancing from Mill Hill in Sussex.

turning your head? You do not have a field of vision which is 180 degrees, it's more like 60 degrees. Hold your arms out like the police directing traffic and try to measure that visual distance you see. You will probably find that your arms are about a metre apart, fully stretched. Of course, as you pay particular attention to what you see, not all of that view is in focus; at any one time only a much smaller area is in focus. If you were to draw what you see, you will find that unless you have a piece of paper that is a metre across, you will run out of room. Most people draw too large on location, drawing the

view sight size. There is nothing to stop you doing that, you can take large paper into the landscape and here, it is useful to have a lightweight drawing board and bulldog clips to hold your paper down. You can lay your board on the land itself, or prop it on your lap, whilst sitting on a plastic sheet if the grass is damp. Alternatively, you might have a sketching easel that you can work at. In these instances, you have enough room to capture what you can see and you can utilize sight size drawing techniques. You have to ensure that you do not move relative to your easel. It can be useful to mark the

A square can be cut out of thin card. This can then have either thread stitched into it or acetate attached so that you can create a grid, which divides the square into a series of subdivisions. These could be halved and quartered or you can create a series of smaller squares.

By attaching this viewfinder to your easel and looking through it at your landscape, you create a reference image that can be used to map the features of view against this network of squares.

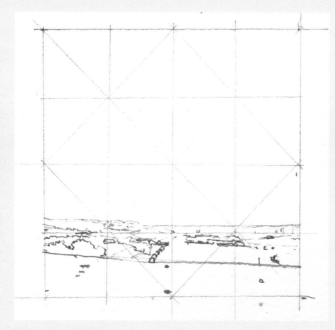

By drawing a square grid in your sketchbook at a suitable scale, you can now use this map to help you scale your drawing and discover where the landscape lines up to your viewfinder grid. Make sure you keep your head still.

position of your feet and stand at arm's length from your easel so that your hand rests on the side of your drawing board. By holding your pencil at right angles to the direction of your straightened arm, you can run your thumb up and down its length to capture the visual size of a motif within your field of view. This can then be transferred to your drawing and the process continued, incrementally drawing small shapes fitting together like the partial peek exercise. Once again, you might start from the horizon working downward, or build outward around some prominent feature. With sight size drawing, it is

useful to either take your measurements vertically downward onto your drawing, if you are sitting down on a camping chair, or horizontally across, if you are standing and have an easel next to you. So as to not block your view, it helps if your easel is to your left if you are right-handed and vice versa if you are left-handed. That way when you are drawing but not blocking the view you have of your drawing, you can make a quick visual comparison between the landscape and your study.

Holding your pencil up to the angle in the landscape can also help in transferring it to your drawing, moving only your shoulder to retain the angle of the pencil. You can also use a simple measuring device made from two plant labels held together with a paper fastener. These measuring callipers can be screwed open to capture the angle seen. You must make sure, though, that you measure angles against either the horizontal (horizon) or vertical. It is also important to understand that if your drawing lies flat on the ground, you see a distorted view of it, which will mean it is easy to make errors based on fact that your drawing will be foreshortened, so if possible have your drawing perpendicular to your line of sight. In most instances it will be useful to travel light. A small sketchbook can contain a large space; you just have to learn how to scale your drawing down. There are a number of ways to do this.

You will find that approximately five pen lengths fit into your field of vision. If you now take the shortest side of your sketchbook and divide that into quarters, this will equate a scaled down version of your pen length. If you now measure a feature in the landscape against your pen and calculate the relative size of the object in the landscape against that pen (it will be a fraction of it), you can then refer to the scaled down measurement on your sketchbook and calculate the fraction

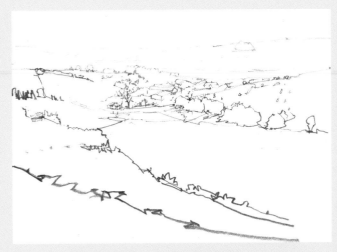

A linear drawing of the landscape with a variation in light, weight and tone to describe distance.

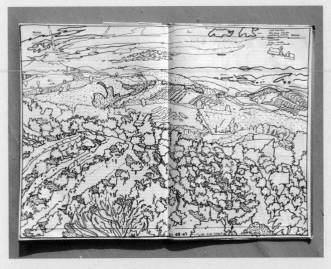

Julian Vilarrubi, *Umbrian Landscape*.

measurement of that. Once you have established this scaled measurement, you can now create a proportional measured drawing. Here, all the features in the landscape are measured against this one unit. So it might be the width of a tree. How many tree widths get you to the next feature, and so on? It is also important to measure the horizontal width against the vertical heights of objects within the landscape. That way you ensure that the relative proportions of these are the same, as there is a tendency to see vertical distances as longer than they are. This is especially true as the vertical distances will be very small, and it will be easy to make them larger than they are, meaning that you will run out of space. The more you practice the skills, the more you will find that you will naturally adjust to the scale of the sketchbook that you are drawing in, but it does take some getting used to.

Now begin to use measuring techniques to plot your landscapes and explore your line weight to define the space. Make your own *plein air* drawings, experimenting with sight size drawing, proportional measured drawings and the use of the viewfinder and the measuring callipers to help you get all the space that you see in your pictures.

Decorative line

In most instances, line is being used to articulate space or form. Cast your eyes over a Julian Vilarrubi drawing and you see line being used in a different way. Julian obviously explores the different weights of line by changing pens, but here there are heavy lines in the background, fine lines in the foreground, and little attention is given to the mass of an object; instead, the objects in the landscape become a series of shapes that are defined largely by an unwavering line. There is a real confidence to the line, finding the rhythms and repetitions of motif within the landscape.

Try making your own decorative line drawings, investigating the potential of direct *plein air* painting as well as placing tracing paper over your photographs and tracing the shapes you find there. Experiment with both black and coloured line as well as coloured paper.

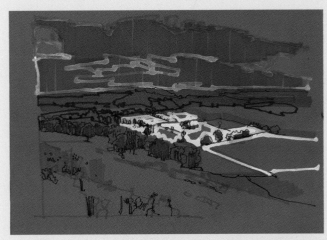

A mixed media decorative line drawing on coloured paper using Aqua marker pens, fountain pen and Tipp-Ex.

HARRY STOOSHINOFF

I will often make a brief one-minute diagram with ballpoint pen on folded up photocopy paper. This is a response to a reaction I have in front of a motif. I call them diagrams, not drawings, because they simply map the arrangement of shapes, scale relationships, and value placements. In these preliminary diagrams, I pare things down to essences. I keep all these little diagrams (there are thousands of them) and glue them into sketchbooks afterwards.

– Harry Stooshinoff

DAVID HAYWARD

I use drawing in a completely different way to painting. For me, drawing is an excuse to lose oneself – to sit quietly and observe and record and, above all, to be in the moment and relish it. I don't consider 'quality control' as I would in painting. By this I mean that, for better or worse, drawings just happen – they are a record of a specific time and place. My paintings on the other hand come about through more complex processes and they demand a great deal more decision making. Unlike drawing, paintings can be altered much more radically and require more time for critical analysis. Interestingly, my landscape drawings are more likely to engage with issues of distance whereas, in my paintings, the illusion of space is largely avoided in order to heighten the flatness and overall organization of a painting's surface.

– David Hayward

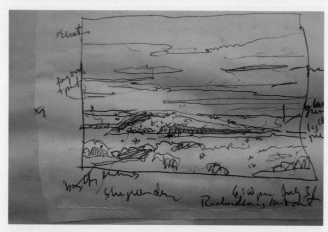

Harry Stooshinoff making an annotation drawing, recording information about colour.

LESSON 6

Contoured landscape

Materials
- White photocopy paper
- Ruler
- Pencil
- Camera
- Sketchbook

A simple exercise can be created to help you understand this further and help you perceive this in the landscape.

Take a ruler, a pencil and a sheet of A4 paper. Using the ruler on the paper, draw along both long sides of the ruler, moving the ruler so that one edge lines up with one of the lines that you have just drawn and draw another line, repeating this exercise until you have created a series and parallel lines that run across the page. Turn your ruler at right angles to the first line and repeat so that you have produced a network of squares.

You can produce a few of these or photocopy your results. Now begin to scrunch these up to form undulating hills, valleys, a small paper landscape. These can be set up like still lives and you can begin to map the movements of the lines across the space and across the structures that you have created. You could look at your photographic source material as a guide and make models of those or simply make up your own landscapes.

Contour

In the majority of instances, linear drawings describe the outside of an object and the edges of planes. The use of line can be somewhat ambiguous and lines can be used of varying densities, to mimic the idea of proximity (generally, darker lines come forward and lighter lines recede). Lines can also be used to describe the structure of the landscape through the use of contour drawing. Imagine a net stretched over the land, visualize the transformation of that net as it moves across differing planes. Suffice to say, the appearance of the net will be wider if that plane is closer to you, narrower if it's further apart. If the mesh of the net is made up of squares, these shapes will become distorted into curved shapes and trapeziums depending on the underlying structure, which will unveil the nature of the surface that's being drawn, whether curved or flat. Contour drawing can be very useful when it comes to drawing the landscape as often the shapes and movements in the land itself unveil contour lines moving up and down and across the changes of plane, whether it be hillside, riverbank or a field.

Ruling a grid onto A4 paper. The width of the ruler makes it easier to construct parallel lines.

Once the paper is scrunched, it creates a hillside landscape.

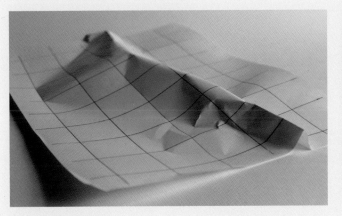

Lighting is all important.

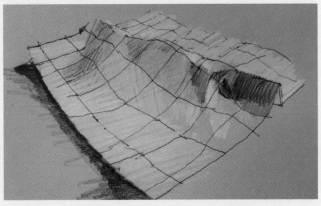

Coloured pencil and fountain pen drawing on the paper landscape.

Pay particular attention to the placement of these lines. Try to get some understanding of their rhythm and movement.

When you return to the landscape, you will have a much clearer insight into how contour can be used in your drawings. Unlike linear drawing, which relies on the notion of drawing what you see, contour drawing is a more intellectual pursuit, in that you have to deconstruct what you are looking at and draw what you understand about the form. Having a good understanding of contour will certainly feed into your tonal work, your contour hatching exercises and also help you think about the direction of your paintbrush works when you come to painting the landscape.

If you did nothing at all to the paper, but left it flat on a table, notice how the grid changes its dimensions according to its closeness to you. Look carefully at the lines on the paper that are in line with your line of sight and you will see that the angles on the sheet of paper appear to come together or converge to a common point above your sheet of paper. This phenomenon is called perspective.

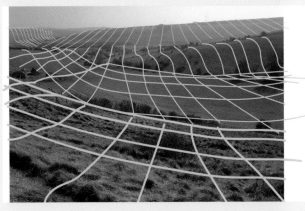

Taking a contour line over the landscape, visualing the changing planes.

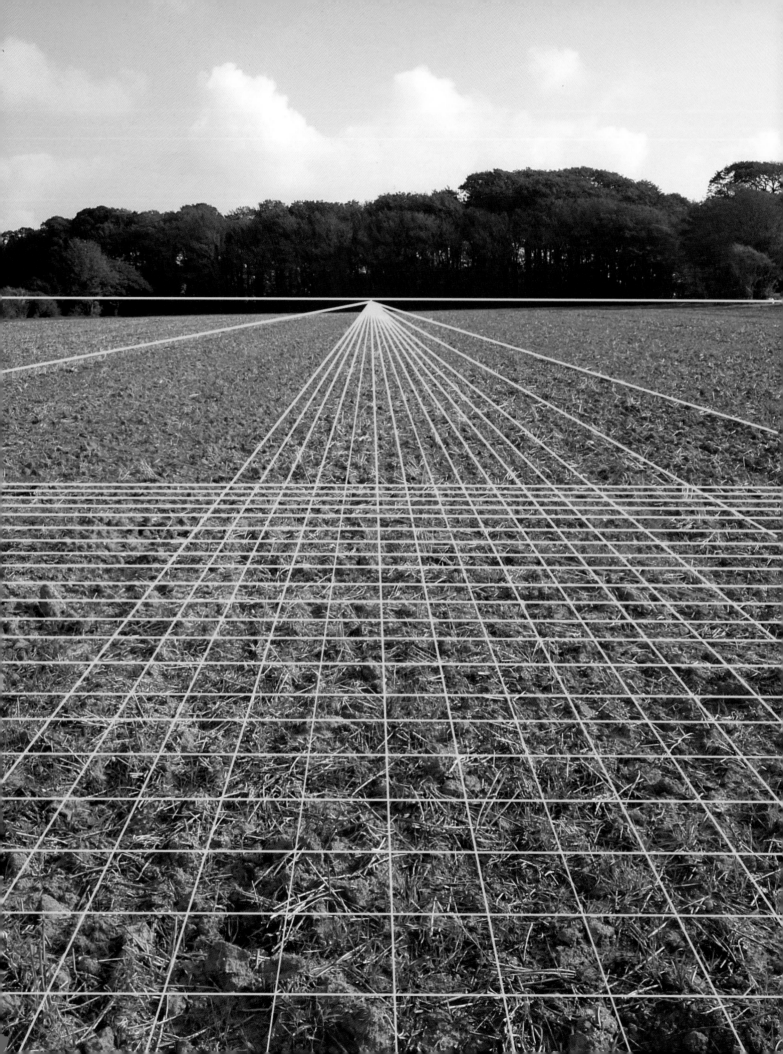

Perspective

L *ike a conjuring trick, there is a moment when the simple drawing of a triangle, a straight line and some verticals transforms itself from a series flat shapes into a deep recessional space, and from that moment you know that the surface of the paper can become a place that you can disappear into.*

The use of linear perspective in painting has its roots in fifteenth-century Italy during the Renaissance. It was invented by Filippo Brunelleschi and Masaccio and was used for almost 500 years before artists such as Cézanne, Picasso and Braque began at the turn of the twentieth century to challenge this as the sole means of representing space in European Art. The Chinese did not use perspective at all, instead using parallel projection to represent space, from the second until the eighteenth century.

Linear perspective gives you an understanding of how objects behave in space. It is not a set of hard and fast rules that have to be adhered to, but a little bit of knowledge will go a long way and will certainly help you create a convincing depth in your landscapes, and help clarify how man-made objects, like buildings, recede and converge, making them seem more three dimensional.

RULES

There really are only two rules you need to know. Try to remember these and apply the knowledge when you are confronted with a visual problem.
- You are the centre of this universe. The world transforms according to your position within it.

A single vanishing point drawing of a field.

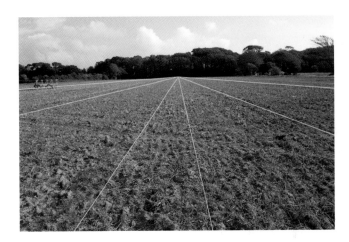

- All parallel lines appear to converge on a common point as they move away from you.

Try to think about what this means. Consider where you are, and what height, distance and angle of view you have of whatever you are trying to draw. The object will look different if you move.

TERMS OF REFERENCE

Perspective means to see through. If you were to draw on a window the view you saw through it, you would have made a perspective drawing.

How big your drawing is depends upon two factors: how far away from the subject you are and how far away from the glass you are. In perspective drawing, we refer to the picture plane (PP), which you can think of as the window.

All the lines and angles of your drawing would change if you moved, and you have two slightly different views of the same view from each eye. So perspective drawing requires

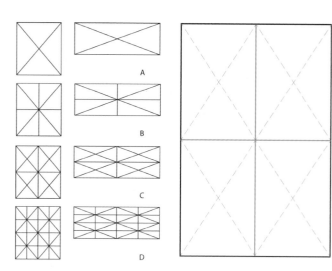

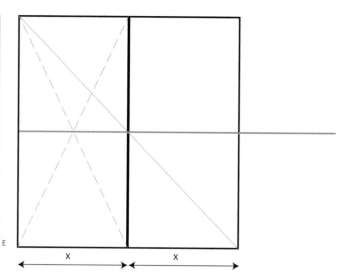

Gridding A

Draw a couple of rectangles of different proportions. Draw through each vertex so that you form a cross inside the rectangle. This identifies the centre of the rectangle.

Gridding B

Construct a vertical and horizontal division of this rectangle through this cross. You will now have divided each rectangle into four rectangles, each of which is in the same proportion as the original.

Gridding C and D

Repeat this exercise with each of these rectangles until you have divided the rectangles into sixteen boxes.

Repeated distances.

You will notice that each time when you create a vertical divide, you find a halfway point of the original. So conversely, if you have a rectangle and you know the mid-way point of one side, if you draw a diagonal through the vertex on one side and through this mid-point on the opposite side, by projecting this distance outwards, you can find the same distance again. This can be a useful discovery if you are trying to calculate the location of regular distances in your landscape, for instance, fence posts, telegraph poles or electrical pylons.

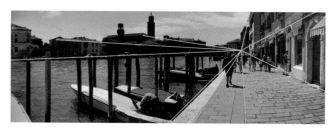

Single vanishing point 1. Here a line on beach huts stretch out along a concrete walkway at Cromer. The beach huts, path, railings and shadow are all parallel to the LoS and converge directly in front of the viewer, producing a single vanishing point.

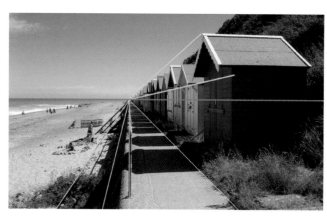

Single vanishing point 2. In this view of Murano a similar thing can be seen. The tiled floor is not completely level so instead slopes toward the shops.

that your eye remains fixed and you only record the view of one eye, preferably your dominant one.

Dominant eye

Look at any object in the distance and point at it. Shut one eye and then open it. Do the same with the other eye. With one eye open your finger stays in the same position. This is your dominant eye.

GRIDDING

Materials

- Pencil
- Sketchbook
- Ruler
- Set square

Whilst perspective drawings can seem really complicated at first, they rely on some very simple ideas. Before getting complex, you are going to construct some basic drawings, which will be useful for some of the later exercises and will be useful to refer back to.

LESSON 7
Simple perspective

Materials
- Pencil
- Ruler
- Paper

Converging lines
Imagine a spear driven through the back of your head, so that its shaft points out toward the subject and travels through your dominant eye. Gruesome as it may seem, this will be known as the line of sight (LoS). Whenever you turn your head, the line of sight moves giving you the direction of your vision.

If you were standing in the middle of a very long and flat road, the sides of the road will eventually converge, meeting at a point in space. This is called the vanishing point (VP). As your line of sight is parallel to the sides of the road and all parallel lines converge to a common point, the vanishing point will be directly in front of you. Stand to the side of the road and, if your line of sight is still parallel, the vanishing point is still directly in front of you. But roads are invariably not straight nor infinitely flat. Roads go uphill and downhill, sway to both the left and right. The key to understanding how they conform to perspective is to go back to the rules.

We are going to draw a very simple diagram of a road in perspective with a pavement to the left and a line of telegraph poles running off into the distance.

It will be assumed that a line of telegraph poles are of equal height and are equidistant away from each other. As such, if we were to imagine running a thread across the tops of all the telegraph poles and along all the bottoms too, these threads would be parallel to our road.

While this is a very simple exercise, it begins to give you some insight into a basic method of construction of recessional space.

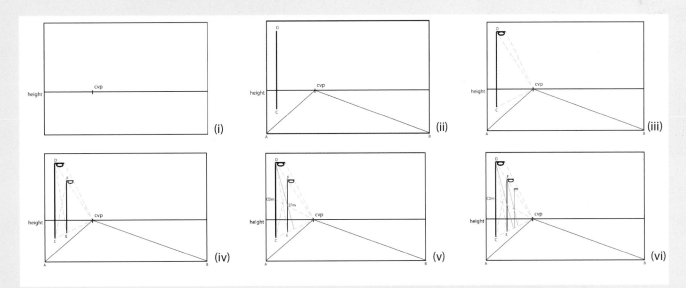

A Road pt i
Draw a rectangle in your sketchbook. Draw a horizon line and locate a point on it (cvp: central vanishing point).

A Road pt ii
From this point, draw two diagonals to the lower corners of your rectangle (Acvp and Bcvp). You have drawn a road.

A Road pt iii
From the point (cvp) draw another line, a small distance away from the A. You now have drawn a pavement by the side of the road.

On the pavement draw a vertical line (CD), so that it is above the horizon. You have drawn a telegraph pole.

A Road pt iv
Mark a line from the apex D and bottom C back to cvp. These lines will be our threads running off into the distance sharing the same vanishing point. This will tell us how high the telegraph pole will appear to be as it recedes into space.

A Road pt v
Now construct another vertical line a little distance away from the first (EF). The height of this line will be governed by the diagonal lines Dcvp and Ecvp.

Now measure CD to find its mid-point CDm. If a piece of thread was attached to all the mid points of all the telegraph poles, this would also be parallel to the road and the top and bottom threads so it will also recede to cvp. Draw a line through the mid-point CDm back to cvp. This will indicate where all the middles of all the telegraph poles will be (EFm and beyond).

A Road pt vi
Now using the exercise from before, a line drawn from D through EFm will cross the line Ccvp. This will indicate where the next telegraph pole will appear and this will go on continuously allowing you to produce an infinite number of equidistant telegraph poles

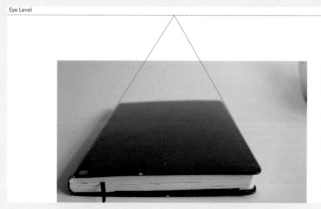

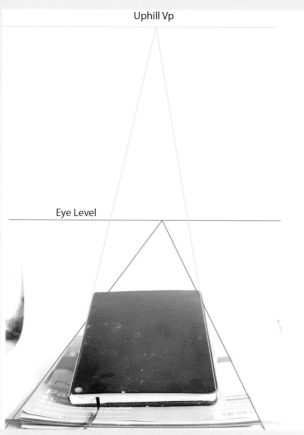
Uphill Vp

Eye Level

Seeing it. Lay your sketchbook on a table flat; while you know that nothing has changed, the sketchbook no longer looks the same. The edge that is closer to you will appear larger than the edge furthest away. The sides of the sketchbook are visually no longer parallel; instead they look more like a trapezium. While your brain may tell you otherwise, look at the sketchbook with a pencil held vertically in your hand to make a comparison. Look at how the angle of the sketchbook is different to the vertical referent. Compare this to the other side and see how these angles appear to converge.

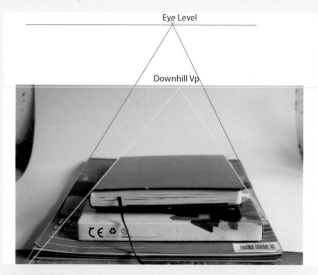
Eye Level

Downhill Vp

Put something under the sketchbook so that it slopes. Once again, the sides will appear to come together (converge). This time the angles will be steeper or shallower depending on whether the slope goes uphill or downhill.

Perspective

Hold a sketchbook in your hands so that you are looking directly at the centre of the front cover with your hands holding both sides. The front of the sketchbook appears to be a rectangle, with top and bottom edges parallel to each other and the sides the same.

Materials

- Pencil
- Sketchbook
- Digital camera
- Printer
- Ruler

Take digital photos of a sketchbook (or any book for that matter) from a number of different angles and print these off (A6 size images will be fine). Place each one of these into the centre of sketchbook pages so that you have plenty of room around each image. With your ruler, rest this against the two opposite sides of the sketchbook. Draw a line so that it extends the edge of the sketchbook into the space behind it. Extend it enough so that the lines cross (if they fit on your page). Where do these lines cross? They actually cross at your eye level.

Only when held at right angles to your line of sight, will the sides of the sketchbook appear to be parallel (whatever the orientation), but in any other plane they appear to come together. So any plane, which has parallel sides, will appear to converge into space, and if these are on a flat plane, i.e. parallel to sea level, these will converge on the horizon, which is at your eye level.

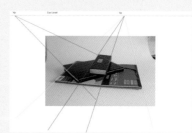
A series of sketchbooks demonstrates multiple vanishing points on the same horizon.

LESSON 8

Cubes

Materials
- Pencil (H)
- Fine line pen
- Sketchbook
- Ruler
- Cardboard box

If you had a cardboard box in front of you, so that the front and back planes of the box were at right angles to this line of sight, the imaginary spear would run parallel to the left and right planes. If you were looking straight ahead of you and not looking down at the box then the spear would also be parallel to the top and bottom planes, as well as the top and bottom planes as well. If you could trace all the different angles that you see on the receding planes, they would all meet in the same place, right in front of you.

If you were looking at the corner of a box, all the planes would no longer be parallel to your line of sight. This means that none of the sides recede to a common point in front of you. Instead each plane of the cube either recedes to the left or the right of your line of sight. By turning so that your line of sight is parallel to those planes, you can now identify where the vanishing points are on the horizon.

Imagine turning your body so that your line of sight is now pointing in the direction of the road. If the road turns right then the imaginary spear points in that direction too, as it turns to the left it points in that direction, so that it is always parallel to the road. The spear will point at the VP for the road. If the road slopes uphill then your head would be tilted backwards until it is parallel with that inclined plane, so the VP will now be in the sky, above the horizon; and if it slopes downhill, the spear drops so that it is parallel to this slope, establishing a VP below the horizon.

The floor that you are standing on will be referred to as the Ground Line (GL).

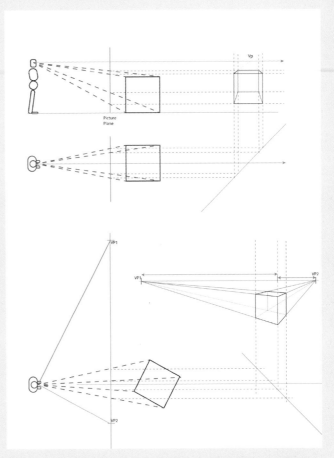

Different directions. When you are looking at an object from the side you are no longer looking at it in line with your line of sight. The vanishing points are found by turning your self so that your line of sight is parallel with each side.

Horizon (height)?

The next time you visit a high vantage point, an Iron Age fort, a castle, a hillside, look across to the distance and rest your finger across the bridge of your nose. The horizon is at your eye level. Visit the sea and repeat the exercise, from the moment you first see the sea to the moment you lie on the sand to make sand castles, the horizon is still at your eye level. So your view of the landscape depends upon your height above it – makes sense, doesn't it? That is why when you are at some high vantage point you may see tower blocks lower than the horizon; that is because you are physically higher than they are.

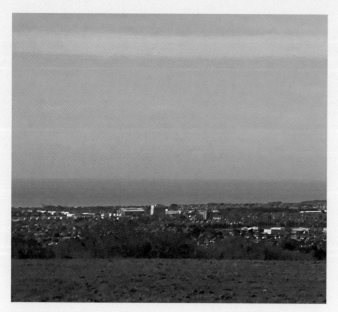

Eye level. In this photograph the tower blocks are clearly below the horizon

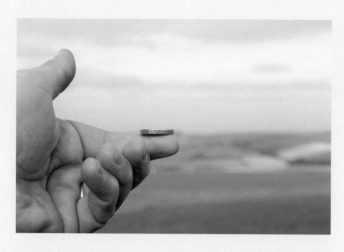

Where has the horizon gone? You cannot always see the horizon. So how do you know where it is? Hold a coin on one finger. Lift it toward your eye level. At a certain height, you will see the top of the coin. Keep going and you will see less of the top until eventually the coin becomes a straight line. Now it's at your eye level (above that point and you will see below it.) Look at where this straight-line coin is in relation to the landscape you are drawing. You can now know where the horizon should be even if you cannot see it behind a hill.

Inclined planes

Not only will you look at objects in the landscape that are at an angle to your line of sight, they may also be inclined, either going uphill or downhill. You might be walking along a path that goes up and down hill. You might see a road in the distance, a waterfall, the beach, sand dunes; all of these planes that will not be parallel to the ground line.

Rex Vicat Cole wrote a great book called *Perspective for Artists*, published in the early twentieth century. Cole describes how you can translate what you see in nature, as well as the buildings found within it, into effective drawings with the application of perspective. He advocated the use of an old carpenter's rule, which is hinged to capture the angles you are trying to draw. You can use this idea and make your own. A simple measuring tool can be made from two plant labels, joined with a paper fastener. This can be opened up so that one arm is on a horizontal or vertical, and the other on the angle being measured. If the ends are cut to form two points that meet, then this can also be used to measure and scale distances.

All buildings are built on level foundations. All buildings will have a vanishing point on the horizon. Not all buildings share the same vanishing point, but all parallel ones do. Understanding this can help you draw farmhouses, barns and other man-made structures you will see in the landscape. Most mistakes are made by drawing what you think you can see. You might be drawing the corner of a building and assume that the roof slopes off in different directions, but it may just be that the corner is at your eye level and both fall on a straight horizontal line.

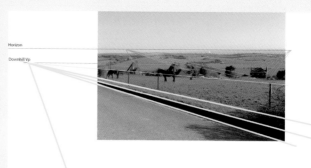

Farm buildings. Seen from a high vantage point, these farm buildings may converge way off the picture, but they will converge on the horizon. The road, however, is sloping down-hill to the left.

Constructing space

Materials

- Pencil (H)
- Sketchbook
- Ruler

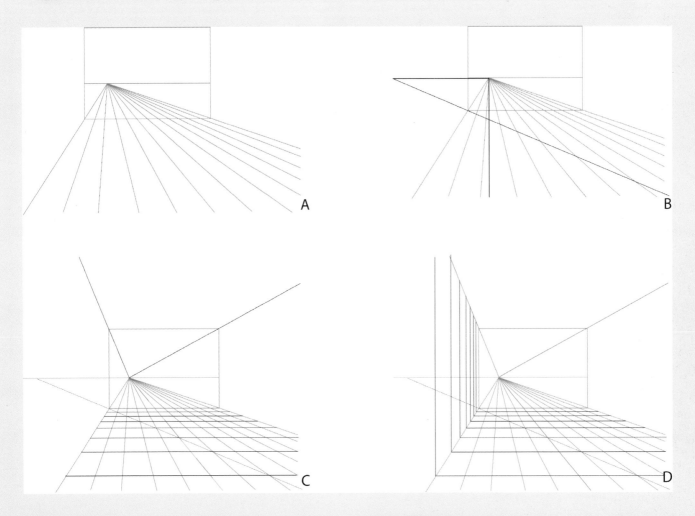

Constructing space A

Draw a rectangle about 8cm × 12cm in the middle of your sketchbook page. Imagine you have drawn a glass wall in front of the landscape. How high are you in relationship to this wall? Draw a horizontal line across this rectangle at your height (you choose a scale for this drawing). What part of this wall are you in front of? Mark that position on your horizon and draw lines from that point, through the corners of the rectangle as if you were drawing the inside of a box. On the lower edge of your rectangle, mark off 1cm divisions. From your central vanishing point (cvp), draw through each of these points to create a recessional plane.

Now measure from the central vanishing point down to the bottom of your sketchbook page. Transfer this measurement on your horizon, measuring from the cvp. You have measured off two sides of a square. The diagonal of a square is forty-five degrees. You have identified on the horizon the Vp for all things at forty-five degrees to your line of sight.

Constructing space B

Draw from this point to the corner of your rectangle and continue so the line bisects the recessional diagonals emanating from the cvp. At each intersection draw a horizontal. You have now drawn the inside of a room with square floor tiles. This space can be made to recede further, behind the glass wall. Draw a diagonal from the forty-five Vp to the other corner of the rectangle. These will bisect more diagonals from which you can draw further horizontals.

Constructing space C

Where each horizontal touches the wall, you can construct a series of verticals. Any height can be calculated against the initial rectangle which is measured to scale.

Constructing space D

It is useful to know how to construct depth in your picture. The following sequence of images shows you how to do this.

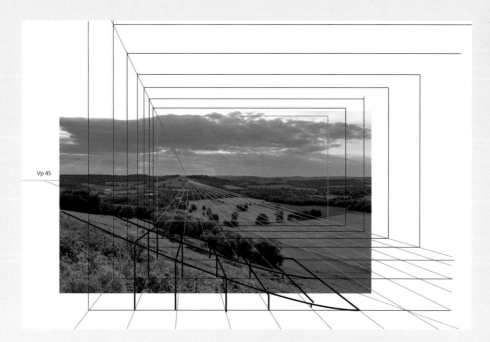

This recessional space can be used as a frame of reference for the mindscape itself, allowing you to see the rise and the fall of the landscape.

You have effectively created a frame of reference, the interior of a room, with walls, ceiling and floor receding away from you describing how the space behaves. While this room is rectilinear in its construction, its basic principle gives you a template, a grid that you can use to map more complicated spaces.

Turning theory into practice

Having built a convincing floor and understood the changes in space as the plane recedes into the far distance, it is possible to use this to map the undulations of the land. So how can this help you with your landscape drawing?

The next time you walk through a ploughed field, you will see a series of parallel lines converging to a horizon. You may not see the vanishing point, as a hedgerow may obscure this. A road at the side of a field may have hedges, which are of a similar height. Even though the road rises and falls, these conform to a basic perspective. A river snaking away into the distance can be thought of as an aerial view. This can be mapped onto a grid, which can then be put into perspective to help understand the way these curves move and compress through space.

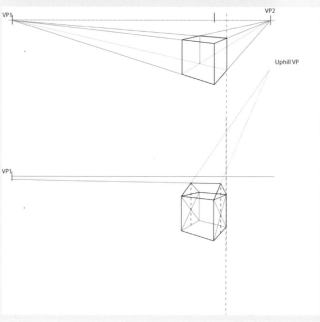

A rectangle in perspective divided through the diagonals will locate the central apex of a building. Here the building converges mostly to the right with the eye level quite low as the view was from a slope.

High above the buildings, the angles might be slight but they will still converge on the horizon.

Drawing a Pier

It is often surprising to see how a simple object like a pier can drawn incorrectly. To help you understand its construction, think about it as a very long cube. What orientation is the cube to you? Are you above it and is it almost at right angles to you? Here the vanishing point will be way off either to the left or the right.

It is always really useful to think of complex buildings as simple structures first. Here the cube of the hut is above our eye level so will converge to meet our eye level.

The pier is almost at right angles to your line of sight. From this high viewpoint it gently slopes upward to meet the horizon. Are you getting very close to the pier and as such looking along its length parallel to its direction out to sea, but still above it so that you can see the deck and people on it? Here the vanishing point will be in front of you.

Now you are almost in line with it, with a lot of foreshortening in evidence. Care needs to be taking when looking at the length so as not to over exaggerate it. Measurement will be useful here. Are you on the beach, with the pier above you? Now the deck will appear to come down toward the horizon, and the supporting struts up to meet the same vanishing point in front of you.

Another pier, this time from below, still converging to the horizon. Here the movements of the sand have also created perspective lines

This view of the harbour observation tower at Wells-next-the Sea in Norfolk is seen from below. The steps nearby provide an uphill vanishing point.

Clouds

While buildings can be thought of as cubic, so too can clouds. They have a variety of shapes, sizes and forms, but can still be thought of converging to a vanishing point.

Generally speaking, for most of the day, this cube will be illuminated from above, and it will only be early evening or sunset where light will reach the bottom. Clouds nearest to you will recede to the horizon, but as they get much further away their vanishing points will be below the horizon. Of course clouds are not perfectly cubic, but one can think of a Lego brick approach to cumulous clouds – lumps and bumps of cubic structures giving at least a simplified version of their form. Of course different clouds cover the sky in different ways, some creating long thin streaks, some large masses.

One has to remember though that wherever you look, you see everything in focus. You need to decide which parts of the sky are given clarity and which are not, in order for you to have a space that appears to recede. Generally the clouds that are near you will appear more diffuse and softer-edged than those in the middle distance.

The sky

It may not seem apparent at first, but the sky has its own perspective. Rather than thinking of the sky as a flat plane, it is much better to think that you are looking up at inside of a massive dome.

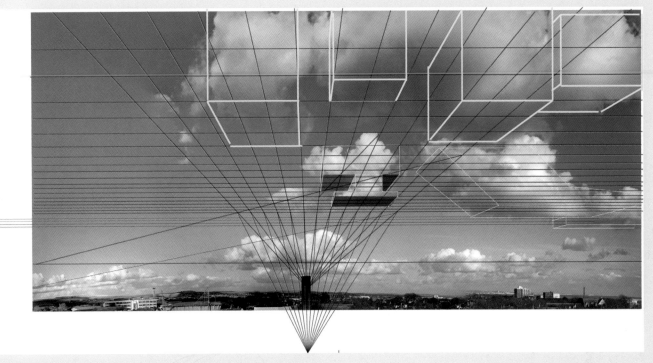

Clouds can be thought of as cubic forms and by so doing, it makes their structure easier to understand. Drawing a cube above the horizon will yield a structure that has a front, a side, as well as an underside plane.

The sky is not quite the same as the land. Whilst the earth or the sea moves towards the horizon, the sky curls behind it; as it nears the horizon, the sky becomes an inclined plane, getting steeper and steeper until at the point of the horizon it disappears.

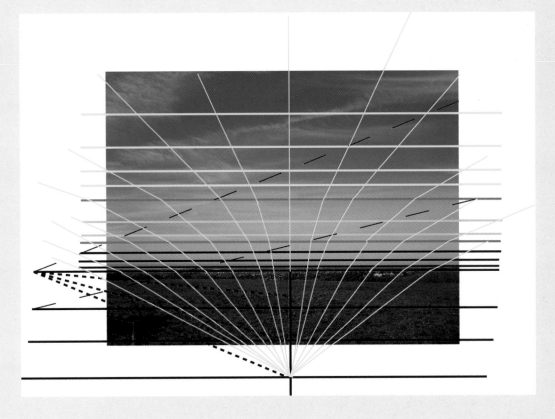

The figure in the landscape

Materials

- Pencil
- Tracing paper
- Photos of people in the landscape

Of course perspective is all about space, but when looking at the landscape it is not always easy to see just how big it is. Only when you see people climbing up a hill, standing near a river's edge, or looking out from some high prominence, do you get a true sense of just how big it is. It is therefore really useful to understand how the scale of people changes in the landscape. They too recede to the horizon.

Most people's bodies are approximately the same size. Standing in a public space, resting your hand (not too conspicuously) on the bridge of your nose, you would realize that everybody's eye level is approximately the same. When people stand, the difference between head heights is governed by the size of the femur; tall people have tall in their legs! Standing in a room, people's head heights are roughly the same give or take a few inches. If your horizon is at your eye level, then most people's eye levels are the same sharing the same horizon.

If you are drawing figures in a landscape, with a small amount of variation on a flat ground, most people's heads will be at the same point on the horizon. You will have a pretty good idea of where their head would be in relationship to that landscape.

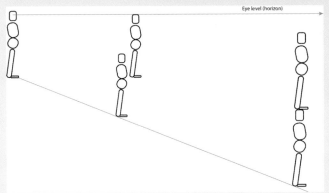

A useful trick is to understand how many body heights need to be stacked on top of each other to reach your eye level.

If you were to measure the height of a person in the distance and take that measurement and place it on their head, how many more of those measurements would it take to get to your eye level? If three people needed to be stacked up on top of each other to get to your eye level, then you can use that knowledge to create people of different sizes that will all look as if there are standing on the same plane. The key thing to think about is the idea of the scale of the figure in relationship to something else that you drawn. That way you will not produce and incorrectly scaled figures in your landscapes.

Looking across towards the beach at right angles to the sea, most people's head heights will be in the similar position to the horizon. As they walk towards the sea they are on a shallow slope, their head heights will gradually lower below the horizon. Standing on higher ground, people will appear smaller and their heads well below the horizon. People above you will clearly be above the horizon. Once again it is important that you use proportional measurement to calculate their relative scale.

Reflections

Whether you are looking at a glass-fronted building, a wet pavement, a river or a lake, the reflection of the landscape and the objects seen in the reflections share the same vanishing points as their original sources. This is useful to know and can help speed up the construction of your drawing. Water, however can move, and tides, waves and ripples will distort the reflection of the objects seen in it.

When one looks at still water, then you can be sure that you are looking at a flat plane. Flat water will reflect the surroundings and the height of an object above the water line will be the same in reflection. The reflections of objects will share the same vanishing points as their counterparts.

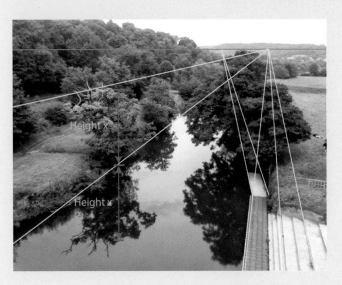

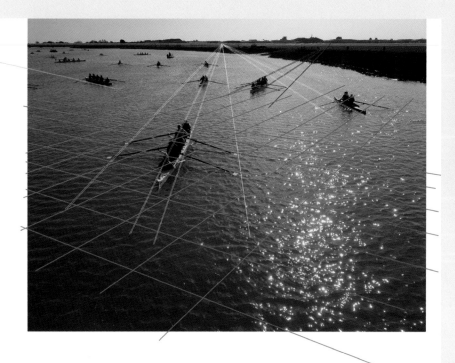

A gentle breeze may reveal undulations in the water and these will usually be at right angles to the direction of the wind. These movements of water, plus your own height above the water will quickly identify the vanishing points of this plane. This high vantage point from the old Shoreham Toll bridge provided an aerial view of rowers, each creating their own vanishing points on the horizon.

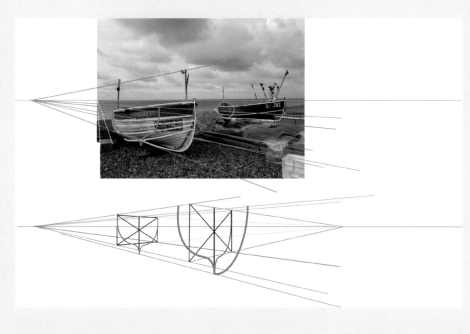

Plotting the vanishing points of the boats and understanding their construction within a box can help with drawing them correctly.

Boats

Boats and buildings can add narrative content to your landscape studies. You begin to think about the journey you are about to embark on or the home that you long to possess. By thinking about the boat initially as a cubic box, and plotting the direction of the curved planes as they move through the box, it can help with their construction.

Shadows

As the sun moves across the sky, so the objects within the landscape cast different lengths of shadow. The nature of the shadow is a distorted version of the object itself. By carefully looking at cast shadows, it becomes apparent that the same sun is illuminating all the objects so, generally speaking, as the sun is approximately ninety-three million miles away one can think that the rays of the sun are parallel. The sun's rays taken through the height of the object onto the floor plan will predict their length.

The changing scale of people will cause different sizes of shadow and the position of the sun in the sky will also influence the direction of the shadow.

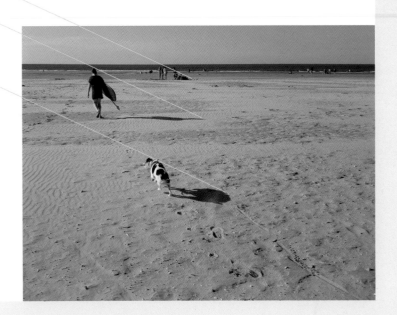

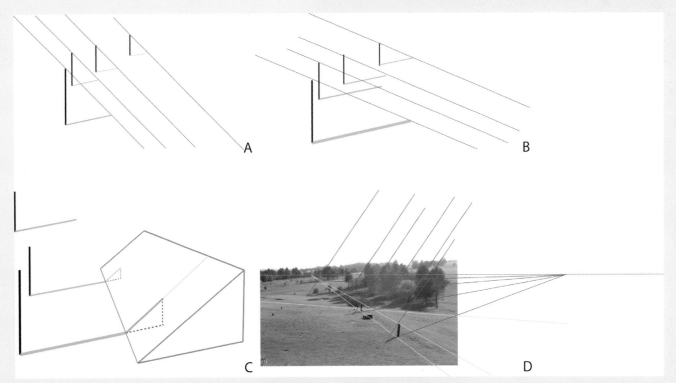

Shadow diagram A
It can be assumed that the rays of light from the sun are parallel.

Shadow diagram B
The changing scale of people will cause different sizes of shadow and the position of the sun in the sky will also influence the direction of the shadow.

By looking at the angle of the sun in the sky, it is relatively easy to see how one can calculate the length of a shadow. In the early evening, shadows are longer and clearly defined. On an overcast day, shadows are invisible.

Shadow diagram C
The floor plane will also affect the length of the shadow. If the shadow hits an inclined plane it will shorten or elongate the shadow, depending on whether the plane goes uphill or downhill.

Changing planes D
Here the golf course is far from flat, and the high position of the sun and the changing planes affect the length of the shadow.

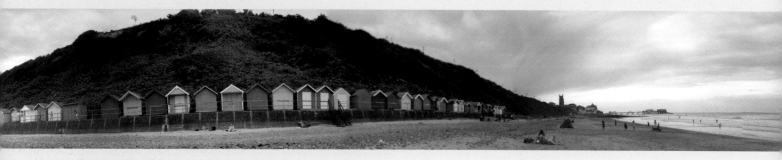

Curvature. Google Images stitch together individual photographs that have been taken of the same scene, but with different viewpoints creating a panorama. This illustrates the curvature of vision, which can be seen in the line of beach huts.

Distortion and the cone of vision

Perspective relies on the idea of a small cone of vision. How big is that cone of vision? As we learned from the drawing chapter, it takes approximately five pencil distances from the extreme left to right. This gives you a sense of the panorama (that distance is also the same for the space between the sky and the foreground literally a circle of vision). If you are drawing the landscape, you will need to draw much smaller than you are used to doing if you want to fit everything in.

The laws of perspective start to break down when the cone of vision is too great. If you were seated in a large room and you looked straight at an end wall, you would notice that the line where the end wall meets the ceiling is not straight at all and curves downwards forming a gentle arc. Similarly, the line formed by the wall and the floor curves gently upwards. Your retina is curved and you will realize that straight lines begin to curve subtly according to their position on your retina. This is a very subtle change but you soon realize that perspective needs to be treated lightly. It will give you a fairly convincing space but, on the peripherals of your vision, you need to use your eyes rather than rely on the theory.

If you were to follow the rules too rigidly, you would begin to produce visual distortions. The theory is, after all, theory and a little bit of perspective knowledge will help you in the construction of recessional space. It will certainly help you construct realistic buildings, fields, roads and lanes, and place people in the landscape with the right scale.

Aerial perspective

Look into the far distance in the northern hemisphere and it becomes obvious that the distant hills are indeed blue. Or rather they are not, but the light coming from those hills has been seen through successive layers of moisture in the air (about 80 per cent) and the various wavelengths of light have been filtered out apart from the blue ones. So the landscape become bluer in the distance, the saturation of the hues becomes reduced, the visual contrast between the tone becomes narrower as objects move away, and our perception of detail diminishes. So without the need for receding parallels converging off to a vanishing point, changing the weight or tonality of a line, the visual contrast of the lines in a drawing can be a way of creating space and, as we will go on to see, the use of mark making and colour can do the same.

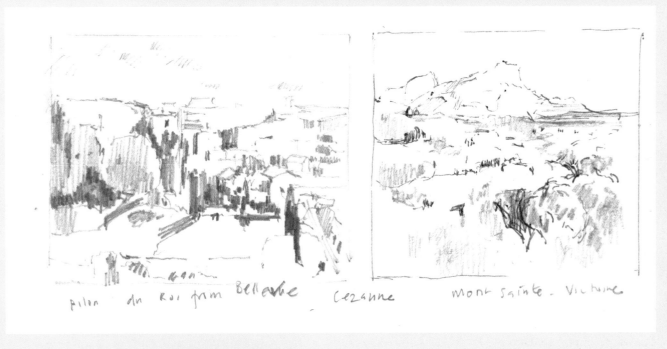

Pilon du Roi from Bellevue Cezanne Mont Sainte-Victoire

Cezanne

When Cezanne began as an impressionist, he, like his Impressionist contemporaries, was trying to forge a new pictorial language. Light became the subject matter of their paintings. The changing nature of light meant that Monet would start making numerous paintings of the same subject, in order to capture the transitory nature of the changing light conditions. Pissarro would use dashes of colour to capture the sparkling light and the use of perspectival space would be abandoned. As colour became the dominant formal element of the work, so the pictorial space of these pictures would decrease.

When Cezanne left the impressionists, and returned to his native Aix-en-Provence, he would stare at Montagne Sainte-Victoire and realize that he did see two different views of the same scene. Each of his eyes would yield a different view, a different piece of the puzzle, and so he recorded both of those views in his paintings and drawings.

Picasso and Braque would take this one stage further and include multiple views of the same landscape and Cubism would herald a complete transformation of pictorial space. Perpective can help you make realistic space, but perfectly realized paintings do not necessarily need perspective.

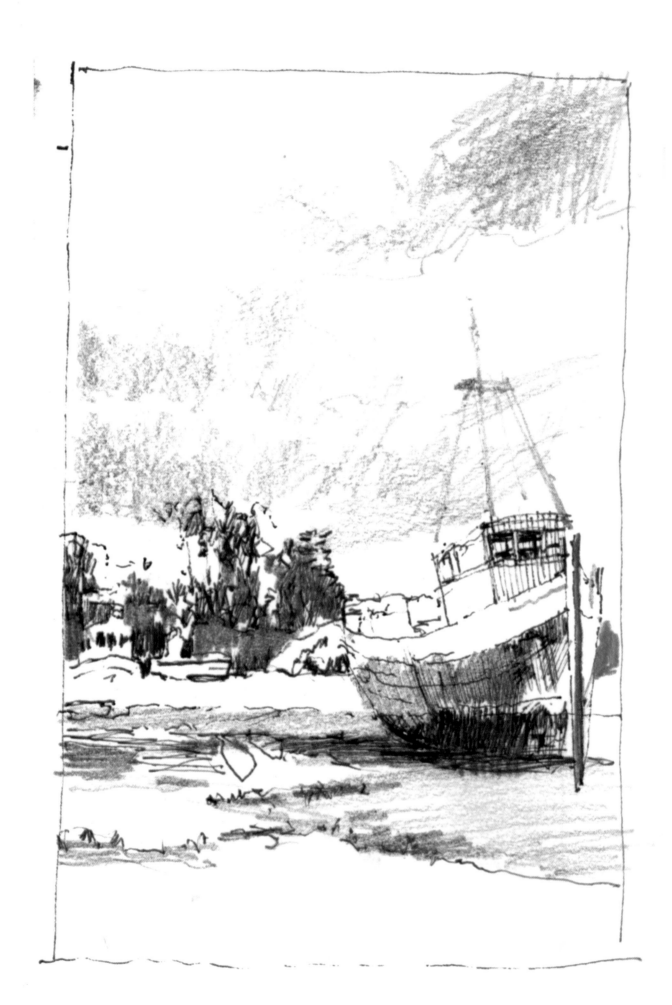

CHAPTER 4

Tonal drawing

*T**he light in the sky starts to fall and the landscape becomes transformed. What had been luminous, a golden glow, begins to fade, a darkening blue, trees, which had seemed afire, now silhouettes of blue-black amorphous sentinels.*

Outlines do not exist; we have created them as way of describing the beginning and end of objects. We perceive the landscape because the objects within that landscape receive light from the sun, absorb light and reflect it. Our eyes receive this information on the retina, which sends it to the brain. No light and we do not see anything (the landscape at night is a dark and mysterious place). Moonlight gives us more to work with but the forms in the landscape become amorphous, fluid and flattened. As the sun rises and we enter the magic hour, light illuminates and illustrates the forms with greater clarity. We distinguish the separateness of objects; we see them spatially, one form in front of another. As the sun moves its arc across the sky, so the landscape transforms, a hedgerow can come alive or disappear from view. A cloud passes overhead, casting its shadow on the land and the landscape transforms again and so too with changes in the weather conditions. Nothing is bound by outlines.

Tonality is a relative term: what governs how dark one object is seen is determined by how light and dark all the objects are in that environment and the quality of light falling on them. Tonal drawing is different from a linear way of thinking where the edges of objects are delineated. You have to look at the whole landscape and determine within that space what is the darkest and lightest areas. Of course, visual contrast diminishes the further away an object appears. So whilst you may think that banks of trees are black, they may not be. It would be useful to have some kind of scale to measure these against.

With tonal drawing, you're thinking about the light falling on the object, not the object itself. You need to find a way of drawing the landscape quickly to enable you to record these changes. You are looking for the lost and found edges, allowing the brain to make sense of the transitions of tone in space. There are different approaches to tonal drawing depending on the scale, the media and technique used.

What are the darkest and lightest areas of the landscape and where are the other values in relation to these two points? Of course, what sets these parameters is the medium we exploit, you cannot squint at a drawing or a painting in the same way that you would squint at light reflected off the sea of the sun low in the sky. Tonal drawing is a much more organic way of working, where broad areas are established, gradually being refined to the point where the subtleties are achieved at the end. As light falls onto a three-dimensional object, some of it will be illuminated and some of it will fall into shade and cast a shadow. The landscape is made up of different planes and each will be a different tone depending on its angle to the light source. That which is perpendicular to the light will be the most illuminated, but its local colour will also affect its tone. The plane that points away from the light source will be the darkest, but again this will not necessarily be black on the page.

Cloud study. Graphite and pen on paper.

Grey scales

Materials

- Charcoal
- Chalk pastel
- Compressed charcoal
- Pencils 2B, 4B, 6B
- Scrapbook
- Extra firm hold hairspray

Tonal scale

It would be true to say that tonal drawing presents a few challenges for many students. One of the key things to understand is that a lot of people find it easy to differentiate between one tone and another but cannot see the global overview, how one tone relates to the whole range of tones in the image.

Produce some grey scales on good quality paper out of a range of media. A simple tonal scale of two tones would be white and black, a three tone would include mid grey (people misconstrue mid grey, making it too dark) and five tones would include light grey and dark grey.

If you take out your mobile phones and turn in the opposite direction, away from the landscape, it is reflected back in the black glass. This tonal ghost can then be used as a way of evaluating the whole scene, as it will remove a lot of the mid tones. Of course, this is not a new idea, as it is a modern take on the Claude Glass, but it is another way of seeing tone in a simplified way.

Work from white paper through to black with acrylic. Paint some paper to a mid grey to create a tonal scale. Cut a small aperture out of the middle of the paper. By looking through the hole, you can more easily judge the tone of an object by comparing it with your scale.

If you are shortsighted, it is useful to draw without using your glasses as the lack of focus will help you see the tones more clearly and of course, you can almost shut your eyes so that you can look through your eyelashes to see a more muted image.

A change of plane makes us aware of an edge, which appears in sharper contrast where two tones meet. A spherical object graduates evenly in tonality across its surface, until it meets the areas of the object in shade. Clouds can be spherical and flattened, especially on their underside. So light hits the clouds and gives them the illusion of form.

As an object receives light, it also reflects it. This will affect objects near to it. In the case of a sphere, the background will reflect light into the shaded area so usually, one sees that the centre of the shadow is lighter than the edges. So a brightly coloured tree will reflect its colour into its neighbour, a field of rape will influence the colour of the surrounding hedges, but your perception of those colours will also be influenced by their surroundings, so the same field may appear very different seen against a bright blue sky, to a dark overcast one. In practice, though, tonal drawing is much more complex. The real difficulty is to match your visual impression of the object's tone with your choice of media.

Focus on the idea of tonality, using fugitive materials which can be easily removed: pastels, compressed charcoal and charcoal will be your best allies in this exercise. It is important that you understand that the success of these drawings will rely on the surface of your sketchbook page. A sketchbook that is too shiny won't have the tooth that will enable it to bite the charcoal or the chalk pastel. Compressed charcoal can work on smooth paper.

Try to make ones that have between nine and twelve tones, finding as many variations of tone as possible. You will find that producing a charcoal tones scale will be much easier than compressed charcoal. However, compressed charcoal can be bought in a range of pre-mixed tones and these can be very useful tools in your armory of drawing media. It is also useful to buy yourself a cheap scrapbook. These cheap books can often be made of sugar paper, the texture of this paper is quite coarse and lends itself beautifully to the use of soft media. You will also need something like extra firm hold hairspray or fixative to make this adhere to the paper once you have made your drawing.

Think about the surface of paper a bit like a doormat, the roughness of the mat scrapes a shoe clean, so the roughness of the paper bites the charcoal and leaves a heavier deposit. Too much material will clog up the fibres, preventing a further deposit of material (think really muddy boots). So the charcoal can end up skidding across the surface of the paper. Fixing with PVA and a spray diffuser will add some texture back to the paper, which makes it easier to rework. Try using coloured paper with this toned charcoal, and pastels too as it gives you a tone to work against.

Once you have created these grey scales, you can cut them out of the paper and then offer them up to the subject. Looking through your eyelashes, with your eyes almost shut, you can look at the tones in the landscape and try to find a tonal equivalent on your grey scale. It is useful to hole punch apertures into your greyscale to make it easier to compare and isolate the part of the landscape you are looking at.

Depending on the conditions of the landscape, whether it's a bright summer's day, overcast, cloudy or stormy, you will find surprising juxtapositions of tone. Sometimes the sky can be almost black against a beautiful illuminated fragment of landscape. Never assume anything about what the landscape might be doing.

Block-ins

You are now going to produce a series of tonal studies from the landscape itself. Don't worry about linear detail, instead use the side of your charcoal the same way that you use the side of the chalk to make some initial block-ins. Think about big tonal masses and try to see how light and dark these areas of landscape are. Work directly from the landscape itself, from other artists' tonal studies or from photographs. It will be really useful to make any photographs black and white rather than in colour. Some phone apps will also enable you to produce much more simplified tonal images, again removing some of the detail from the image. It will help you see the tones more clearly. Another invaluable tool is an eraser. An eraser can take out areas and create highlights. You can cut them with a scalpel or craft knife to make points or edges. Some stationary shops sell old pencil erasers that were used for typewriters. This can also provide you with a very fine element of control.

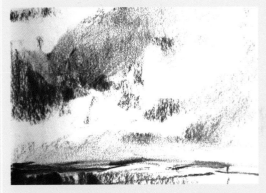

A charcoal block in establishing the main lights and darks with the side of the charcoal.

Nick Bodimeade uses hatching and cross-hatching blocking in the main areas of light and dark. The titles of Bodimeade's drawings relate to the digital file name of the photographic source.

The notan

Materials
- Black acrylic
- Black ink
- Permanent marker (promarkers are optional)
- Large brush
- Charcoal
- Compressed charcoal

Working with a brush and ink or brush and black acrylic (watered down so that it flows off the brush), practice making notans. Don't be tempted to draw an outline around the shapes and then fill it in, instead, think about a blob of black that ends and another that begins.

You should also look at John Cozens, Rembrandt's etchings, Samuel Palmer's drawings and John Virtue's paintings to give you an idea about how black and white can be used to evoke a sense of the landscape with very limited means. Remember that black woodcut prints are effectively notans, so looking at these too will also help you with your understanding.

A notan derives from the Japanese, for a light dark harmony. You are merely thinking about the darks of an image; in much the same way a woodcut only records black, you are only thinking about the shadow areas of an image. Consider why you see the branches of tree as dark against a light background, and the bough as light against dark.

You can make a Claude Glass by painting a sheet of glass black or brown on one side, which will reflect the landscape back at you in a significantly reduced set of tones.

To help train your eye, it is useful to have a digital image of a landscape and manipulate its tonal range by adjusting the histogram levels. You want to push the tonal range to the extreme, losing all grey values. You may find that by manipulating the levels, you can yield a series of alternative readings of the same landscape. You can also photocopy an image, pushing the contrast right up to achieve a similar result.

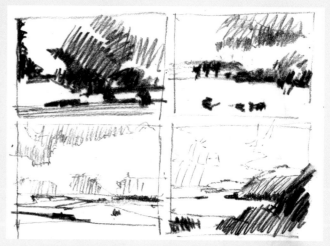

A series of four small block in compositional studies made from compressed charcoal.

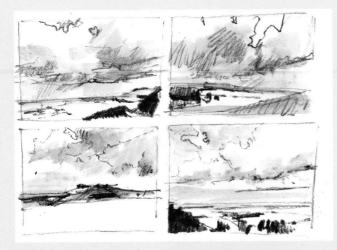

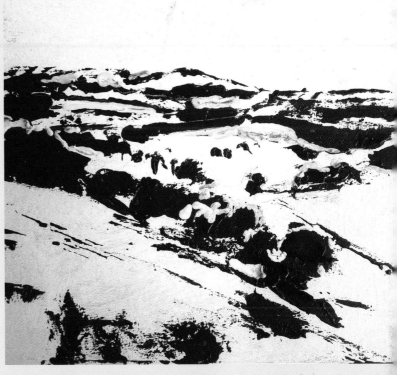

Experiment with combining water with the compressed charcoal to create a wash to give you much more subtle tones. On tonal paper, try to do the same again, this time using white pastel and charcoal.

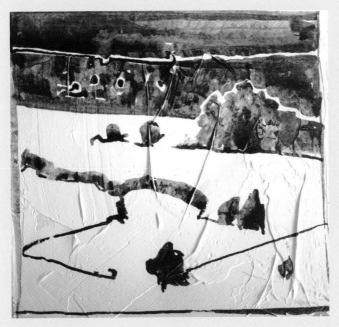

Thick black paint on top of thin white. Some white paint was used to find the edges of the trees.

Thin transparent black on top of thick white paint.

Once you have exploited this approach enough times, try the same with compressed charcoal. Be physical and gestural with it. Don't be frightened of making the mark in the wrong place. Compressed charcoal comes in uniform sticks, which transfers pigment to the hand easily. You may wish to hold them in a piece of tissue or wrap them in tin foil if you don't like getting your hands dirty. You need to handle the medium very delicately if you want to achieve very fine tones or mix with water to get washes. This can produce some very sensitive landscapes because you end up turning the compressed charcoal into paint. But this is much more difficult to make changes to. Pastel is effectively the same thing. It too can be handled in the same way.

Look at drawings by Dennis Creffield or David Tress. Consider their dynamic treatment and try to get a similar energy in your own studies.

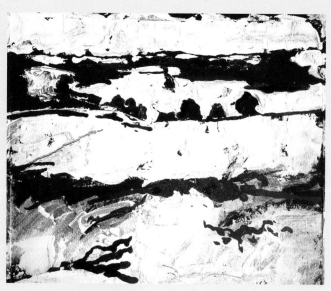
Thick palette knife, white on black.

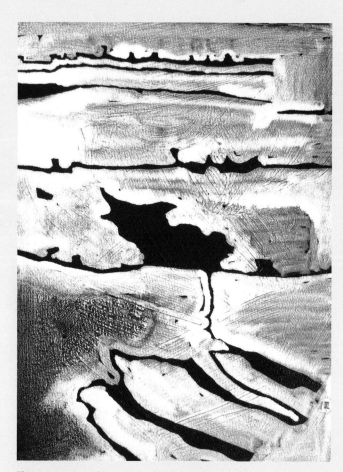
Thin transparent white on top of thick black.

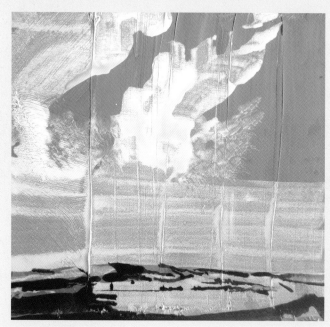
Thin white and black on grey.

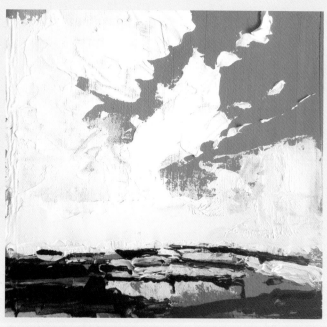
Thick white and black on a grey ground.

LESSON 14

Negative painting

Materials
- Black and white Acrylic
- MDF
- Greyboard

Paint six rectangles, two white, two black and two mid grey, onto a sheet of greyboard or MDF.

For each tone you put down, make one a thin layer and one thick. Use a palette knife or a stiff hog hair to create raised ridges. You can add Daler-Rowney impasto medium to your acrylic to create even more texture.

Once these layers have dried, investigate another notan study, modifying the opacity and application of paint. Onto the thick white background, apply a thin, transparent black acrylic. Apply a thick viscous black on top of the thin white ground. Do the same with white on black, with a thin white on a thick black and a palette knife white on a thin black. Onto the grey grounds, experiment with alternate thin and thick white and black so that you create a richly textured image. Look at the way in which the thin layer on thick creates exciting surface qualities.

LESSON 15

Duotone

Materials
- Letraset Promarkers, medium grey and black
- Black and white acrylic
- Grey paper

You should now introduce a second tone, mid grey into your studies. How would you define mid grey in your landscape? Is the whole image grey with a few black shadows and white highlights? Is the sky grey in comparison to the land? Are all the structures in the landscape black, or are some grey and some white?

Three two-tone studies using Letraset Promarkers.

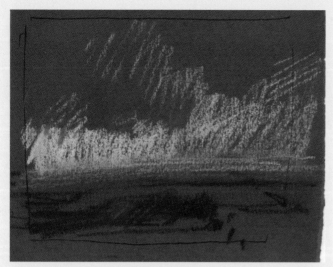

Two-tone study using white and black coloured pencils on a blue-grey Ingres paper.

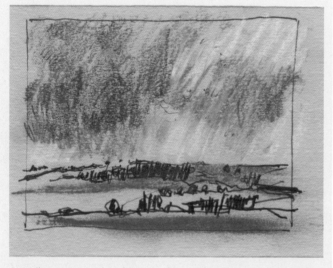

A small compositional study on a mid-toned pastel paper using graphite, chalk and fountain pen.

Some digital cameras, or camera apps, may have a cartoon setting, or a posterize option. Photoshop gives you a duotone setting and the cut out filter, which can help simplify the landscape into tonal masses.

Try making studies on white paper, grey paper and black paper. Think about the Claude Glass to reflect the landscape in a muted range of tones to help you see it simply. You can even try photographing a reflection of the landscape from a car's body, which will not only remove the mid tones, but it might also produce some interesting visual distortions.

Go on to make a series of three-tone studies using a range of dry and wet media

LESSON 16

Collage

Originally developed by the cubists, collage was a means of both asserting and denying pictorial space. By placing textured paper onto canvas, the flatness of that support is clearly in evidence, yet at the same time the material itself can act as a mnemonic for real objects (wood grain as a table).

There are three main types of collage: mosaic, cut and torn. Mosaic collage uses lots of tiny pieces of paper cut up into squares and the collage is built up rather like a mosaic. Making mosaic collages can be a pretty time wasting activity so try to avoid it. You will spend more time cutting up all the paper into little squares, than actually making the collage.

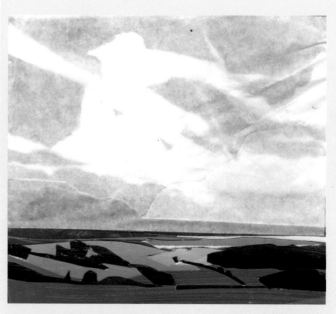

Painted paper using white, Yellow Ochre and black. You want to make sure that you have a good range of tones.

Paint some newspaper with white, black and Yellow Ochre acrylic. Use this paper to make some collages. Experiment with cutting and tearing the paper with scissors, scalpel and fingers. If you tear the paper away from you, you will get a clean edge; torn toward you and you will get a shallow edge of paper colour. You may find this useful to create small highlights. Turn the paper through 90 degrees and you may find it much more difficult to tear the paper in a straight line. That is because you will be tearing the paper against its grain. When machine made paper is manufactured, the fibres align themselves to the direction of the conveyor belt. It is easier to tear paper along the grain, and create thin strips of paper. Tearing

Collage using white, Yellow Ochre and black with the addition of parchment paper to make the sky recede.

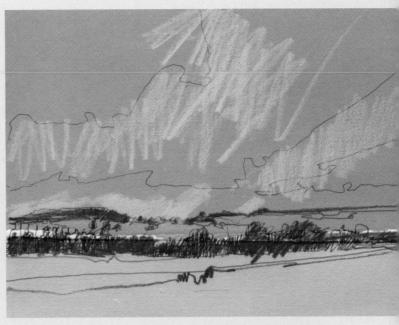

You can also experiment with drawing back into these collages with white and black pastel pencils or coloured pencils.

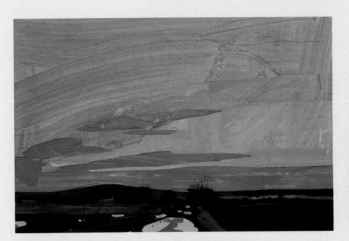

Harry Stooshinoff, *Evening Cloud, Chickabiddy Place.*

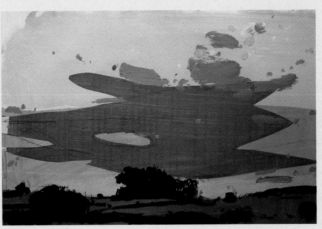

Harry Stooshinoff, *Dusk on Chickabiddy Line,* acrylic and collage on archival paper.

against the grain is more difficult and the natural tendency of the paper is to want to tear with the grain, which means that the paper tends to want to form an arc rather than a line.

Think about collage as a drawing medium. You can tear paper with considerable care, and scissors and scalpel can be used with real precision. Do not be tempted to trace the image of the landscape onto your collage paper or draw out in pencil the shape; instead, see your scalpel or scissors as your drawing tool. If you have cut out too much paper, cut into it, but if it's not enough, stick a bit more on. See the collage as an organic process of addition and subtraction.

Work the big masses first without getting too stuck with detail. Think about how you might use the grey and the Yellow Ochre combinations to articulate the space. You might also wish to combine the collage with tracing paper, parchment paper or grease proof to reduce the tonal range and make the sky recede.

Whilst painting newspaper is a good way of recycling your waste, the underpinning text and image will have an impact on the kind of colours you generate. So it is useful to also paint some white cartridge too. You will also find that newspaper becomes very fragile when wet and tears easily.

A dramatic charcoal study using the eraser to create the clouds.

Continuous tones

Once you have understood the notion of a tonal range and feel more able to make value judgements not just from photographs but the landscape itself, consider using charcoal in the same way. Rather than working with the point, explore the edge of charcoal to create tonal masses.

Block in your darks and reserve your whites. Consider your mid points and work toward your intermediary tones. Think of a block of tone rather than layered hatched areas filled in outlines. This is the best way to tackle the main forms of the landscape.

A heavy quality paper with a good tooth makes a big difference. Don't use shiny paper as the charcoal skids off. Use a rubber to add highlights but also to rework and correct. Charcoal is a fugitive medium and can be easily moved around the page. You can make marks and erase them, which is great when working from the landscape, so that you can find out where forms begin and end.

You can smudge out what you have done and redraw quickly. You can blur the whole image and return it to a medium grey mass and rework the surface, finding the drawing anew. Don't be frightened of it. When you work from a real landscape, the mutable quality of charcoal will help you capture the transitory light conditions and develop a drawing, which reveals a sense of history, as well as evoke the atmospheric qualities of landscape.

Buy a thick stub of charcoal or use a bit from your barbecue (it's the same stuff). A big piece of charcoal can yield a delicate mark and a sensitive line when handled correctly (and it can be sharpened). A thin piece of charcoal can only produce a thin mark and, worse still, it breaks all the time. Charcoal can be moved around with the hand or a piece of kitchen roll. You can also use a paper stump to create delicate tones, which reduces the oily residue from your hand, which can cause the charcoal to stick to the paper more, making it difficult to erase.

As it is fugitive, charcoal needs to be fixed to the paper. You can buy fixative in an aerosol form to do this, but you must spray your drawing in the open air. Extra firm hold hairspray can also be used. Another alternative is to mix PVA with water until it is the consistency of milk. This can be applied to your drawing with a spray diffuser. If you use this method, try to ensure that you use a container so that the liquid goes a long way up the lower tube of the diffuser. This will minimize the distance the liquid has to travel up the tube before it atomizes in the air (otherwise you have to use a lot of puff). Ensure that whatever your fixing method, you do so about 40cm away from the surface; if you are too close you can get runs.

Initial drawing is made on the A1 paper to plot the clouds and land.

Using the side of the charcoal, the darks were added into the clouds and some indication of the land was made.

Using the side of the hand or kitchen towels, the mid tones are now added, trying to see the tone really simply at this point.

More subtle work is now done, forming the mass of the clouds and the trees.

Erasers are vital tools with charcoal. A plastic rubber can be cut with a scalpel and shaped. It can also be washed if it gets too dirty. A putty rubber is really useful as it can be kneaded and made into a fine point. Some rubbers can be awful and not rub out your drawing, but leave a greasy coloured residue on your paper. A humble slice of bread can also be used to remove charcoal from your paper, but it will leave a lot of crumbs.

Erased drawing

Materials

- Charcoal
- Rubber
- Fixative

As you work and rework charcoal, the surface of the paper seems to allow the medium to move more freely over it. Use some kitchen paper to cover the whole paper with charcoal first and rub it into the paper to create an overall mid grey. It can be useful to rub your charcoal against a sandpaper block to create a charcoal dust. This dust can then help you achieve a mid grey tone without losing the texture of your paper.

Think about where you see the light and use your eraser to rub away the grey to reveal the white paper. Once you have established your highlights, work back into the drawing with charcoal to enrich your darks.

Pencil drawing

One of the most widely used drawing mediums is pencil. Pencil can yield a wide range of greys from incredibly delicate to an almost black. One of the main issues with pencil is having a sufficient range of grades. When drawing the landscape, have a basic set of pencils: HB, 2B, 4B. This will provide you with a good start. Pencils are graded according to their level of hardness (H) or blackness (B). The ordinary lead pencil is not made of lead, it's a combination of the two main ingredients, carbon and clay. The carbon constitutes the soft black pigmented material and clay is the harder binder. More clay, the pencil will be harder and lighter, more carbon, the darker, richer and greasy the black is (watercolour washes can be held in place with the grease).

Pencil drawing can be a rather time-consuming way to produce areas of tone. A graphite stick is effectively a very large pencil and will save you a lot of time if you are blocking in big areas. Some are very chunky and are wrapped with a paper

James Naughton, *Tetons*, pencil sketch.

James Naughton, *Green River*, pencil sketch.

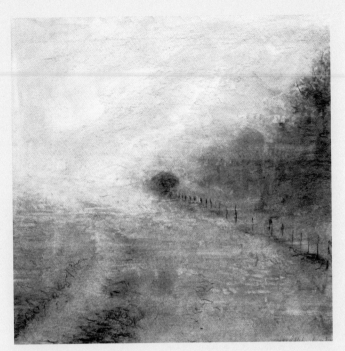

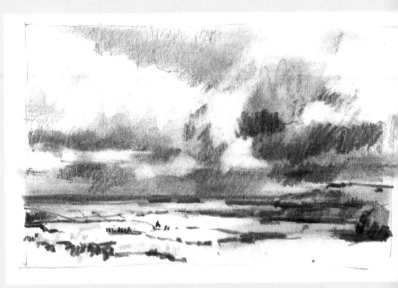

Make a series of pencil studies from your landscapes, and experiment with different grades of pencil, with the hardest being used for the background and the softer darker pencils in the foreground.

Richard Whadcock, *Lag Wood*.

Julian Vilarrubi, *Catalan Landscape*, pencil drawing.

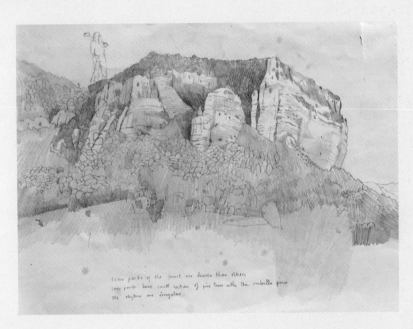

covering. Some are more slender and can snap in half if used too heavily. They can be used in combination with a clutch pencil, which holds the lead and you have a comfortable plastic or metal handle to hold onto. This reduces the chances of the lead breaking and gives you a consistent size to hold.

Some propelling pencils only hold a tiny lead about 0.5mm in diameter. These are much better for technical drawings or for a very light touch. If you are in any way heavy handed, you will find that these leads snap all the time, which can be very frustrating.

A lovely way of working with pencil from the landscape is combining pencil with wash, inks, acrylics or watercolour. Build tones from the lightest to the darkest. In recent times, pencils are available in water-soluble varieties. Like compressed charcoal, the combination of water with these provide an inexhaustible range of tonal qualities and effects.

Make a series of pencil studies from your landscapes, and experiment with different grades of pencil, with the hardest being used for the background and the softer darker pencils in the foreground.

A pencil sharpener is only good for HB pencils and harder. The softer the lead the more likely they are to break. So you really should use a craft knife or a scalpel to sharpen your lead.

The angle of your cutting should be changed to suit the pencil. A shallow angle will cut the wood and not put undue pressure on the lead, so it is better to use this for softer pencils, making the angle steeper for harder ones. You can also manipulate the point more, defining the quality that you want. You can use it to sharpen pastels, graphite and compressed charcoal. Traditional willow charcoal is very soft, but vine charcoal is harder and it is usually sharpened with a sandpaper block.

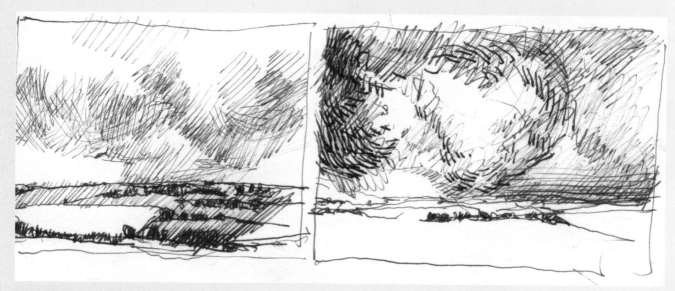

Of course, if one is talking about tonal drawing, one has to discuss hatching, cross-hatching and contour hatching. Hatching is a way of creating tone using the proximity and layering of fine lines. A series of lines sketched on the page, which are a few millimetres apart, will visually appear to be lighter than the same number of lines closer together and this will also change if the lines becomes thicker, creating a darker tone. These lines can be made in one direction or can be in a number of different directions. Lines can also become curved lines and the direction of the lines imply a plane, so if all the lines are parallel, they create a sense of a flat plane and their angle an inclination of that plane.

Hatching

When you hatch in one direction and then lay over the top of these another set of hatching marks in a different direction, you are creating cross-hatching. A number of lines can be superimposed on top of another. As the white paper begins to disappear from view, as more layers go on top of each other, you create darker tones. The real challenge of hatching, as a drawing technique, is knowing what to leave out rather than what to put in.

You will need to experiment with your drawings. It is advisable to look at some of the imagery that you've already used and think about the minimalistic tonal values of the notan and how will this translate into a hatching study. What direction of hatching marks would you give these structures, would you think about their forms in space and try to give meaning to those forms through the directions of the lines? It is worth considering the idea of starting the hatching very openly so as not to make the tones too dark at the start, then gradually building toward the darkest values.

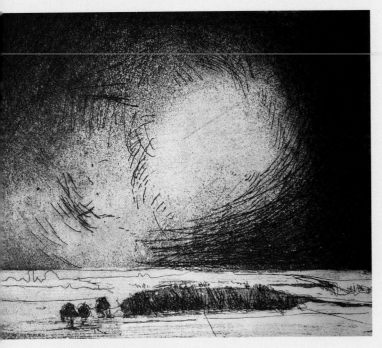

An etching and Aquatint of the Sussex Downs.

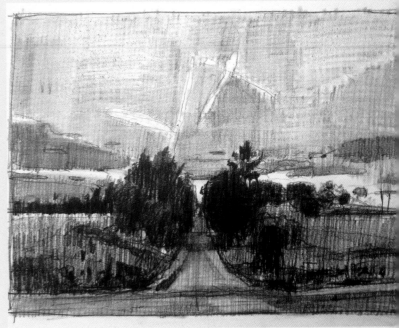

Harry Stooshinoff, *Evening Comes*, pencil on 11 × 15in heavy archival paper.

It can be useful to go back to your gridded paper, and look at the way in which the contour changes when it is creased. This will be useful in giving you a sense of where and in what direction the hatching marks should go.

It is much more difficult to erase a pen and ink study than it is for pencil or charcoal, although alterations can be made with a medium such as Tipp-Ex. You can also cut through the drawing with another sheet of paper directly underneath. You effectively cut two identical holes. The clean sheet can then be placed into position and taped to the underside. This is known as intercutting.

Hatching and cross hatching are used in hard ground etching. A fine needle is drawn across an acid resistant ground, which covers a metal plate. This drawing reveals the metal underneath, effectively reading as a white line on a dark background. Once you are satisfied with your negative drawing, the metal is immersed in acid, which bites through these exposed lines, creating indentations in the plate. The longer the plate is left in the acid, the deeper the line is etched. Some areas of the plate can be protected from the action of the acid by painting out with a varnish (stop out). As the hard ground is effectively seen in reverse (left to right and black to white) it can be really useful to photocopy your original artwork and invert it both left to right and negative. That way, when you make your etching, it is much easier to read the tone you are creating.

Once the plate has been bitten, the plate is covered with a sticky ink. This is rubbed into the plate, forcing the ink into the recesses created by the acid. The plate is then wiped with tarlatan, newspaper, tissue and even the back of the hand, removing the surface ink. Once the plate is wiped, it is put through a press, which is rather like an old mangle. Two heavy metal rollers have a small gap between them. This forces dampened paper into the indentation with the use of soft blankets, which then removes the ink from the plate onto the paper. Dry point is a very similar intaglio process but the lines are scratched directly into the plate with a sharp point. Further investigation would yield considerable insight. Look at the etchings and engravings of: Rembrandt, Thomas Bewick, Sydney Long or Whistler.

Hatching and cross-hatching can be used with coloured ink on coloured paper as well, using a dip pen dipped in gouache, which can be mixed to the consistency of milk, or acrylic inks can be used in the same way. You can employ it with pencil, coloured pencil, pastel and even a paint brush can be a versatile way of creating the illusion of blended colour with a fast drying medium, overlapping colour to create optical colour mixing.

Wash media

Materials
- Black FW acrylic ink
- Brushes
- Plastic plate
- Water pot

Using a dip pen and Indian ink, one can make a linear drawing, which can have transparent washes applied over the top. The drawing acts as an armature to underpin the tonal areas. As Indian ink is waterproof, the line stays in place and the wash create the tonal differences between the light and dark areas of your landscape. The line can also be diluted, creating faint lines in the background, gradually building in darkness and thickness in the foreground.

Instead of a dip pen, a fine sable type brush can be used to create the line. This offers much more flexibility and produces a line of greater variation and complexity. A Japanese calligraphy brush offers even more flexibility and diversity of line and mark, combining both a very fine point but a breadth of fine bristles. Of course, like charcoal, one can use the tone without the underpinnings of line. Here, the flexibility of the brush comes into its own as areas of the landscape are blocked in with broad sweeping strokes before more carefully placed areas of the tone create definition and form to those objects in the landscape. A tired and somewhat dried out brush can yield other drawing potential, especially when the viscosity of the medium is varied from thin to thick. This will be useful in finding a visual shorthand for trees, ploughed fields, grass and hedgerows.

As the tone is permanent once it is dried, it is good practice to work from the lightest, most dilute ink first. This will usefully correspond with those features furthest away at the horizon. The tonal contrast and depth of tone increases the nearer objects are to you. Of course, you can use colours other than black; sepia can give luminosity and warmth to your landscape drawings; blue, coolness and light, but here you are thinking about tone rather than hue.

Acrylic paints can be diluted and will behave in much the same way as Indian ink. Some manufacturers have already done this for you, creating acrylic inks, which are also waterproof when dry. Using watercolour or Quink ink will result in a wash that is soluble in water. This means that it will mix with the layer placed over it. If one draws in line, then this may well disappear into the wash.

Quink ink demonstrates itself to have much greater colouration within the black when it hits water, it is opposed to a similar type of ink manufactured by Lamy. The Lamy ink tends to be more black but both perform well with wash and line. Both of these inks are designed for fountain pens which enable them to fluidly move through the pen without blocking it. These particular inks can also be bleached out, which means that you can use an additive as well as the subtractive process when making the drawings. Fountain pen-type ink is water-soluble even when dry. In this study, the drawing was made with an italic nib on a Lamy fountain pen. The water was applied to the drawing, creating the washes. Thick bleach has been added to the drawing with both a brush and a sharpened stick. Brushes can be damaged by bleach so use an old one for this purpose. In the foreground of this study, salt was dribble dropped onto a wash, creating a more textural foreground.

These brush and ink studies were both made with Indian ink, one using tap water and one made with distilled water (the water from a tumble dryer). Whilst the drawings are very similar, one can see in the tap water study a little bit more granulation of pigmentation. Both studies have great depth and luminosity. A bamboo skewer was dipped in ink and used as a drawing implement. The stick holds enough ink to make quite a delicate mark. As it is dragged over paper, different qualities of a line weight are produced which are also obtained by using the end of the skewer. The skewer itself can be sharpened to create other kinds of marks as well as hammered to produce a wooden brush.

Earth colours

The earth colours are literally made of dirt; Sienna and Umber, the ground from Italy, crushed and mixed with medium. During the Renaissance, the Italians held Northern Europe to ransom over pigment. The Italians could produce paintings of striking intensity and lusciousness of hue whereas the Germans and Dutch had to make do with mud. But what beautiful mud, the drawings of Rembrandt, Durer, Cranach, Rubens. What makes more sense than to draw the landscape in the earth colours?

There is a beautiful warmth in Rubens and Rembrandt's drawings. Although difficult to acquire today, their preferred drawing medium was sanguine, a red chalk. Somewhat like

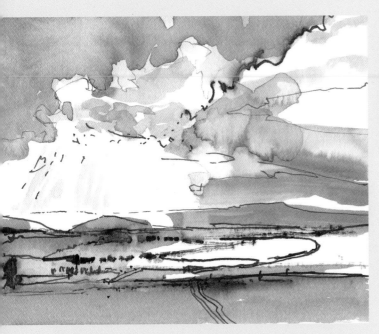

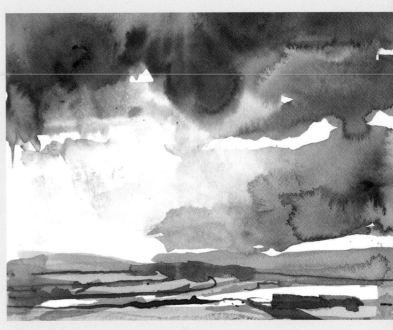

Indian ink and stick. This drawing was made initially with a bamboo skewer dipped in Indian ink. The linear drawing utilized the fact that the ink did not produce a continuous line but a broken one. Once dried, a wash of Indian ink was applied with the addition of distilled water.

Tap water was used in this wash study which produces a more grainy result.

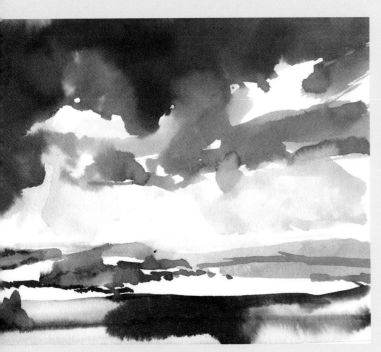

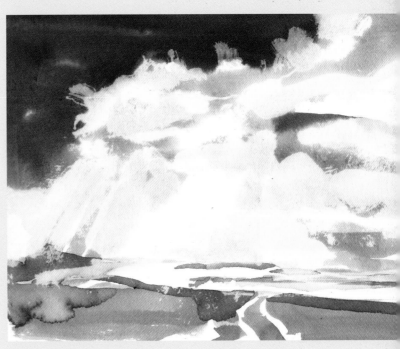

This study was made with fountain pen ink.

Fountain pen ink can be removed with household bleach to create dramatic lighting effects. However, bleach can destroy your brushes though so use old ones for this job.

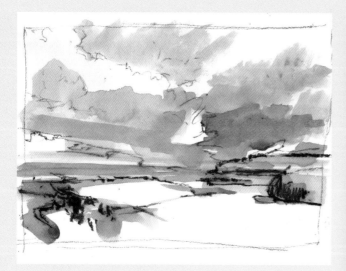

A successful wash drawing can be made using a very strong instant coffee mix. This is combined with compressed charcoal in the drawing.

Chris Taylor, *Outside the eagle and child Gwaenysgor*. Mixed media drawing incorporating collage, paint and oil pastel. The layering of this image creates visual space through the manipulation of texture as well as the saturation of colour.

compressed charcoal or conte, red chalk is slightly waxy. Not as soft as compressed charcoal, it takes to paper well. It can be sharpened with a blade but also used broadly. Watteau used black chalk as well as sanguine, which gave him both a mid tone and a dark.

Limited palette

Working with any kind of pastel, it is useful to experiment with both white and coloured paper. The texture and feel of paper varies considerably.

Begin your first drawing with sepia and try to make the most of this colour before you start to introduce any of the others into the drawing. Experiment with your materials to gain confidence in them and to understand what colours are produced when you mix them together. Consider the idea of limitation, maybe a series of two colour and three colour drawings.

The weight of the arm can be taken through the fingers resting on the paper to allow delicate mark making. If the surface becomes too covered, think about using a mahl stick to raise your hand above the drawing so as not to transfer all the pastel onto the back of your hand. You can also make a little bridge for yourself out of two by one. A length of wood wider than your paper can be lifted off the table with small blocks

of two by one glued or screwed to the ends. This can then be used as a hand rest lifting your hand above your paper.

Pastel can be held in the hand on its side to draw broad areas. It is better to proceed lightly at first so as not to clog up the paper surface. Better to keep an open mesh and build up layers of hatching in different directions than trying to grind the pastel into the paper.

Mixed and alternative media

Very strong instant coffee can be used as a drawing medium but it can be rather sticky. Add four or five spoons of instant coffee to a cup and add hot water. The ratio will influence the opacity and tone of the wash.

Boot polish can be used to draw and paint with. Experiment with it straight from the tub, especially one that has little polish left in it. Try to use it in the hand, although your body heat will cause it to melt. Also experiment with the use of a brush with a little solvent or the use of a palette knife to apply it.

Mud can be ground up with pestle and mortar mixed with egg yolk to make your own paint. Be experimental with the use of alternative media, think about limitation and combination before you get bogged down into the idea of what the colour of the landscape is.

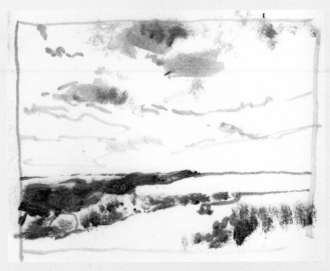

A drawing of the downs made with boot polish applied with a brush. A little white spirit on the tip makes the polish flow better across the paper.

Louise Balaam, *Torrington study 1*. Mixed Media.

LOUISE BALAAM

My practice is to draw outside and paint in the studio. This is because I find my painting can become too literal (for me) if I'm working directly from the motif, or even directly from a drawing. I find the drawings are essential as source material but I prefer not to work from them. By painting in the studio rather than *plein air*, I can allow memory and imagination to play more of a role, and the painting can take on its own life, rather than becoming a copy of a drawing. I can also paint on a larger scale, for much longer, and in series, all the time aiming to paint intuitively and keep a freshness in the way I put the paint on. There don't seem to be many words for this but I find I need to get into a kind of right-brain zone, where I'm completely absorbed in what I'm doing, not thinking or judging, just painting.

– Louise Balaam

Wire drawing.

Mark making

> *I exaggerate, I sometimes make changes to the subject, but still I don't invent the whole of the painting; on the contrary, I find it ready-made – but to be untangled – in the real world.*
>
> – VINCENT VAN GOGH

DOTS: HOW DIFFERENT IMPLEMENTS PRODUCE DIFFERENT TYPES OF DOT

The majority of art materials can only make a limited number of marks: a dot, a line or an area of tone. When one starts to think about mark making, it is really the configuration of these elements, the variables, that creates a diversity of potential textures, structures, forms and surfaces. Dots can be evenly spaced or organized in a haphazard way. Dots can be small or large, rounded, oval or blobby. Dots could be square shaped or triangular depending on the tool used.

Move a dot from one position to another and you create a line. Lines can be vertical, horizontal, diagonal; lines can be parallel or randomly configured, straight or curved and they vary in thickness, in tone as well as colour. Join enough lines together and you can create an area of tone. Lines create hatching and overlaid to create cross-hatching. Arced, they can trace across and form and describe contour and structure, and brought close enough, will merge into shading.

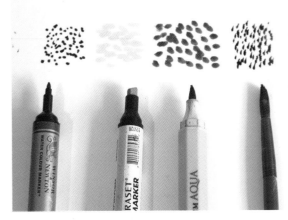

How different implements produce different types of dot.

A series of lines made by the same media that made the dots. Think about how you can create line variation with your tools.

The use of a sponge to create marks on paper.

This drawing based on one by Nicolas de Stael (1914–1955) has been made with a watercolour brush pen (de Stael used felt tips). Here, he made a landscape, sky, water's edge with just dots.

In this study of a Nicolas de Stael drawing, de Stael defined the sky and land with bold lines running off in different directions but which imply the space and the quality of light.

A pen produces a limited number of marks, largely due to the dimensions of the nib and its lack of flexibility although with care, a pen can yield a range of touch responses. A fine line pen or felt tip will produce a different kind of line depending on the tip and age. Some felt tips lose their fine point and splay out at the ends. A dip pen will produce lines of varying thickness as the end widens under pressure. Different nibs can also be attached significantly, extending the range of possibilities.

A grid

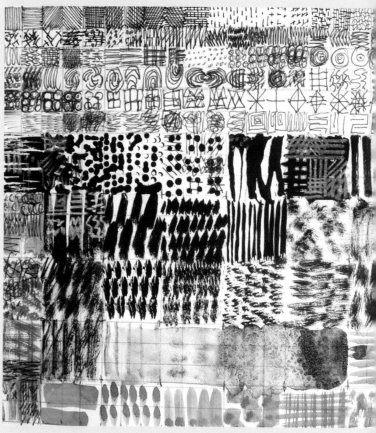

Draw a grid in your sketchbook about 20 × 20cm and divide it into a series of 1cm squares. Try to fill each box with a different sets of marks. Think about direction of stroke, thickness of mark and the distance between each. At first it will be easy but as you continue to fill the 400 boxes, you will probably begin to repeat yourself. It will be a good idea to think about the sound your implement makes as you make your mark. By consciously striving to alter the sound, you will build into your drawing mark making variations.

LESSON 20
Making a mess

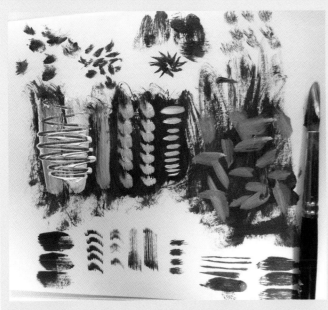

Once you have filled the grid, reach for any tool in your art bin and using scraps of paper. try to make a mess. Think about how you can fill the pages with as many different marks as you can. Be playful, after all, you did this as a child on lots of surfaces (not just paper) to find out how to make a controlled mark. Like a child at kindergarten, you would benefit from using lots of paper to experiment with mark making, without worrying too much about the result. Play can be invaluable and never underestimate its power.

LESSON 21
Dots and lines

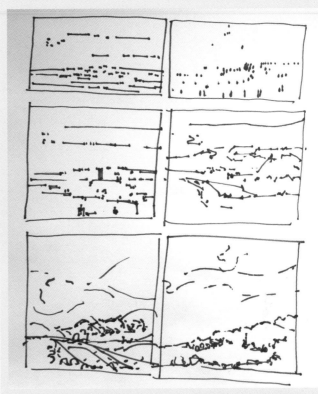

How would you draw the landscape using only horizontal lines, or vertical points? What if you combined both or introduced diagonals or curves? This drawing exercise does just this, reducing the landscape down to some basic elements.

LESSON 22
Drawing games

Materials

When you have looked at the extensive range of media in your art bin it becomes apparent that your mark making grows exponentially with each new media. The side of the charcoal can be used to make broad sweeping marks (if the charcoal is large) and by varying the angle of the medium, changing the direction and weight of the arm, hand and wrist, a much more complicated vocabulary of marks ensue.

When you change from dry media to wet media, you change possibilities again. Thick paint will behave very differently from fluid ink and the implement used to apply it, whether brush, shaper or palette knife, will affect the result. Each one of those tools brings a much more divergent set of

marks. A wet surface behaves differently to a dry one in much the same way that the texture of support impacts on the mark too.

It is the combination of these permutations that will produce the illusion of different textural surfaces in the landscape. Small curved lines running in the same direction will have a different impact to long curved ones and might be used to tell the difference between leaves and hills. Short hatching grouped in haphazard directions might suggest a roughly textured tree and long parallel strokes may evoke distance. You will need to think about the surface quality of the landscape being represented and its proximity to you.

Brush drawing

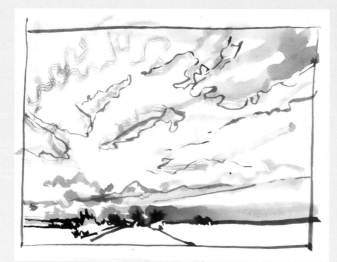

Whilst one tends to think about the brush as a painting tool, Cozens, Turner and Rubens all used ink to make tonal brush drawings of landscape. You are dealing with transparency and opacity, and depending on the medium, soluble or waterproof materials.

Washes can be altered by dropping material into them, salt particles create interesting textural effects, coffee granules another. By wetting the paper first with white spirit, the wash is repelled, creating more marks. Candle wax and oil pastel will repel water-based inks, dyes and paints. Placing tissue paper or kitchen paper into the wash will create textural marks as will the use of sponges, cloth and scrunched up paper to dab paint onto the surface.

Experiment with combining and opposing different qualities of mark and media to describe both the texture and tone of the objects and spaces in the landscape, as well as enhance your drawings, creating both space and dynamic tension.

You might consider the idea of different qualities of media combined in a single drawing. Don't follow the rules that you think exist. Find your own way of drawing the landscape and enjoy the freedom the landscape presents.

A round can produce a fine delicate mark if it is held lightly in the hand and barely touches the paper. Turned on its side, it will produce a much broader stroke. Dragged across a surface with little paint on its tip will leave a very different kind of mark than if it is heavily loaded with paint. Pressed into the support so that the bristles splay outward will be different again.

A flat has a different profile, a wide surface and a thin edge. By working with a single colour and investigating the

The weight of the arm, the speed of the arm, how close or far the brush is from the surface, the texture of the surface itself, all influence the kind of mark made. All of these things have an impact on your ability to render the wide range of textures and surfaces you find in the landscape, sky and water.

potential of each implement, looking at configuration and permutation, you will build up an understanding of each implement's potential. Fan brushes also offer a wide scope of possibilities.

LESSON 24
Mark making tools

Make your own set of mark making tools and explore the marks that they make.

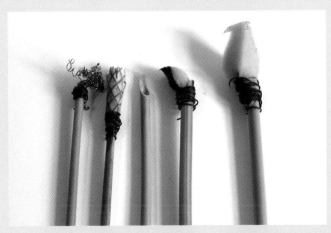

Homemade pens can be made out of many items found in the kitchen: wooden kebab skewers, sponge scourers, J cloths, Brillo pads, anything that can be dipped in ink could be used to make a mark. Here is a range of drawing tools fashioned with a length of bamboo cut from the garden. Wire is used to tie the materials to the end. By cutting the materials to create different nibs and by holding an implement in different ways, using different pressures of movements, it is possible to create a very wide range of mark indeed.

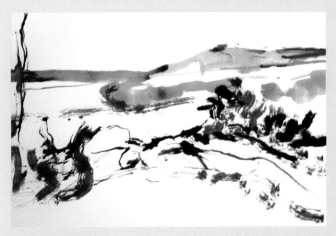

A landscape made with the homemade drawing implements.

LESSON 25
Blind touch drawing

Shut your eyes and feel a branch, touch a bough, stroke a leaf, how does that sensation of touch convert into a blind drawing? Without looking at the paper or the object, but utilizing another sense, this may give you a new insight. Explore the idea of lying in a field or on the edge of a hill with your eyes shut. What do you hear, smell and sense through your whole body? How might that be conveyed through mark making? Try to look at the landscape for five minutes. Think about the information you see before you.

Working with a charcoal, make a drawing of it with your eyes completely shut, trying to picture the image in your mind's eye. Try to use the experiences you have had in the landscape to make something evocative of the experience of

Made with one's eyes shut, the hand moved in response to the stimulus of sounds in the landscape.

being in the landscape. Back in the studio, try to make a series of drawings from these drawings, translating from dry media to wet media, thinking about extending your mark making and use of media.

Music drawing

How would you describe your emotional response to the landscape: angry, calm, relaxed and dreamlike? Emotion might suggest a technique or a particular medium and this will extend your drawing language.

Many composers have been inspired to make music in response to the landscape itself. Try listening to music and finding a way of making marks in response to the sounds and textures of Elgar, Beethoven, Britten, Sibelius, Copeland. Consider the idea of marks which are not descriptive of a sound wave, nor a pictogram of a musical instrument, but are lyrical responses to the stimulus. Shut your eyes, listen to the rhythm of your hand making the mark, and change it to suit the changing metre of the music.

Different juxtapositions of marks create visual contrast, which ultimately create more exciting images.

Drawing over a waxy surface, creasing paper or wetting it first will all have an effect. Use these experiences to broaden and extend the way you make drawings in the landscape. Do not be frightened of 'getting it wrong'; the landscape is a forgiving motif.

Reinventing

As you have already seen from the previous exercises, it is possible to create a wide range of invented marks. But if you are now to use this experience to help develop your landscape drawing and painting, you need to apply this knowledge to some of the visual problems that you will find on location.

Take close up photographs of textures you find in the landscape. How would you make a scribble that captured the essence of different leaves, bark, ploughed fields, hedges and so on?

Consider an avenue of trees, which has different types of tree, leaf and branch. How do you use line to describe these, how far apart should your marks be and what configuration of lines would you use? You might make circular scribbles, oval ones, spiky ones, jagged marks, diamond shaped as well as thinking about their various combinations. Experiment in your sketchbook, trying to recreate these textures, thinking about all the experimentation you have already done. Remember that you are not trying to create a piece of photo-realism, but instead discovering a visual equivalent, a kind of drawing shorthand for that surface.

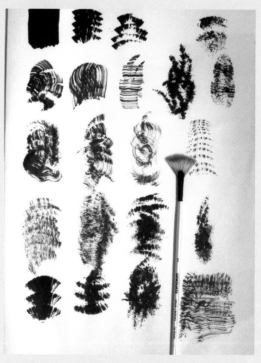

A stiff fan brush has been used to create a range of mark making solutions. Now it would be useful to think which of these might be suitable for trees, hedges, fields and so on.

LESSON 27

Texture and space

Think about something found in the landscape: tree, grass, hedgerow, rocks in water. The closer this is to you, the more you will be aware of its surface and the more detail you will see. The further away it is, the less texture will be apparent and the object may become somewhat flattened in the distance. As you look at everything in the landscape, your eye automatically adjusts to the changing light conditions, putting everything in focus. When you take photographs in the landscape, your camera cannot do this and will instead make a general light reading of the whole scene. On a bright day, a small aperture will put everything in focus but if you try to draw this, you will flatten the pictorial space. So you will need to simplify your landscapes, decide on what your focus is, and what will be given emphasis.

Creating prominent mark making in the foreground with increasing simplicity in the background will be one way of creating the illusion of space. Detail will also draw attention to that object within the landscape. Your eyes will be slowed down, you will look at that area of the image longer so you want that feature to become the main protagonist, a tree in the foreground, a prominent rock or figure, a path leading your eye into the space.

If everything is treated with the same level of detail, then nothing takes precedence and the image lacks visual contrast.

Experiment with this by drawings of the subject, altering what is given more attention. If you use photo manipulation software, you can also do this digitally by experimenting with blur and filters too.

A vocabulary

You can then think about this dictionary of marks and consider how each solution might be applied to a problem in the landscape. How would you make marks to describe moving water or still? The surface of still water reflects the immediate surroundings, so the marks made to represent it actually are marks, which recreate the textures of those things above the water line. Moving water creates ruffles, undulations, which form peaks and troughs. The flat or round might make horizontal or diagonal movements to suggest these raised forms. As the water breaks into spray or foam, another solution might present itself.

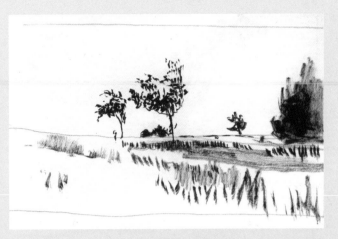

A landscape study incorporating different scales of mark to suggest space and texture.

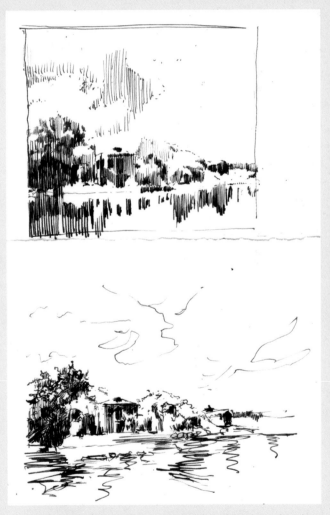

Here, the study is made using just vertical strokes of the pen to describe tone and form. Whilst the line creates a decorative quality to the drawing, the objects within the study disappear into each other.

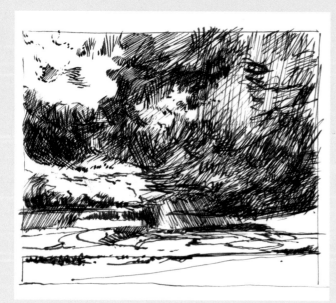

If the mark making becomes overworked, then it might become difficult to differentiate between the different forms in the landscape.

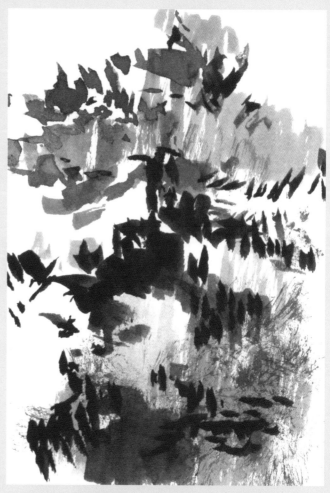

Ink study of tree uses washes of ink to build up mass, and a sense of light penetration through the foliage.

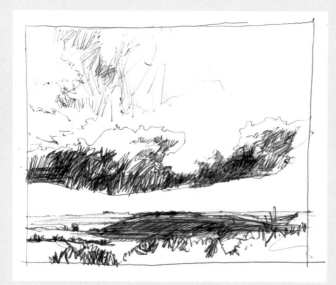

By varying the markmaking, counterpointing intensity with emptiness, quiet against storm, more clarity can be given to the texture of the objects within the landscape and also create a more interesting drawing.

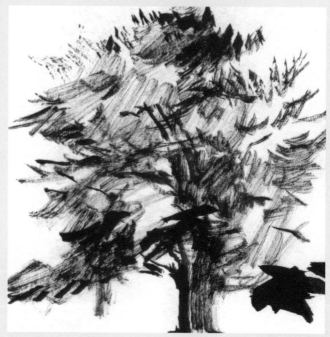

Ink study of trees uses a drybrush technique to create a rougher texture.

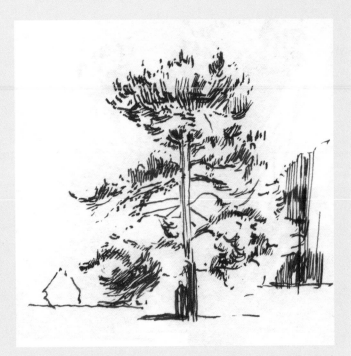

A dip pen used to find linear rhythmic marks in the tree with small curved lines to suggest leaves.

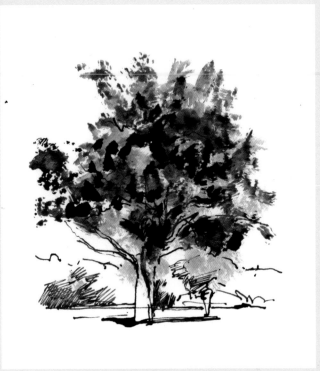

This study combines drybrush, wash and dip pen to the tree.

Trees

Trees differ in size, structure and foliage; close up, they reveal the shape of their leaves so you might want to think about the configuration of brush marks describing a leaf form, but do you use the same marks for those in the distance? Consider the idea of glancing at the subject. Through the corner of your eye, does the tree suggest a type of mark that might act as a visual shorthand for the leaf patterns?

Richard Whadcock, *Ethereal Veils*, pastel on paper.

Richard Whadcock, *Native Ground*, pastel on paper.

Printed textures

Some exciting marks can be made when you draw on a sandwich bag with ink. Place paper over the top and you will get a transfer print. This quality of mark making can be really valuable when finding ways of describing interesting textures in the landscape and more creative surfaces.

Another way of making marks is to use a sponge dipped in ink or acrylic paint. This will create an exciting textural surface. Art shops sell artists' sponges but your everyday kitchen scourer can be ripped and shaped to form an interesting printing device. This could be used as a way of quickly creating the qualities of leaves and bushes. You can work efficiently, changing colour and squeezing the sponge to change its overall shape, making it more tree or rock like. Fabric could also be used to create a printed texture and even a humble potato can be cut and shaped, dipped into acrylic to create a regulated shape, which could be repeated over and over again. This might be a way of creating a forest of similar shaped trees.

Coloured drawing

The use of coloured pencils, oil and chalk pastel builds on both the language of charcoal drawing and of hatching.

Coloured pencils cannot be mixed together to make a new colour (in the sense that a yellow and blue can be mixed together in painting to make a green). You can use a shading technique, applying a yellow on top of a blue or blue on top of a yellow, which will produce a green. The texture of the paper is all important as is the roughness of the paper that will cause the texture to catch the first colour.

Hatching can be used to produce colour by layering a colour in one direction and another colour over the top of that in a different direction. This will create optical colour mixing. It is a good idea to start experimenting with your coloured media on both white and coloured paper, building up a sense of the drawing in much the same way that you started with a hatched drawing, working from the light through to the dark.

The wider your choice of colour, the more you will get out of pastel and coloured pencil drawing. It is worth investing in better quality material, which tends to have richer pigment than some cheaper brands (often containing more fillers and pigment) but with all things, gain confidence by limiting your choice and experiment with the combination of a few colours at a time. Once you are familiar with what colours you can achieve, you can then think about the marks you use together or overlapping each other to describe texture and surface form.

Oil pastels are incredibly versatile and can come in an extensive range of colours. With any pastel, it is advisable to have the largest set possible or to buy a good basic set and supplement this with specific individual colours to suit the kind of palette and subject matter that you are going to work

In this study, you see the initial drawing made in line, establishing the key directions of the sky.

A small amount of colour has been applied, some pink, creams and blues, lightly suggesting some of the lighter and darker areas of the clouds against this blue-grey ground.

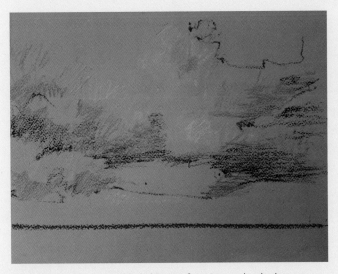

More drawing has been added, this time focusing on the shadow undersides of the cloud, mixing black as well as blues and browns into the cloud masses, still keeping the weave of the drawing open.

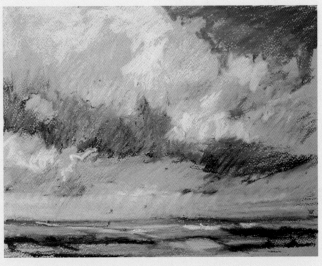

Work focused on the light areas of the clouds again, mixing lighter colours together to form some of the structural changes to the planes of the clouds. Now working with the sides of the pastel, the broad sweeps would mix some of the different colours together, unifying the overall image.

Having established the lightness of the clouds, the sky was blocked in defining the edge of the clouds but also the space behind. Finally, broad sweeps of colour would establish the foreground space and the underpinning armature of the hedges and hills.

from. For instance, some extra greens and greys are useful for the landscape. The main reason for this is that unlike paints where you can mix incredibly subtle transitions between one and the next, the colour of your pastel can only be modified by drawing another pastel over the top of it just like coloured pencils. You will not have the incredibly subtle range of colour transitions, unless you have those transitions in the pastels themselves. Oil pastels are dissolvable in white spirit so they can be applied to paper and then mixed with the addition of solvent. This gives you a range of different kinds of mark

making possibility and blending. As with any coloured media, it is difficult to judge and balance the colours in your composition until you have placed all of your colours side by side.

This is particularly true when working on white paper, so it is a real advantage to make your pastel studies on coloured paper and it is worth buying specialist pastel paper as it has a subtlety of colour as well as a good texture or tooth to hold the pastel. This texture needs to be retained for as long as possible so it is better to begin drawing lightly, building up the intensity of the colour gradually in layers.

Chalk pastels can be used in much the same way as charcoal and compressed charcoal; depending on the brand, they can vary in softness, can be applied with the side of the pastel, rubbed in with the finger, erased with a rubber and you can produce more subtle transitions of tone with a paper stump. Chalk pastels, like compressed charcoal, are water-soluble and can be combined with water to create washes or used to draw into wet areas, so they can be combined with watercolour or other water-based media. Have a look at Len Tabner's paintings, which utilize this approach.

In recent times, there has been a great extension in the number of coloured drawing media, some of which are water-soluble, some larger in size. Consider your budget but be experimental always. Think about the scale of your drawing in relation to the media.

We will talk more about colour later on in the book but for the moment, don't assume that all grass is the same green and all trees are the same colour.

By combining tonal techniques and mark making with your colour, you can open up a whole field of enquiry and this will enrich your drawing. Large areas of an image can be blocked in with collage, or the use of a soft brush with watercolour or gouache. Drawing media can be layered on top, defining the form, space and the texture of the landscape

LESSON 28
Copying others

Materials
- Artist's research
- Sketchbook
- A range of art materials
- Ruler
- Pencil
- A4 coloured card
- Scalpel
- Cutting mat

Small drawing studies of Van Gogh, Antonio Lopez Garcia, Roger de Grey and Andrew Wyeth.

We learn to speak by listening and copying the sounds that our parents make. Overheard conversation develops our vocabulary further, the television exposes us to even more. From books, we learn the formation of words, spelling, grammar and how they are put together in sentence structures and paragraphs. We learn different approaches to writing: poetry, prose, short stories, essays, reviews and novels by reading what has already been written.

We learn to play music by copying what has already been composed, so it makes sense to look at the history of landscape drawing and painting, not as something beyond your reach, but as a repository of images and ideas that we can borrow from.

Look at artists' interrogations of the landscape. Find as many examples as you can and really analyze them in terms of mark making. Rembrandt, Rubens, Watteau, Whistler, Bonnard and Graham Sutherland are a few that will get you started, but consider Chinese brush painting, Hockney, Tabner

Small ink wash study based on Ian Simpson.

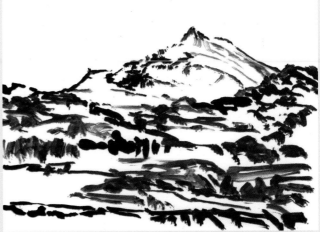

This is a study of a drawing by John Cozens, who produced abstract blot drawings that suggested and evoked the idea of imaginary landscapes.

and of course, Van Gogh. Think about the marks they use and how these function within their drawings and paintings. Take what you want from their work but apply it to the problem that you see in front of you. Like a magpie, you will eventually accumulate your own handwriting.

Turner's drawings of landscape are equally worth viewing, his tiny sketchbooks reveal small economic studies more like notes based on the landscape rather than detailed topographical images, compared to Ruskin's meticulous analysis of the space. His beautiful studies in watercolour reveal his keen eye for detail.

As much as possible, look at other artists' landscape studies, compare the relationship between their drawing and painting. Is there a similarity or a profound difference? What kind of marks do they use, are they drawings on white paper or coloured paper? Are they using watercolour, coloured pencils, pastels, or pen and ink? Look at Rubens's landscape studies or Rembrandt's and think about how they used the brush, the etching needle or red chalk to describe the different textures of the trees.

There's something to be said for sitting there with a sketchbook and carefully studying a Van Gogh, trying to make a copy of it. You don't have to copy the whole drawing, you can place an aperture over a section of the drawing. Using the aperture will enable you to be more selective, looking at small areas of the drawing so that you can focus on the vocabulary of marks. Perhaps you should also consider the intention of a Van Gogh drawing; he was making observational drawings directly from the motif and then taking those drawings back to the studio and using that drawing to translate into a painting.

Patrick Symons's drawings can be incredibly enlightening, a copse of trees has superimposed upon it the underlying geometric configurations that he found within that space. They are compelling drawings because we see someone making sense of the landscape. Symons was taught at Camberwell by some of the Euston Road painters. The group was formed in 1938 by artists who either taught or were teaching at the Euston Road School of Drawing and Painting: William Coldstream, Rodrigo Moynihan, Claude Rogers, Lawrence Gowing and Graham Bell. These artists reacted against modernism and some of the more avant-garde movements of the early twentieth century. Instead, they were obsessed by the idea of pinning reality down as they saw it. Coldstream himself was involved in the mass observation movement (1937–1950s) and at one point was a documentary film maker.

In *Hickbush with Water Pump*, there are a series of three drawings, which shows an equally casual approach to shading, blocking in areas of the drawing with a fairly uniform grey tone. The marks do not really describe a sense of form, instead, suggest a flat shape and this is certainly seen in George's painting too.

Patrick George, Symonds's senior by one year, was also a student of Coldstream at Camberwell. George relayed a story about his experiences there.

PG: Coldstream was someone who showed the eccentric way. I remember some of the things he did teach me and for some reason I was taken in by them… I do remember sitting on my donkey and Coldstream coming up, sitting behind me and taking out his Indian rubber, looking at my white sheet of paper and the model was standing up on the throne and she looked like she would like to sit down. So he then started to make just little marks and after what seemed a long time to me (of course, I wasn't very old so it seems like a long time), he drew back with a puff and said, 'Well, you've got to finish it off now'. Of course, I could see there was plenty of finishing off to do, there was hardly anything there… there was no one as potent as Coldstream. I've never met anyone who could seem to say something, which was obviously… absolutely right, but why these funny little pencil marks did it, I don't know.

PT: When we talked about ways of drawing, you talked about the fact that you were never interested in shading.

PG: Yes, that's right.

PT: Are you more interested in delineation of shape?

Hickbush – Pylon, 1975. (Courtesy of Browse and Darby Gallery)

In *Hickbush – Pylon*, George makes a pencil sketch on what appears to be an O Level exam piece of paper (they were marked with the exam board, schools, student name etc). The drawing appears almost casual, a series of overlapping lines, flicking across the shapes of the bushes, Pylon, hills in the distance, to establish the rhythmic configurations of shape found in the space.

PG: I think so. I always feel a bit guilty with shading, as if you are getting away with it.

PT: What do you mean?

PG: Well, you don't have to do it very accurately if the light's on it, you just make a light patch on your board, and that's the light patch done, but it only goes that far. So I think that's all I would do.

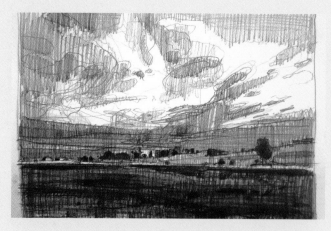

In comparison, a Harry Stooshinoff pencil drawing uses vertical and diagonal hatching, varying the weight of the hand to create different tones. These lines create an overall rhythm to the drawing, which suggests Stooshinoff is more interested in the pattern of the landscape rather than its texture. This is born out with his use of collage, combined with paint, which reduces the landscape into a series of colour planes, modified with a small number of painted marks.

There is very similar quality found in Keith Vaughan's drawings from the mid 1950s. Here, too, the landscape is simplified into rhythmic shapes and tones, which later become the block like landscape oils he made in the studio. These are quite different in flavour to the drawings he made in pen and ink in the mid 1940s. These drawings share a common vocabulary of mark making with Jon Minton and Graham Sutherland, who all used a dip pen as well as a brush dipped in ink to create a wide variety of textural marks, creating stark decorative illustrations and drawings. Look at artists like Graham Sutherland, John Piper, Edward Middleditch, Keith Vaughan, Samuel Palmer or William Blake. Think about their language and appropriate these marks to find your own way of describing the various textures of landscape.

DRAWING ON LOCATION

When I go out and draw, I'm always searching in the drawings
for a way through my painting. Sometimes my paintings rely on
certain things but my drawing is a way of discovery in a particular
place so I would go around with materials that are quiet and
portable so sketchbooks, charcoal, that sort of thing. The drawing
allows me access to the place, to become familiar with the place
in all different sorts of ways so I will draw many different subjects
I might not choose to paint but they are there and they allow me
to make evaluations and decisions about how I progress through
in terms of painting. My drawings are very important to me, I
absolutely love drawing; it just provides me with such a direct
approach to the subject where I'm not forced to think about
colour and form in the way that you do in a painting. You've
got to find a language in drawing that allows you directness of
looking and responds to things quite quickly. In my paintings,
there is the addition of colour and texture which comes in supply
but essentially, my approach is quite similar in that I want to
respond directly as I can to what I am seeing and I put that down
in the same way that I would make a drawing. Other elements
that come into play are the negative spaces in a drawing that
have to be filled in with a painting and I have to work through a
period in the painting where the elements of the drawing come
back into it. There are a lot more things to think about in painting
and hopefully, I keep that energy and fun and liveliness in the
paintings that come through my drawings. Drawings always
spark that, I always start with drawing as an activity to find a way
to allow myself the courage to make paintings. With the same
sort of bravado.

 – David Atkins

Something very similar again can be seen in Nick Bodimeade's drawings.
These rapid black marker pen drawings delineate the shape and tone of
the big planes of minor B roads dotted around the country; their titles
simply the number of the photograph given by the camera.

'The turning of space into marks on a flat surface which in turn become
spatial again. This seems to unite the two disciplines for me, otherwise
they are very separate. My drawing tends to be diagrammatic and
functional, I don't want it to compete with or take energy away from my
painting.' Nick Bodimeade

Only through experimentation and risk taking will you find
new solutions to the problem. You can also consider the idea
that if a drawing or a painting is made up of the same kind of
marks, it can become visually stale. The diversification of mark
making can create interesting rhythms, patterns and textures
within the landscape that begin to create exciting images in
their own right, as you consider the drawing or painting that
you're making in formal terms.

All of these things will give you a much greater insight into
how you can develop your own visual language. You learn to
speak by listening to the words of others, you learn to draw by
looking carefully at the marks that others have made and why
they have made them. These will ultimately inform your own
vocabulary and develop your understanding, not just how to
draw, but why you might use drawing to inform your painting.

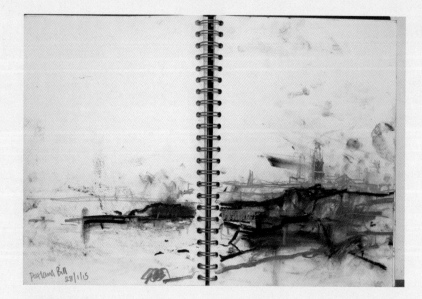

David Atkins, *Portland Bill Sketchbook.*

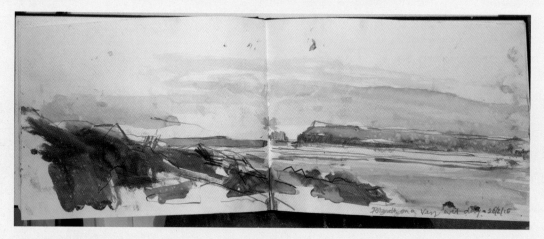

David Atkins, *Polzeath on a Very Wet Day Sketch Book.*

Intention

Once you have the confidence to make some marks on paper, you can also start to think much more seriously about why you are making your drawings and how you are using them. Think about what the problem is you are trying to solve and try to find the solution. If you are working directly from the landscape in black and white, how do you record colour? Maybe there is a way of recording this information through mark making, which may describe different colours so that your drawing is not just describing the textures of space in the landscape but may be exploring something else too. William Coldstream made detailed annotations on his drawing to better understand the colours he saw, so that they could use that information in the studio afterwards.

There are no hard and fast rules and by investing time making work, reflecting on what you have done and how you have interpreted the landscape, you may begin to see common threads of interest emerging in your work. You should

also do the same by looking at the work of the artists you particularly admire. Is there a general approach, a quality that connects them together?

You might be interested in creating a visual depth, the illusion of a space that you can mentally enter into and wander through. You might want to create a sense of atmosphere, a mood, the spiritual uplift of the landscape, the sense of the sublime, or the majesty and sense of awe one has in front of a vast space. You might be more interested in the decorative, finding that the patterns, shapes and colours of the landscape intrigue you more. When you begin to understand more fully what you are interested in, you can begin to clarify how to respond to the problem. In order to do that, you might need to make a lot of work first, challenging your approach to find out how to solve the problem.

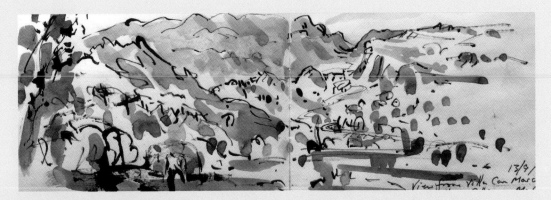

David Hayward, *Mallorca 2*. Working from direct observation, Hayward responds to the variety of textures, surfaces and light of Mallorca by using a range of marks made with a brush and a dip pen.

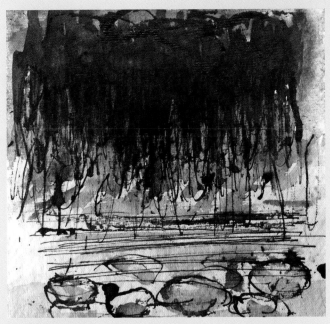

David Hayward, *Weather Drawing 3*. Motifs, shapes and configurations of patterns are synthesized to put forward the idea of landscape, evoking the mood and the atmosphere of place.

Lands End. Trevor Sowden has used the lino cutting tool (a gouge) to make a variety of cuts in different directions and thicknesses to describe texture, land mass, light and space. The varying width, proximity and direction creates a visual rhythm as well as describing form, mass and light.

A number of David Hayward's sketchbooks showing both location-based observational drawings as well as compositional problem-solving drawings.

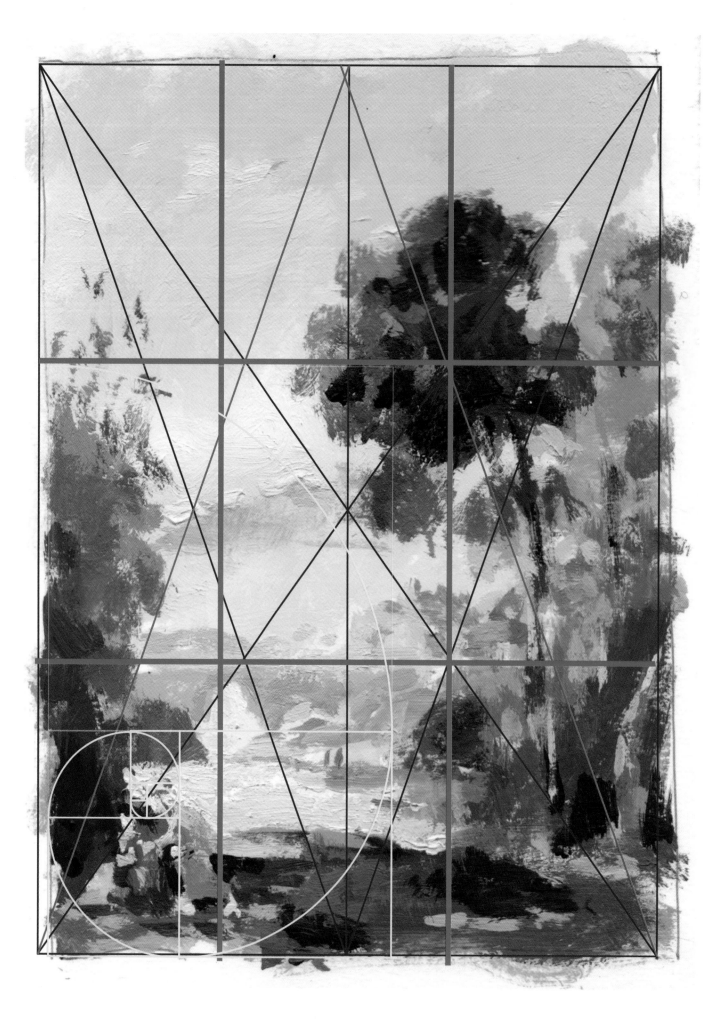

Composition

*Here on the edge of the river, the motifs are very plenti-
ful, the same subject seen from a different angle gives a
subject for study of the highest interest and so varied that
I think I could be occupied for months without changing
my place, simply bending a little more to the right or left.*

– PAUL CEZANNE

WHAT IS COMPOSITION?

If you think about cooking, you have a series of ingredients,
which come together to form a cohesive whole. Composition
is the art of arranging the various elements of the image into
a whole, a balancing act with the shapes, colour, tonalities
and mark making to create a visually interesting, exciting
landscape.

LESSON 29

What is the proportion of the rectangle?

Golden logarithmic spiral

Draw a small square. In the corner, place a compass and meas-
ure the side and describe a semi-circle. Draw another square.
Now open the compass up the length of the two squares and
describe an arc. Draw the new square. Continue this process,
opening up the compass to the next long distance, describing
an arc and making a new square each time.

As the drawing progresses, you create a logarithmic spiral,
which is the same spiral seen in nature, snail shells and seed
heads, and was also used as an underpinning design struc-
ture. This spiral creates a rhythm, a movement to take the eye
through the composition and guide the viewer toward points
of visual interest.

The spiral is created using a simple number progression:
1+1=2, 2+1=3, 3+2=5. Each new square is arrived at by the
addition of the previous two squares, creating a sequence
which is called the Fibonacci Series, named after Leonardo
Bonacci (1175–1250), the Italian mathematician who
was known as Fibonacci. This number series continues:
1:1:2:3:5:8:13:21:34:65 and it becomes interesting to look
at some of the number pairs, in particular, 1×1, 1×2,
2×3, 3×5 and 5×8 which form the basic ratios of off the
shelf canvases.

Painting and compositional study based
on Claude Lorrain incorporating the rule
of thirds and the golden spiral.

Rectangles in different proportions: 3:1 3:2 4:3 5:4.

Take out some thin card and cut out a series of rectangles in the following formats using your compass to give you the proportions:
1:1 1:2 2:3 3:5 5:8.

Look through these viewfinders. Can the landscape fit into these different rectangles and what impact does this have on your images using these different rectangles? Make a series of compositional studies. Consider making the landscape bigger, smaller and also moving the horizon up and down and to the left and right of the rectangle. What happens to the landscape and how do you read it when you change the proportion of the rectangle or its orientation (landscape format or portrait format) and what creates the most visual interest? Make a number of drawings of the same idea but each time changing one variable: format, scale, colour, placement. This is the way that you discover the most visually exciting possibility of your landscapes and it's a really good way of making decisions before you start working on a larger, more considered piece.

The progression of the logarithmic spiral and the Fibonacci series.

The first decision that you make when buying a canvas is what proportions you choose. This can have a significant impact on the success of the painting. It is worth spending time in your sketchbook investigating composition, exploring different permutations of rectangles, so that exactly the same image might be painted on different formats of canvas, yielding significantly different results.

Mathematics underpins many things but one shouldn't be bogged down by it.

The divine proportion

The golden mean was used as way of creating order in a painting or a piece of architecture to create divine order.

It is the division of a line into two parts, where the small part relates to the bigger as the bigger part relates to the whole. It is a divine proportion, was used in witchcraft (the pentagram) and underpins the growth patterns of nature. It's deemed to be the most aesthetically beautiful division of a line.

This mathematical logic might yield an underpinning logic to your work and certainly give you something to explore further in your landscape studies.

Get some photocopies of some of your favourite landscapes and draw over these images using your compass and ruler to calculate the golden rectangle, and see if key parts of the composition conform to this underpinning grid.

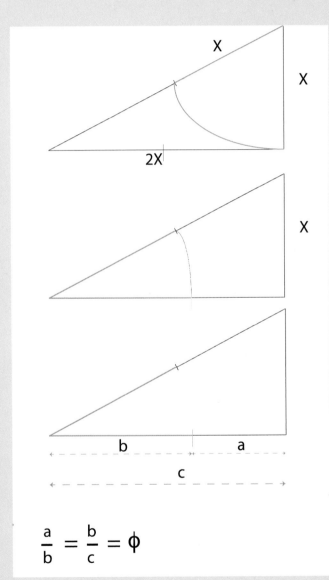

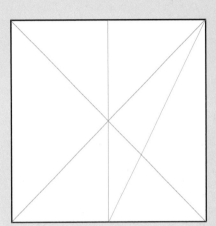

$$\frac{a}{b} = \frac{b}{c} = \phi$$

Calculating the golden mean.

Using the diagonal of a square to calculate the centre and the length of the square diagonal.

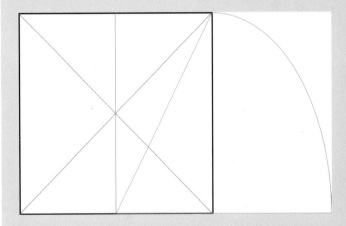

The extension of this length to create a rectangle in the golden ratio.

Divisions

Draw through the diagonals of a square to find its centre. Draw a vertical line through that and you will have divided your square into two rectangles, both of which are in a proportion of 1 to 2.

Now measure the diagonal of one of these rectangles using your compass and bring this diagonal down, to extend the length of the square.

You have now created a rectangle, which is in the golden proportion.

The analysis of this study, after Morandi used a gridding system, is to allow you to realize that he placed key parts of his compositions on these mathematical divisions. The underlying geometry of art has been well known and is a key component of guiding the eyes around the rectangle in such a way because it points you in the right direction. The Euston Road artists became fascinated by recording reality and finding the underlying logic of the observed world. Uglow's paintings were informed by mathematics and so too were the drawings and paintings of Patrick Symons. Symons was interested in finding the underlying geometry of nature, but he was also fascinated by perspective.

Understanding the golden mean will help you in your exploration of composition. The division of rectangles into diagonals will yield discoveries about the placement of objects within the landscape and where that is placed on your canvas.

Study based on a Morandi landscape.

LESSON 31

Root rectangles

If you measure the diagonal of a square and create a rectangle in the proportion of that diagonal to the height of a square, you create a rectangle, which is in the same proportion as A paper. This ratio is based on root rectangles. The length of the diagonal is found by using Pythagoras.

$A^2 = B^2 + C^2$
$y^2 = x^2 + x^2$

If x equals 1, then $y^2 = (1)^2 + (1)^2$
so $y^2 = 1 + 1$

which means that $y^2 = 2$
so $y = \sqrt{2}$

So A paper is in the mathematical ratio of $1 : \sqrt{2}$. If you now measure the diagonal of this rectangle and create a new one, you create a rectangle in the ratio of $1 : \sqrt{3}$. If you continue to do this measuring of the diagonal, each new rectangle creates yet more root rectangles : $1 : \sqrt{4}$, $1 : \sqrt{5}$.

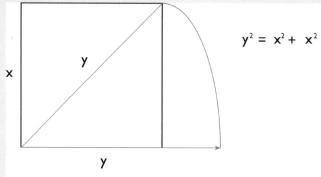

Root 2 rectangle.

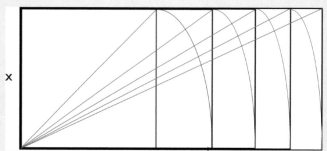

A series of root rectangles.

If you fold the short side of some A4 paper over and line it up with the long side, you will have created a triangle of 45 degrees. If you place the diagonal against another sheet of A4, you will see that it is the same length as the long side. If you think of a square as having the proportion of one by one, the next logical rectangle might be based on the proportion of two squares as one by two (1: square root 4) and you can also have a one by three and one by four. These long thin panorama-type formats, of course, are more suitable for landscape paintings.

Experiment with these other formats. On a smaller scale in your sketchbook, experiment with a series of compositions using rectangles derived from the diagonals of the previous proportion. Start by exploring a square format, then use your compass to find the length of the diagonal. Now make a new composition using the diagonal length as the longer side. Repeat this exercise a few times, considering whether your rectangle should be portrait or rectangle.

Placement

Composition is the art of placing parts of the subject in the rectangle to create a visually interesting image. You have already explored the placement of the horizon in some of the first exercises you did. When you move the horizon, or the junction between the land and the sky, where is your focus?

Repoussoir was a compositional technique where an object is placed to the right or left in the foreground that would direct the viewer's eye into the composition by bracketing (framing) the edge. Claude uses it in *Pastoral Landscape with a Mill*, (1634), as can be seen in this study of the painting.

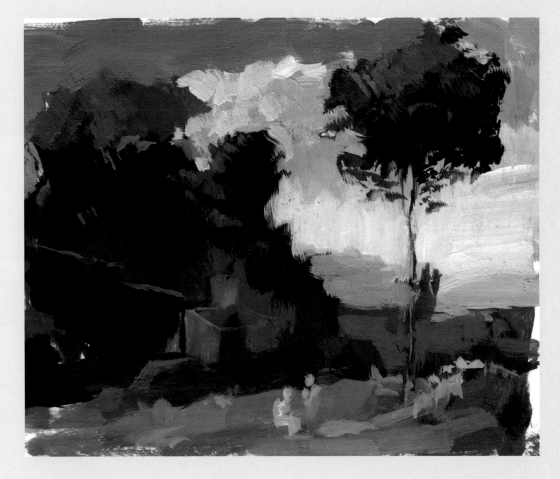

Rule of thirds

The viewfinder of most digital cameras has a grid on the back, which is a series of nine boxes. The rectangle has been divided into three vertical divisions and three horizontal divisions. The union of these two lines create powerful intersections and the notion of the rule of thirds is that key aspects of your composition are placed on one or more of these points. Explore the rule of thirds in your composition. Consider where the horizon might line up, where a tree might be placed, or indeed some other point of focus in your painting (a figure in the landscape?). If key elements of your composition align to elements in this grid, you will create visual interest, especially at their point of intersection. Placing the key elements dead centre within your picture will create a static image. When you think back to your very early experimental imaginary landscape studies, dividing the rectangle perfectly in half creates harmony, balance and calm. Lower or raise the horizon and the centre tries to pull back the horizontal line to the middle.

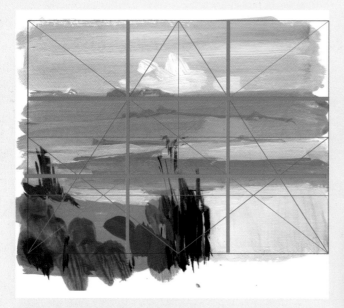

In this study, made after Henry Twachtman's *Arques-la-Bataille*, it becomes immediately apparent that the composition is based on the rule of thirds.

Taking the same photograph and cropping it in many ways, using different formats of rectangle, will really help you see the compositional possibilities of the same view.

Compositional principles

Materials

- Camera
- Sketchbook
- Drawing materials

Find a suitable location and experiment with taking as many photographs as you can, considering the options above. Your task will be to see how many different versions of the same subject you can photograph. Once you have captured these, make a series of diagrammatic drawings, thinking about which images work best.

When confronted with the landscape, what is your point of focus? What is interesting about the subject and how can you lead the eye to see this? There is a difference between making a small drawing and a compositional study. Rather like the plans for building your compositional studies, consider the implications of placing the various elements of the subject in the rectangle. They do not have to be detailed; they can be more notational in their quality.

As you have looked at composition in linear terms, it will be equally valuable to consider the use of tonal and colour contrast in the work of others. Seeing an image in black and white can help you see the tonal scheme of the image and photo manipulation software can help you see the contrasts of hue, saturation and temperature to create visual interest.

In John Ruskin's book, *The Elements of Drawing*, he identifies nine laws of composition. Whilst these might seem rather old fashioned, they are quite useful in making you think about some of the ingredients of composition.

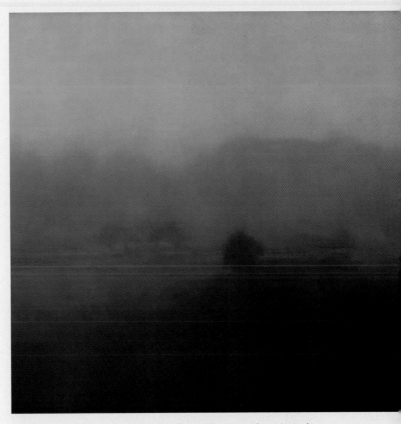

Adagio, oil on canvas. Richard Whadcock provides you with a principal point of focus with the use of the tree in the middle of the painting.

Pond, 1998–9, oil on board. Patrick George utilizes the repetition of vertical reflections in the river to create a visual rhythm.

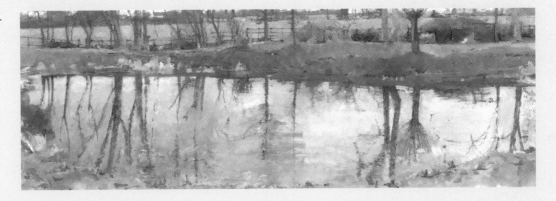

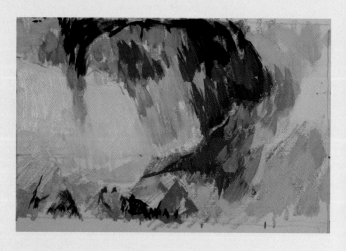

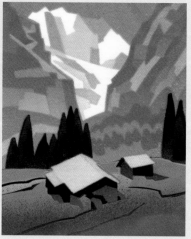

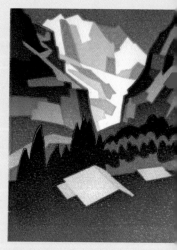

In this lino cut by Trevor Sowden, the strongest point of visual contrast is the foreground building with black walls and a white roof. This lino is cut and printed on two layers, one of which is tracing paper which reduces the tonal contrast of the background space, making them recede.

The movement of the cloudburst in this study of Turner creates an implied pair of circles.

Principality

When you begin with a sheet of white paper or canvas, you have unity, a beautiful balanced surface. Any mark made creates a series of imbalances and the true art of composition is to balance out the opposing forces of the image. So what is the main point of visual interest in your landscape and where do you want the viewer to look?

The placement of these key features in the landscape might be governed by the rule of thirds or the intersection of the golden mean. It might be a tree, a sun low in the sky, a cloud. Look at other artists' drawings and ask yourself the question, where is my eye being drawn to and try to use this in your own work.

Repetition

The rectangle has two verticals and two horizontals. Diebenkorn's *Ocean Park* paintings reiterate the edge, but also create movement against these with the use of diagonals.. The landscape has repeated elements: fields, trees, clouds which create rhythmic movements for the eye to move across the space. The lines of fields going towards the horizon create thin repeated stripes that slowly expand in depth as they reach the bottom of the space. Cezanne and Roger de Grey used the repetition of mark making, short diagonal strokes to create a rhythm to the picture.

Continuity

Ruskin referred to the repetition of forms, which might subtly change across the image; a series of trees or hills receding into the distance, conforming to perspective. But it might be interesting to consider the idea of constants and variables. Why not make more than one version of an image? Why not make a series of landscape studies of the same subject or utilizing the same visual language? Many professional artists pursue ideas through painting, sometimes revisiting the same place, the same scene, many times (think Cezanne). Each new painting tries to find a new nuance, a new variation and something else to say about your experience.

In this highly pixelated version of a Claude painting it becomes immediately apparent that the highest point of tonal contrast is at the edge between the tree and the horizon. The figures in the foreground become both a tonal and temperature counterpoint to the surrounding landscape.

Placing a landscape painting that you particularly like into Adobe Photoshop and significantly reducing down the DPI (dots per inch) turns them into a highly pixelated version, a kind of mosaic of square coloured patches. This produces a simplified map of the composition of the image and makes it easier to ponder how the orchestration of various tones and colours have been put in place.

Contrast

If the arrangement of shapes within the rectangle has a visual impact, then so will the arrangement of tones within the picture.

In the days of wet based photography, a well composed image could be badly printed using the wrong grade of paper. Photographic papers had different paper grades, which corresponded with different tonal scales. The photographer was not just responsible for taking the photograph, they manipulated the image in the darkroom, altering tonality, contrast and may well have cropped the image too.

Now with the advent of digital photography, the image seems to arrive readymade.

Photo manipulation

A digital image can be significantly transformed by altering its tonal range. An image which is lifeless and dull can become much more visually interesting when the visual contrast increases. The junction of light and dark can be another factor in the production of exciting compositions.

It is quite useful to make small scale painting studies of some of your favourite landscape images as this will help you consider the construction of the painting. Made quickly and broadly, you are not trying to make an exact copy, but you are breaking down the tonal values, seeing the big shapes.

These studies have been made in acrylic, using a limited palette of Titanium White, Cadmium Yellow, Crimson, Ultramarine and black with a Sap Green. They were made using a size eight round synthetic, establishing the big areas

In this study after Constable's *Dedham Lock and Mill*, circa 1818, see how the golden ratio spiral creates a movement for the eye, taking it through the composition and leading one's attention to the tree trunk and in particular to the point at which the light begins to break through the trees' foliage.

of colour first, thinking about tonal and temperature masses.

Note how the rule of thirds can be applied to this image with the main junction between the land and the sky resting on a lower third division, whereas the tree to the right, the buildings to the left, correspond to the vertical thirds. It is interesting to note too that the golden rectangle conforms to the line of reflection in the piece and that the distant church falls to the left of the centre vertical line of the painting.

This is a study after John Henry Twachtman, who was an American Impressionist working at the end of the nineteenth century. *Arques-la-Bataille* was painted in 1885 during his time in France.

Twatchman uses virtually no colouration whatsoever, relying on a grey-green palette. The visual interest comes to the juxtaposition of strong visual contrast in the foreground of the image where a patch of reeds reach up from the base of the image into the middle of the painting.

In this study after *Corot, Rocks at Civita Castellana*, Corot has significantly reduced the range of tone and colour in this painting of rocks, with only the slightest alteration of value near the top edge of the hills. This subtle manipulation of tone doesn't necessarily create visual interest, it is through the use of warm and cool colour variations and the use of curvature along the top edge of a pale blue offset against the warmth of the hillside that makes it interesting to look at.

It can be clearly seen in the highly pixelated version where the strongest area of visual contrast is in the foreground. Twatchman uses this to bring your attention to the various reeds in the foreground, which act as almost vertical counterpoints to the various horizontals of the image. Tonal contrast was used extensively during the early development of landscape paintings and can be particularly seen in Claude and early Turner, John Crome, Gainsborough and Constable.

When one half closes, one size all looks at a pixellated version of the Constable. A painting study can be made in this instance as above; the simplification of colour and tonality makes evident much more clearly the powerful triangle which enters in from the left hand side, pointing towards the tree which becomes the central motif of the painting as we have already seen from the use of the golden spiral. This becomes Constable's focus of interest and he's now used a series of technical compositional devices to draw your attention to it: use of composition in terms of the shape, organization, the rule of thirds, the implied movement of the eye as well as strong tonal contrast. The study allows you to see much more clearly the implied triangle which enters in from the left hand side of the painting and has at its apex at the trunk of the tree, the same point that the implied golden spiral finished at. So Constable used a series of compositional devices to focus the eye on his points of interest: contrasting shapes, the rule of thirds, strong tonal visual contrast, all of these elements utilized to make you see what he wanted you to see.

It is important to remember that one is making a picture, not just simply a recording of you whilst one may utilize photographic and drawn research, material watercolour studies, collage experiments. Ultimately, one is thinking about this research and sifting through it, deciphering the relevant information to them to make decisions that will ultimately guide the viewer through your ideas.

Curvature

Ruskin states that curved lines are more beautiful than straight ones. Hogarth pointed out that great image making contained a line of beauty which was sinusoidal in its nature.

Stillness

When the rectangle is divided into verticals and horizontals, the internal shapes become more rectangles. This can lead to a very static composition. Mark Rothko created paintings of stillness and quiet. He wanted something spiritual and contemplative. His shimmering fields of colour hovered above and below the centres, creating whispers; the eye has nowhere to go and instead falls into the void. This idea of hovering above or below the horizon is used constantly by many landscape painters. The amount of figuration within these can vary from virtually nothing at all, like Robert Roth and Eric Aho landscapes, which have a very minimal aesthetic, to the highly articulated topographies, Antonio Lopez Garcia and Andrew Wyeth.

Radiation

When you introduce a diagonal line into the equation, you begin to create an implied movement. As the eye travels along the diagonal, you can move both across the space as well as in and out of it. Two diagonals meeting at a point recede into the picture plane as we have seen in the chapter on perspective. Adding more diagonals cause the eye to move around and through the rectangle and that dynamic creates visual interest. The sea is of course a perfect horizontal line, but the ground is invariably not perfectly flat. The subtle transitions of directions, curves and angles of inclination creates beautiful rhythms and movements for the eye. As the land meets the sky, clouds can form in the sky, creating implied rectangles which create a sense of infinite depth. When the eye is confronted with horizontal compositions, it can create a visual wall for the viewer, almost seeming to be impenetrable. The diagonal offers a way into the space and a mental journey through it.

The introduction of diagonal divisions of the space creates a much more dynamic composition as this creates movement for the eye, a sense of radiation that draws the eye into the image.

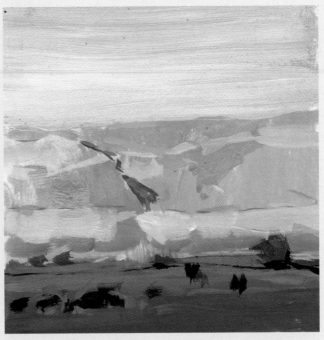

In this colour study of Michael Workman's *September Morning*, the painting uses a near square with the series of stacked rectangles conforming to the rule of thirds. This compositional device is used in a number of Workman's paintings, the stacking of diffused areas of scumbled colour, creating almost abstract fields of colour punctuated by small narrative devices like cows or farm houses in the foreground. The diagonal of the cast shadow in the background hills creates two trapezium shapes which wedge together as well as just opposing warm against cool. Sometimes inverting a painting upside down begins to make you see the painting much more in abstract terms, which in turn makes you think about the compositional devices that have been explored.

The highly pixellated version of the images highlight the contrast of tonality and colour temperature to create visual interest.

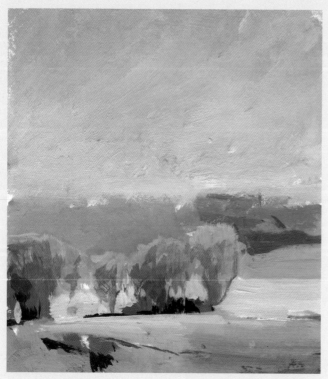

This study is based on a painting by Michael Workman, an American artist living and working in Utah. He describes himself as a contemporary traditionalist and his work often plays with quite formal approaches to composition.

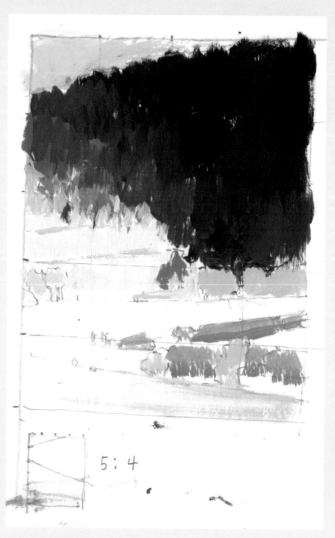

In this study of Chatham's *In Late Winter*, the painting is based on a series of interconnecting triangles where the tree line forms one triangle coming in from the right and the foreground comes in from the left. At the bottom of the painting you can see the small annotation drawing that analyses the image formally.

Interchange

This explores the notion of opposites. A busy area may be opposed to a quiet area, colours may be played against each other or tonal contrasts may be opposed. Itten (*see* Chapter 8) refers to the notion of a contrast of extension. A large amount of green with a small part of red will look very different to a large part of red to a small part of green. This might be the way in which the branches of a tree are dark against a light background, but the bark becomes light against a dark.

Consistency

Ruskin reflects on the way in which the constituent parts of the image come together to create a coherent whole, a painting may be built on a consistent use of colour, based on one hue or a limited palette (*see* Chapter 8).

'Hence many compositions address themselves to the spectator by aggregate force of colour or line, more than by contrasts of either; many noble pictures are painted almost exclusively in various tones of red, or grey, or gold.'

It might also be something to do with the facture, the way in which the artists use a consistent approach to mark making composition or tonality.

Harmony

Ruskin mostly makes reference to harmony in the context of colour which will be more clearly addressed in that chapter, but this may relate to the use of Triad, split complementary or a limited palette.

Another element in your armoury might be mark making. The way you hold your implement, the weight placed on the arm, the intensity of quietness of touch can create a wider range of different marks, which, combined together, create different visual movements for the eye to rest upon. Like a piece of music that counterpoints cacophony with quietness, the changing syncopated rhythms of mark making can allow

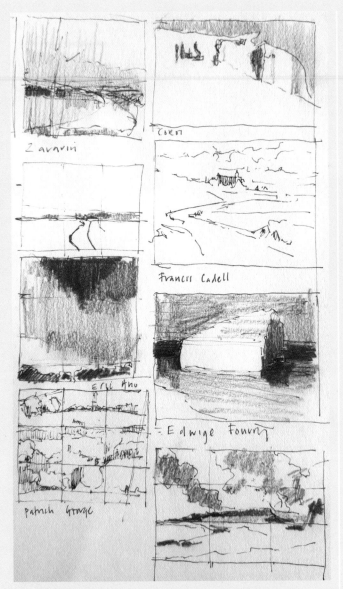

This is a page taken from a sketchbook analyzing the composition of a series of interesting landscapes found on Pinterest. Note the implied curve and diagonal movement of the Corot, punctuated by tonal shifts to prevent the eye from falling out of the picture. The Constable sketch identifies a similar use of the rule of thirds as does the illustration and the image of *Valley Farm* by Patrick George shows how each box creates its own complicated composition.

the eye to skim over the surface of a painting or be held in check. The determination of the mark making, and the force and energy of its execution can be seen to create a series of oppositional forces that counteract one another. Patrick Heron once talked about two massive rocks resting against each other, so whilst they were both experiencing considerable tensions, the overall effect was stillness.

Format

Changing the format of your image can have a profound impact on your work and be quite revelatory. Don't fall into the trap of complacency, stretch yourself, challenge how you approach the composition of the landscape. What about using a portrait format rectangle? If you could photocopy an image, cut this up so that you can see all the positive and negative shapes. Are these all the same or are there differences? Often, good composition is a way of ensuring that each shape in your image is interesting and different, yet their overall effect is to create harmony through the opposition of different forces.

The camera can be an invaluable tool in quickly allowing you to see a range of possible compositions. Are you using a horizontal format rectangle, a portrait format rectangle, a square format or even a Panorama setting on your camera? Each decision will have an impact on how your image is read. Your eye will travel around a square format image very differently from a panoramic one. Largely speaking, your eye will move from left to right through the panorama, skipping through the information contained within. Your eye will tend to travel down through a portrait format image and be more settled in a square one.

A compositional drawing is not a small drawing. It is an opportunity to explore the implication of placing various elements of the landscape in the rectangle. A compositional drawing can take a few moments but solve the problem and potentially save you hours in the making of a painting and realizing that you've placed elements in the wrong position. Remember that the landscape in painting terms can be mutable, objects can change and be moved.

We have talked about the value of a camera, but a camera not held to the eye and instead swung around the neck or held lightly in the hand below eye level will yield unusual compositions, which may provoke new ideas. Some photographs may not work at all but the unpredictable can sometimes inject some new life and invigorate your visual research. Consider the possibility of photographing some of the work you have already made and recropping, finding out how many new versions of the same image you can produce.

You may find that you often compose photographs in the same way, so it can be useful therefore to introduce a strategy to force change. How about photographing the landscape? Shooting at chest or waist height will produce different

Photograph of the Downs.

Getting in closer reduces the space.

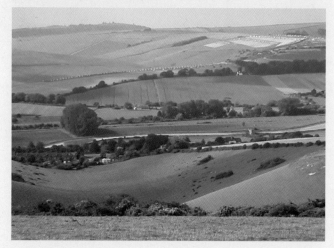

The landscape becomes flatter and more pattern-like as you zoom in.

perspectives and although you might not shoot what you expect, you might be surprised.

The expediency of the digital camera has a significant advantage, allowing you to take many thousands of photographs without worrying about the cost of printing. Photographs can be cut up and collaged back together again to produce new possibilities for image making. It may also be a refreshing reminder to go back to one of those very early exercises where you cut out viewfinders in quite different proportions and place those over the top of your source material. Cutting out two L shapes of card will also give you a viewfinder option that is easily changeable and this can be placed over some of the work that you've already done, allowing you to see new starting points, from images that you thought you had finished with.

So far, we've explored all of these ingredients as separate entities, but now you can begin to bring them together, considering the idea of what you look at, where you look, how much of the landscape you take on board and how you translate that visual impression into an image. Often it's not about changing the problem, but exploring the variations that produce a body of work, the constants and variables. Change the placement of the horizon, consider whether that tree or river moves to the left or the right, change the format.

The more you explore and borrow from the work of others, the easier you will find creating images that move from the mundane to the magnificent.

Many landscape artists develop a formal visual language, which means that one can begin to see similarities between groups of paintings. This might be the repetition of certain formal elements, colour palette, technical approach, compositional devices (i.e. the use of a high horizon).

You have explored a variety of media, techniques and processes, but you are now at a key point where you need to begin to consider limitation as a creative process. By limiting yourself, maybe to a particular format or a particular use of media, you can begin to clarify your intention, to know what you want to say. In much the same as language, you have acquired the formal elements of your visual language, now you can start communicating.

Piers Ottey, *Lone Beech Arundel Park*, oil on canvas, 72 × 92cm.

Piers Ottey, *Houghton Hill*, 2009, in oil, 10 × 10in. Ottey makes you aware of the image's construction by retaining traces of the underlying diagonal grid, as well as providing you with a colour key at the bottom edge of his paintings. This reveals the history of their making and the colour decisions made along the way.

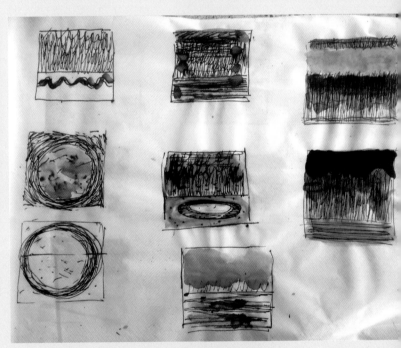

David Hayward here makes a series of drawings that questions the relationship between the various compartments of the colour. One can think about constants and variables, the horizontal and vertical line, the ellipse or circle; as these drawings move these elements around, new ideas form. Rather like a set of raw ingredients, these drawings posit the potential recipes that might ensure. Drawings like these might come prior to the painting, or during the process, as the painting ultimately finds its final form.

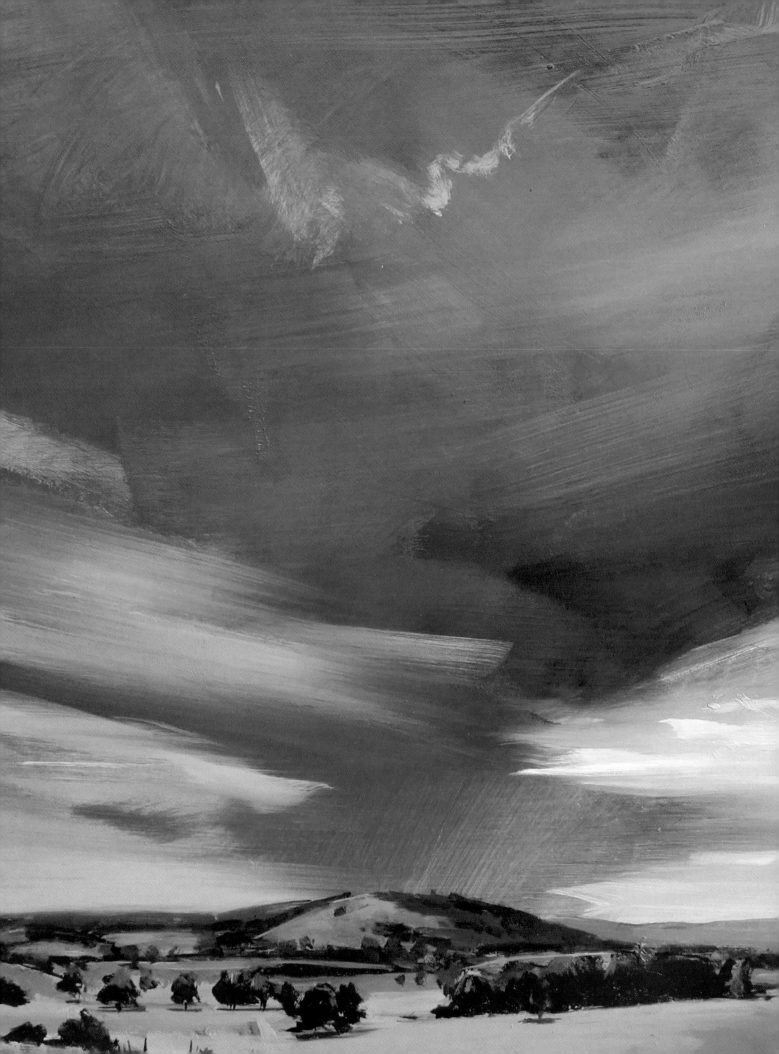

Painting

> *The landscape becomes reflective, human and thinks itself through me. I make it an object, let it project itself and endure within my painting... I become the subjective consciousness of the landscape, and my painting becomes its objective consciousness.*
>
> – PAUL CEZANNE

Why are cooking programmess so popular? They deconstruct the problem, taking everything apart to its basic set of ingredients and then begin to put them back together again. Different cooks do the same thing in different ways. There are lots of ways of cooking an egg.

The same goes for painting and painters. There are many artists painting landscape, many who specialize in it, and some painters who focus on it as a part of their work. The point of this chapter is not to give you a formula, a 'how to paint a Richard Whadcock or a James Naughton'. Instead, it is about finding a way into painting landscape, alluding to the clues to allow you to explore the subject and find your own visual solution.

THE PROBLEM

Painting can be seen as a series of problems and to some extent, we have tackled these already: drawing, tone, composition, colour, material, support and techniques as well as opacity, transparency and the tools themselves. Whilst many people talk about having confidence with drawing, a large percentage of these shy away from painting, finding it too difficult. So where does this come from?

Students' first experience of painting may come from the nursery school and tins of powder paint, large hog hair brushes and sugar paper. Whilst the tins of rich pigment held promise, by the time they were mixed with water (not always successfully) with dry powder floating to the surface, the sloppy paste skidded around the surface, soon becoming mud. Children's paint sets would come in plastic trays, little discs of colour, which did not yield that much pigment when mixed with water; a rather insipid hue would stain the paper, which would soon roughen up or curl.

These memories put students off, make them think that painting is about mess and a lack of control. True, there is a mess, but an organized one, and controlling the paint and the brush is about experience. You have to use paint to find out what it can do, by experimenting with it, by investigating its physical dimension, opacity, transparency, viscosity and by using different kinds of brush, you will begin to discover the right combination that suits your temperament.

Whilst you do not need to spend a huge amount on brushes, as one of your main tools the feel of bristle and its resistance to the paint itself is vitally important. Brushes are often displayed with a small amount of starch at their tip, which will of course hold their point (if they are round). Break through this so that you can feel the tension. Too floppy and you will struggle to move the paint around. There

Oncoming Storm, Cissbury. Oil on Board.

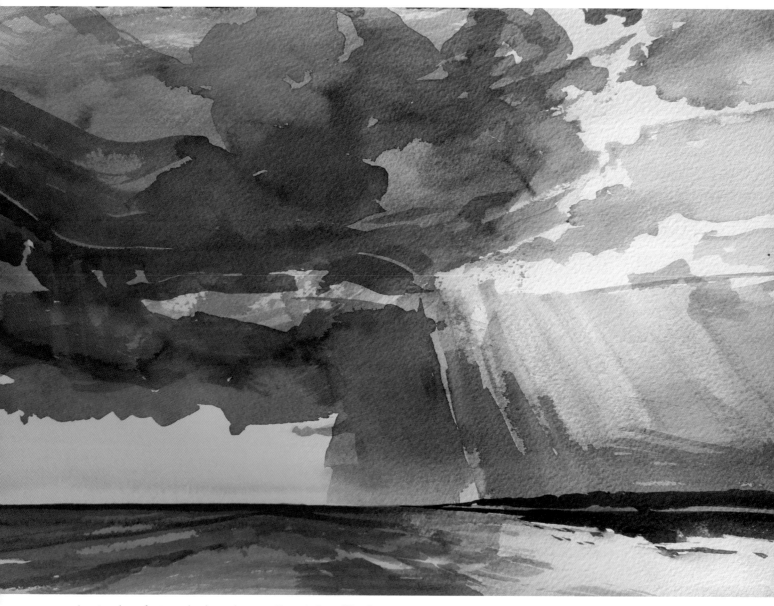

A watercolour of a storm cloud over the sea at Kingston Gorse, West Sussex.

is a co-relationship between the stiffness of a brush to the stiffness of your paint. If paint is used in a watery fluid way, you can use a soft synthetic, but too floppy and the control is lost. The same brushes with stiff buttery Cryla will be a struggle, so you need to investigate the size, types and makes of brush. Some household decorators' brushes can be excellent for impasto and textural paint marks, soft flats are excellent for laying washes, fine rigors are great for detail.

As the viscosity of the paint changes and the brushes change as well, you have to discover the best way of moving the material around and decide whether you're aiming for something see through and luminous, or thickly impastoed and physical. Key to any successful painting is this notion of decisiveness; if a student struggles with painting, it can sometimes be as simple as using the wrong tool for the job.

In much the same way that we referred to mindsets, painting techniques fall into the similar kinds of category. What you are as an artist is reflected in how you make your painting. Experiment, explore, take risks and never be frightened; just scrape down and start again.

WATERCOLOUR: A BIG MISTAKE

For the hobbyist taking up painting for the first time, a watercolour set seems like the best way in. You will generally have all the colours you want, a brush and even a palette. So the outlay seems reasonable, you have got a lot for your money and better still it's small, compact, transportable, just the thing for holidays and painting the landscape that you see there. However, watercolour is the most difficult painting medium to use well as it is unforgiving, allowing you little room for error. You have to mix up the right colour with sufficient water to create the wash you require, get it in the right place and at the right tone first time. It is difficult to make alterations without losing the freshness and directness of the medium and worse still, the brush that comes with the set is usually inadequate for the task.

Trevor Sowden once described watercolour as a draughtsman medium, in that it was so closely linked to drawing and you have to be confident and purposeful in its use. That is certainly true and your drawing practice, especially in line, will come in useful enormously at this stage. This will give you an armature to hang your paint onto. Watercolour is a medium that lends itself to a strategic approach, building from the light through to the dark.

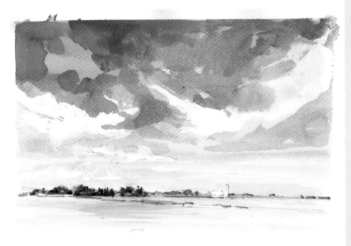

This watercolour of Murano utilizes masking fluid in the sky to create the clouds.

Monochrome study

It is a good idea to create a crisp linear drawing to establish the placement of the key elements of the landscape. Use a HB or B pencil to pin down the main structures of the landscape, creating location to place your colour. It is much easier to paint the large expanses of colour rather than trying to paint around the trees and hills. It is therefore sensible to block in the large sky or a general colour of the land before you start to work in the details.

In many ways, it is useful to work with a single colour and experiment with, adding water, seeing how transparent the colour becomes, seeing how much colour you need to make to cover your paper. By getting the feel of watercolour and producing some monochromes (some brown studies might be useful here), you will be solving quite a few problems. You can see the impact that different brushes have, particularly if you start with large ones and end up with small ones.

Once you have practiced this approach enough times, you can then begin to introduce colour into the equation. Having solved the material handling issues, you can then concentrate much more on colour mixing, and here it is useful to focus on a few colours rather than getting too carried away. One of the key things in your favour is that landscape is a much more forgiving subject than the figure, you can splash watercolour around a bit, achieve some exciting results which allude to the landscapes you paint. Late Turners were made in a highly experimental way, often immersing paper into water and allowing watercolour to move into these puddles, creating atmospheric effects.

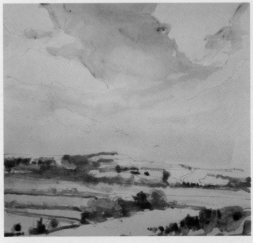

Single colour study.

Masking

When working with watercolour, it is really important to consider the lightest values of your landscape. This might be a cloud, a mountain covered in snow, the light reflected off the water surface. In order to retain the freshness of a water-colour, it is not always possible to paint around these areas so it is useful to consider the idea of protecting the surface of your paper first from the application of paint. This is where masking can come into its own.

There are a number of strategies you can explore here. The first is to make a fairly precise drawing of your subject to ensure that the drawing is crisp in its execution as over excessive use of the eraser will rough up the surface of the paper, meaning that the paint will not flow as well over it (this will yield darker patches). Once the drawing is made, you can then identify where the paper needs to be reserved (kept white) and this may be the point where you consider the application of masking fluid before you start blocking in the washes. Masking fluid is a rubber-based low tack adhesive, which can be easily removed from the paper once it is dry. It can be applied with a brush, but this can clog up the hairs. This can be removed with the application of Vaseline so you might choose to keep a brush for the task. Brushes can also be dipped in washing up liquid prior to dipping into the fluid which prevents them clogging up.

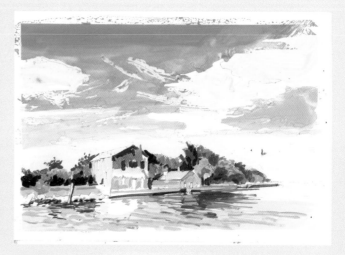

Originally developed as a flexible palette knife, shapers can be used to apply masking fluid with control and the fluid is eas-ily removed from their tips. Made from silicone, they come in a variety of shapes and sizes and can be used to apply paint too.

Experiment with making a watercolour, utilizing masking fluid. It is important to remember to let the masking fluid dry before a wash is applied, and that the wash is fully dried before the masking fluid is removed with the point of a finger or a rubber.

Masking tape

As the name suggests, masking tape was created to mask areas from paint. Different brands have different levels of adhesion which means that they can tear the surface of the paper if they are removed from the paper. Tape, which is a bit too sticky, can have some of their adhesion removed by first placing the tape on items of clothing, sticking it on your jeans can be a really useful way of reducing its tack. Masking tape can be cut with a scalpel or torn which will create landscape like edges.

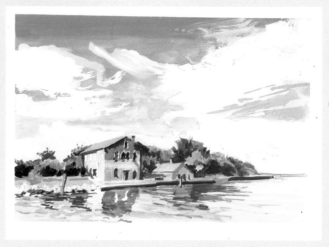

A drawing of Murano has been mapped out in pencil and masking fluid and sellotape have been applied to the drawing.

Larger areas of paper can be protected with paper which then has a thin edge of tape applied to its perimeter, reducing the surface area which comes into contact with the paper. Many brands of masking tape are designed for household decoration and sometimes watery paint can bleed under the tape, causing an unsightly edge. Frog tape is a brand of tape that prevents this from happening, but as with all things, experiment with different brands to find out what works.

Masking film

If you find it difficult to create the blends of colour with wash, then you might prefer to experiment with the use of an airbrush. The fine mist that is produced by an airbrush can create incredibly subtle transitions of colour. Masking film is a clear, low tac adhesive film, which can be applied over the top of your drawing and areas are carefully removed with a scalpel, exposing the paper beneath. Thicker paper or thin card can also be cut to make stencils too, although paint can bleed under these. Paper stencils tend to give softer edges as some of the paint mist blows under the stencil (*see* Brendan Neiland).

Opacity and transparency

Classically, watercolour is used in a transparent state, building one see through layer on top of the other. As the medium is water-soluble, too many layers will result in the colours mixing together to make mud. The colour needs to be laid down cleanly, without too much working the paint backwards and forwards. That is why a small brush is not up to the job, as you end up with streaky watercolours. It is better to have a larger brush, one that is capable of holding much more paint.

A Japanese calligraphy brush will hold a lot of paint but also yields a fine tip, allowing you to create broad washes as well as fine detail. A medium-sized synthetic flat will also help you make washes and broad swathes of colour. Poly brushes or foam brushes can also be useful as well as sponges to lay down washes.

Time is an important factor, in that too much time spent laying down the first strip will allow the colour to dry, so it is better if you can establish these washes quickly so that the paint evenly moves across the surface. If after laying a wash you return back to a drying area and lay another over the top, the new wash collects some of the underlying pigment and moves it, creating a wash back. This can be frustrating or used purposefully to create exciting textural effects in the landscape or sky.

When creating a large expansive wash, it is easier if you tilt the watercolour on a slight incline. That way as you apply a band of colour at the top of your paper, gravity will cause a puddle to form at the bottom of the band. As you apply another band of colour next to the first, this pool of colour flows into the second strip, allowing the paint to move fluidly across the surface of your paper, creating an even tone.

Of course, it is important that you mix up sufficient colour before you start this procedure, otherwise as you mix up a new colour, you will find that the first wash has dried.

This is when it is useful to buy tubes of watercolour, as this will make it much easier to mix a sufficient quantity. If your intention is to create a series of different colours in your backgrounds, then try to mix these first, testing them on separate pieces of paper before you carry out your exercise. It is useful to practice making coloured washes and to see what happens if you cover your paper with water first before you apply any colour, as this will aid the flow of colour across the surface. Sometimes a small amount of washing up liquid can be mixed in, as this breaks the surface tension of the water and increases the flow of colour across the surface of the paper.

Direct and indirect watercolour

As we have seen with watercolour, one approach is to use an underlying drawing to establish the placement of colour before you start painting (indirect watercolour). However, with practice, you can work directly with the paint, drawing and establishing colour at the same time as this will give your watercolours not only considerable spontaneity but great confidence and vivacity. Using a monochrome approach can be useful in gaining your confidence, seeing the brush as a drawing tool rather than a filling in tool.

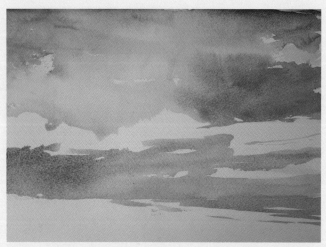

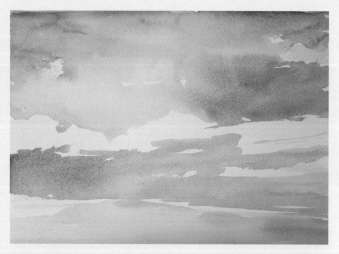

Whilst it is advisable to start with the lightest colours working through to the darks, this particular watercolour didn't start in that way, in fact, it began with some of the darkest colours on the painting. Take Ultramarine and establish the edges of the clouds, working with a broad brush blocking in the big areas of exposed sky then mixing this colour with water and moving the paint around to create the transitions between the top most part of the sky and the horizon, reserving the white paper to create the cloud formations. Having established the blue sky, it is important to move the painting to one side and let it dry. It is sensible to work on four or five watercolours at the same time, that way as you work on one sky, you can begin to work on another and a third and so forth. By the time you have completed the fourth watercolour study, you will then have your first painting dry.

Returning back to the first painting, this time the small amounts of black was added to the palette mixed with a lot of water to create a transparent grey. The underside of the clouds was formed, establishing their mass, weight and position in the sky, gradually transforming the tonality of the underside of the clouds, making them lighter as they reached the horizon so as to create the space. Working water back over the top of the whole sky meant that there would be some run backs (stain marks made by wetter colour moving into the previous colours). However, this alluded to the texture of the clouds in the far stratosphere, soft mutable unformed clouds against a more structured foreground cumulus which was largely described by untouched paper. Blue and black were mixed together to create a soft grey, which was worked above and below the horizon, creating a cloudy sky space as well as indicating some of the sea colour. Next came the beach and this was broadly established with a pale green, and again this was left to dry whilst other watercolours were developed to the next stages.

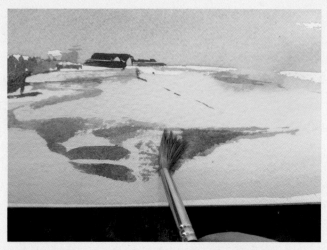

It was important that the next stage in the painting would go on dry paper so the edges would be crisp and clear rather than soft and muted. Now that the vast majority of the paper had been covered with colour (with some white paper reserved for the edge of the sea and some of the big cloud formations) the size of the brush was changed. Working with a small round, the next key ingredient of the painting was to establish The Bluebird Café. This meant using the brush almost like a pencil, delineating the roof and sides of the building. Having established the scale of this, it was then possible to calculate where the pathway would lead from the café along the beach, the lines of trees, the wall and then move on to the beach itself. The brush has now been held at right angles to the horizontal direction of movement and dragged across the beach, indicating some of the structures and shingles that were found on there. As the brush splays outwards, it creates unusual textures that suggest some of the movements of the beach.

The edge of the sea and horizon came next, mixing up a stronger blue-grey; this was painted in one long continuous stroke, trying to keep the line as straight as possible. If you find this difficult to do, then use a ruler, resting one edge on top of the watercolour to raise the other end up so that it forms an inclined plane. The brush tip can then be run along this edge, allowing you to draw a straight line. If the ruler was placed flat on top of the paper, capillary action would cause the paint to bleed under the ruler. Now the brush was turned almost flat to the paper and dragged away toward the right edge. This horizontal movement would indicate the motion of the waves mixing up a green.

Finally, another large blue-grey wash would be added to the space above the cafe and the sea. When one is making a painting, the first decisions of colour and tone are made against white paper and it isn't until the colours are placed that they can be correctly balanced.

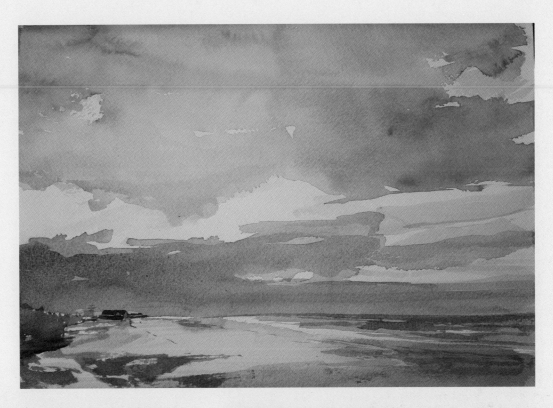

STRETCHING PAPER

Good quality paper is an absolute essential for watercolour. Whilst you can draw on a humble piece of cartridge paper, if the weight of the paper is too light, the surface can corrupt and the paper will deform as it gets too wet. You can of course stretch your paper. This requires gummed tape, a drawing board, stapler or drawing pins, a clean sponge and water. Measure out your paper and cut gummed tape so that is approximately 10cm longer than the sides of your paper. Wet your drawing board with a sponge dipped in clean water and then wet one side and do the same on your paper. There will be a degree of suction that will hold your paper against the board. Pull your paper toward you and leave for about five minutes. This will give your paper a chance to expand. Run your lengths of tape along the wet sponge and firmly press your gummed tape onto the board and around the edges of your paper, so that the tape is equally divided between both. Once this is done, place either a staple or a drawing pin into each corner and allow to dry. As the paper has expanded in size, it cannot shrink while it dries. This means that when a water based paint is applied to it, the paper remains flat.

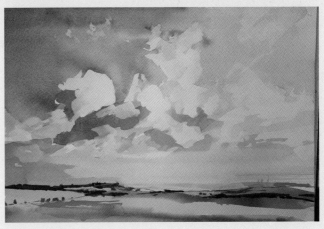

Whilst traditional watercolour relies on transparency and white paper, a derivation of this medium is body colour. Body colour is the addition of white gouache or Chinese white into the mix, which allows you the possibility of both transparency and opacity with your techniques. Rather than working on white paper, you can also experiment with body colour on coloured grounds. This was a preferred way of working for John Sell Cotman and the Brighton based painter, Charles Knight. Coloured paper helps unify the image, allowing you the ability to both darken and lighten your image as well as painting out layers.

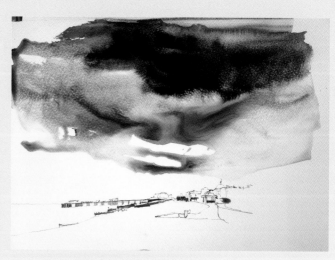

The drawing used a black watercolour pencil to map in the main structures of Worthing pier. It was not important to establish the exact details, but it was essential to understand the proportions of the pier in relationship to the beach and the sky to create a sense of drama and scale.

This scene was a particularly dramatic one with a large heavy rain cloud hovering ominously over the top of the pier, about to burst its contents upon the sea. A large puddle of water was placed onto the paper with the brush moving the puddle around so that it roughly formed the shape of the cloud. A mixture of both watercolour and gouache was created, producing a very rich blue-black. This colour was pressed into the puddle and the paint began to move in its own direction through the water, creating a dramatic statement in the painting.

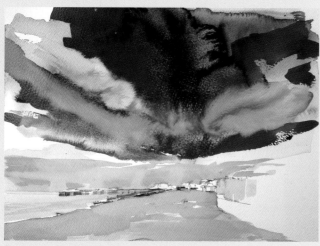

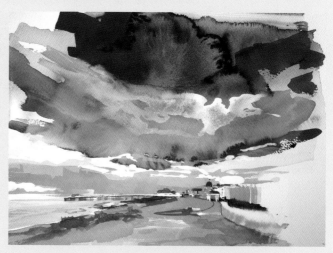

More paint was added to the top most part of the sky, applied with a broad horizontal stroke. This painting was left for a couple of hours to let the colour settle into place. It would be difficult to predict exactly what would happen on the paper, so patience is a good thing with this approach.

When the painting had dried, some of the really exciting passages of paint had been lost, so it was important to re-establish some of the drama in the scene, working back into the sky with both watercolour and gouache, creating more layers above the horizon to establish the muted quality of the sky as well as work some of that colour into the sea. Having blocked in some bright colour for the beach, some of the grey that had been applied to the skyline was also worked into the beach, muting the colour and assisting in the drama of the scenario. Now, more careful painting continued, working on the pier as well as the foreground groins, the beach and some of the beach architecture; shelters and buildings, indicating the suggestion of people huddled in preparation for the oncoming storm.

Two drawings made with acrylic ink of a thunderstorm (study for *Murmur*).

Investing in some good quality watercolour paper is a good idea and it will really help your landscape studies, the paper is designed specifically for the application of watercolour, however, they do come in a variety of surfaces and the surface quality has a significant impact on the quality of your image making.

Designer's gouache, as the name suggests, was originally used by designers to plan artwork for print. The travel posters of Frank Newbould offer a real insight into the way that gouache can be used. Here, colour is flatly applied with crisply defined shapes and edges. His work from the 1930s offers a fantastic richness of colour and a vision of the romantic British landscape.

As a point of note, on a bright summer's day, light reflects off the white paper shining directly into your eyes. This can cause some damage to your eyesight. Be careful and consider the use of polarized sunglasses. Whilst this may alter your perception of colour, it would be much better to protect your sight; the use of coloured paper may be less harmful.

As gouache can be worked in both an opaque and transparent way, you can work with dark colours on top of light and light colours on top of dark. You can work with the paint thickly and thinly and you can paint with it on cardboard, paper and board, but if the paint is applied rather thickly on a flexible support, it is highly likely to crack as it lacks the flexibility of oil paint or acrylic.

With watercolour, you need to be fairly strategic in your application of the medium whereas with gouache, you can work in a more organic way, applying colour to find the landscape. Like watercolour, gouache is water-soluble, so the application of colour will be affected by the colour

Two gouache studies of Venice.

underneath it. Similarly, these colours can be mixed together with the application of water, blending colours together to create subtle transitions.

In this study of storm clouds over Sussex, large areas of colour were applied with a broad Taklon brush blocking in the dense cloud masses. A lot of this was painted wet in wet and the colours allowed to mix and run back to create interesting textures as well as suggest the brooding sky.

The quality of the pigment colours are rich, the tubes small and if left with a lid off, will dry out. Whilst it is possible to use this dry pigment by adding water, it will not be the same as fresh colour from the tube. The scale of these tubes does mean that gouache is a very flexible medium to take with you on location. It is fast drying and dries flat, which makes it very easy to do a lot of studies and take them safely home. You can also work back into the gouache with coloured pencil. The surface takes the pencil well and can be an excellent way of working into the painting with detail, mark making to suggest the textures and forms in the landscape.

Wash media

Acrylic paint can be used like watercolour and gouache. The washes do not flow as well as watercolour, and the colour is not as opaque as gouache. A wash can be created by adding water but the overuse of water will create an unbound paint, so it is more advisable to add medium to acrylic, otherwise some of your colour can lift. Daler-Rowney produce a set of acrylic inks. These are effectively a much more watered down acrylic, which is already combined with medium. The colours are generally bright and come with an eyedropper, making them easy to colour mix consistently. The eyedropper itself can be used as a drawing tool and can also aid in creating textural effects by dropping paint into wet areas of paint. Their main advantage is that once dried, they become waterproof, which means that many more layers of colour can be added to each other, without any chance of the colours becoming muddy.

Underpainting

There is no doubt that for many people, the idea of landscape painting has its roots in Impressionism, an idea that painting is done in oil, on the spot, on a white canvas and the artists battles the elements, wind and rain, struggling to put down their impression. Of course, in terms of the history of painting, this is a relatively new approach. For centuries, oil painting was approached in a different way.

When one thinks about it, the history of the medium is a history of pigment and how it was applied. Oil dries slowly, some pigments dry quicker than others. Thinly applied colour dries quicker than thicker layers. Mud is everywhere, it is cheap and easy to find, the earth pigments are made from them: Burnt and Raw Sienna and Umber denote places of origin. Minerals are rarer, more difficult to find, more expensive to purchase.

As more obscure pigments were sourced, it was obvious to use it sparingly, so as not to waste it. So artists would work in a monochromatic way, using oil paint that could yield a wide variety of tones and would allow the complicated problems of drawing, tonal balance and composition to be solved before the problem of colour could then be dealt with.

Underpainting is therefore a simple piece of problem solving, working with paint through a succession of layers. Solve the problems with paint that dries quickly, before moving onto layers that may require more delicate and subtle transitions of colour, tone or surface manipulation.

At the start of this chapter, it was discussed that to understand watercolour, it is advantageous to work with a single colour first, to explore the opacity of the material and how much water needs to be added to the paint to enable it to flow, cover an area or create a particular tone. If one is working with opaque painting, invariably the drying time increases as there is simply more paint to dry. So with underpainting, there are techniques where a single colour is applied to a support and the opacity of it creates a range of tones, and there are others where white paint is included in the mix.

Experiment with underpainting techniques, utilizing *bistre*, *verdaccio* and *grisaille* before overpainting them with glazes once dried.

Underpainting medium

Acrylic and egg tempera can be used as an underpainting medium for oil paint, which provides a very fast drying layer. Acrylic dries to a waterproof layer so it could be used under watercolour or gouache, and you do not have to always work on a white ground. Egg tempera would need to be sealed with a layer of Liquin before the oil painting commences. Acrylic does not need this, but if the acrylic has been applied directly to a support that has not been primed, the varying densities of paint may cause uneven sinking of oil paint, leaving patches. This can also be alleviated with a coat of Liquin once the oil is dry, but it is important to remember that Liquin is not a varnish. Varnish should be applied six months after the oil paint has dried.

Bistre study of Fulking in oil on a mid-toned 220gsm paper prepared with a layer of acrylic.

Bistre relies on the opacity of brown to create the image. This is usually applied to a ground that is not that absorbent, allowing it to be wiped away. So Raw or Burnt Umber make suitable choices and as they are fast driers. Black can also be used and can be applied in the same way, or mixed with white. This is referred to as grisaille, which means grey. Yellow Ochre can be mixed with white and black paint and this is referred to as verdaccio, but in fact, you could work with any dark colour, blue, green, Paynes Grey, to enable you to construct a tonal underpainting. The underlying colour needs to dry before successive layers are built on top, and this colour will have an impact on the overall feel of the work. Underpainting is not a technique that is just used in oil. You can make an underpainting in acrylic ink, acrylic, watercolour, gouache, egg tempera and so on, but not all mediums are insoluble when dry.

Oil colour is now being worked into the study, blocking in the big colour masses.

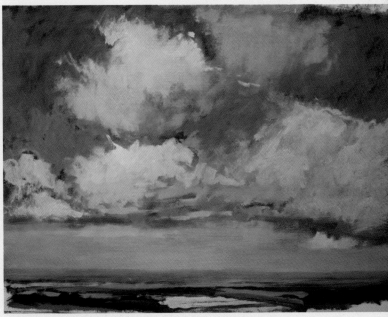

The final layer is scumbled over the top to achieve the diffused quality of clouds.

LESSON 38

Oil painting

Materials

- Titanium White
- Mixing White, Lemon Yellow, Cadmium Yellow, Cadmium Red, Crimson, Ultramarine, Cobalt Blue, Cerulean Blue
- Liquin
- Roll of cellophane
- Kitchen roll
- Brushes
- Palette
- Knife
- Paper of canvas board support
- Gesso primer

For the artist painting in the landscape, the advantage is that you have time to modify and change your painting as the weather conditions alter. It is easy to make changes to your painting as the surface remains wet during the whole duration of your painting session. Because light changes so much over the course of the day, it is advisable when working *plein air* to have a number of paintings on the go at the same time. Each painting would last a maximum of one and a half hours, ensuring that during that period of time, the light or weather conditions remain relatively consistent. The colour that can be mixed with oil painting does not change its hue or tonality as it dries, so it is much easier to capture the true likeness and the variety of colour in front of you. However, as your paintings are still wet for days, the transportation of wet paintings can become problematic, unless you use something like a pochade box, which will keep your wet paintings separate from each other. As oil and water repel each other, it is also an incredibly useful medium to work with when it's raining.

A general rule is lean over fat, or put another way, faster drying paint underneath slower drying paint. So if you are working in a layered manner, starting with an underpainting of the landscape and then overworking colours on top, the use of mediums enables you to do this without the problem of the painting sinking in, or cracking. You can work on paper, card, board or canvas, but the absorbency of the support will affect how the paint moves. Unprimed paper will suck up your oil painting, making it quite resistant at first, until the paper is covered. It then slides around. In this instance, your first mark needs to be fairly considered, or you need to get the whole support covered before you start painting in a more organic way, adding and subtracting paint as you go.

Oil does not cause paper to expand or contract, so you do not have the problem with cockling that you get with watercolour.

Priming your board or paper with gesso or a solid layer of acrylic can allow you both to add paint and remove it, rather like a monotype. You can paint with a brush or use rags and even cotton wool buds to manipulate the paint on the surface or completely take it away. You can also experiment with using different coloured grounds.

Produce a series of small landscape studies (approximately 20 × 30cm), working directly from the subject. Try to keep each one under an hour in execution; you will keep your painting fresh and it will allow you to develop a confidence of approach as you get more familiar with your view. Learn from your experiments with watercolour and gouache, investigating transparency, opacity, and viscosity too. Experiment with hog and synthetic brushes, using paint with turpentine, Liquin or other mediums to discover the combination that works best for you.'

Produce a series of landscape oil studies on prepared boards or on paper. Explore a range of brush types and paint applications.

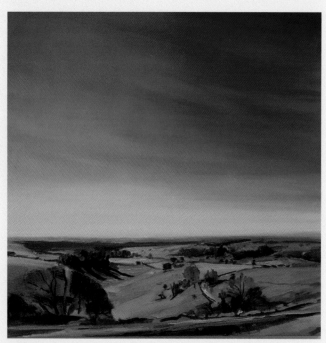

Blue Sky, oil on canvas. Working in the studio requires the use of photography, as well as drawings and memory to develop the work. These were selected from a walk made a day earlier on Cissbury Ring, and another from a few weeks earlier from Fulking escarpment. The sun had this incredible intensity on both occasions and the majority of the landscape was bathed in it. From Cissbury, the view toward Worthing and the sea is channelled by the golf course wedged into a valley. This was a view that had been contemplated many times but had not been attempted before. There are steep inclines and lots of trees dotted around the hill, which, from the left, were casting long shadows down the hill, with the town in the far horizon.

LESSON 39
Alla prima

One of the great advantages of *alla prima* is that everything dries at the same time so there should be no potential hazards with cracking, which occurs when earlier underneath layers of paint dry at different rates to those above. If a board is primed with acrylic or gesso and sanded down, any marks made can be very easily removed with a rag, which lends itself to a more gestural direct approach, adding and subtracting the colours and the tones. If the support is very absorbent, it becomes more difficult to move the drawing once it's placed, so a more precise drawing is a good way to start. However, saying that, paper can be covered with a layer of oil first, and an unprimed board can have a layer of medium applied to it. One thing to consider with oil paint is the notion of touch; carefully place the colour and be forthright in your mark making. That way, you will retain the freshness of your paint and colour. The more the paint is manoeuvred on the surface once it's been placed, the muddier your colour becomes. If that is the case then it is also useful to consider removing excess paint from your image either with the use of a palette knife, scraping away the surface or tonking the painting with the use of absorbent paper. The fact that landscape is so open to interpretation means that it gives you a certain amount of freedom in the way that you paint it. Try to retain the pure excitement of making a painting in front of the view. Whilst it may seem horrible to paint in the rain, the challenge of working quickly and the emotional effect can help create the tension needed to be decisive. The more you work from the actual landscape, the better able you are to reinterpret photographic source material, drawing on your memories and experiences of the location. The more we work, the more we are able to interpret and translate any photographic material into something which has the same excitement. Enjoy the journey.

So if you are working on a white ground, it is useful to build up from light colours through the dark, working quite transparently with your oil paint mixed with Liquin and where needed, Zinc White. This resembles a watercolour approach, building one transparent layer on top of the next, ending with your darkest tone. Working on a medium-toned ground, you can work in opposite directions, working down to your darks and up to your lights. Working on a coloured ground will also unify your pictorial surface, creating an overall colour atmosphere so it can be useful to mix up a colour that is a dominant hue in the figure, for instance, Yellow Ochre, Burnt Sienna or it

Cellophane is a very flexible palette which can be adhered to a non-absorbent surface by lightly wetting the surface and capillary action causes the cellophane to stay in place. The great thing about this is that you can have a large palette but once it becomes filled with colour, it can be thrown away and a new palette quickly created to replace it. This keeps your colour mixtures clean, especially if you are working on a large scale with big brushes. Like the collage exercise, it is straightforward to paint up to 20-gram cartridge with coloured grounds of acrylic, ensuring a reasonable coverage of acrylic is in place. You have a great and inexpensive support to paint on in oil and it will allow you to experiment with different painting techniques and different coloured grounds before you commit yourself to more expensive canvases and prepared boards.

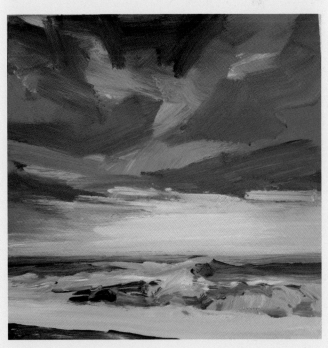

There are moments in the landscape where you become overcome with emotion and awe. Suddenly a dog walk becomes a tumultuous cascade, of sight and sound. On this particular day, high winds whipped up the sea, producing large explosive waves crashing into the beach. Vast plumes of water became vaporous clouds of spray drifting down the beach. With nothing but a phone to hand, these fleeting moments were captured in pixel.

Back in the studio, with the memory still fresh and the salt spray still in hair, the paintings tried to capture the raw energy of these fleeting moments, the grandeur of the sky, the diffused light and heavy clouds as well as finding some way of describing the waves.

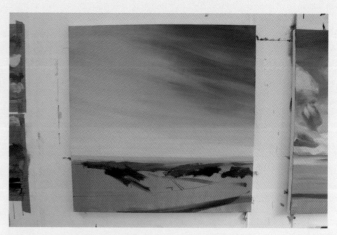

A Lucas mid blue was mixed with Liquin and applied thinly, scumbling colour over the painting. This was very transparent, and almost became a chromatic grey on the orange ground.

Titanium White was added, creating greater opacity to the blue. The paint was worked backwards and forwards, from a light to medium blue transition blending colour in horizontal strokes. As the colour neared the top most part of the painting, Phthalo Blue was added, creating a darker note. With the golf course, painting the transition moved across the painting from light to dark, as well as from top to bottom.

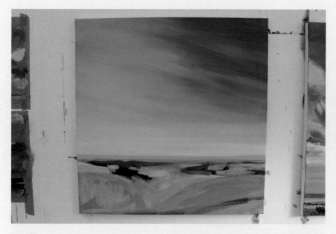

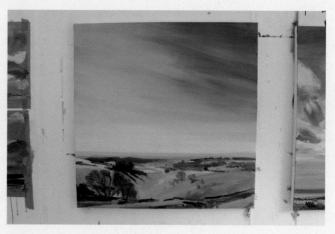

For a long time, the other Fulking paintings continued whilst the golf course painting remained a sky. The valley started to be described with the movement of oil paint being pushed into the direction of the dip. Blocks of colour were used to suggest the land masses and groups of trees and shadows.

More robust areas of paint were trowelled on with a stiff decorator's brush working the paint wet in wet to form the various structures on the hillside.

can be exciting to work with a colour which is a counterpoint colour to the main colours of the landscape. As you begin to make decisions about your ground colour, it is important that your palette has that same ground underneath to help you judge the hue and tonality of your paint mixtures.

If one has the space, it is always advisable to work on more than one painting at the same time. You create a rhythm, where each painting feeds off the last and informs the decisions you make. As you mix a colour for one painting, you can use that colour in another, so although you will use more paint, you will not waste as much. If you work from landscapes with similar lighting conditions and multiple views of the same space, then the colour choices will be similar anyway. The following three paintings were all made at the same time, working backwards and forwards across all three canvases. Each one is 100cm square.

Demonstration paintings: Blue sky and Fulking 1 and 2

The Downs are very steep and once you climb up the escarpment, you get this magnificent view of Sussex stretching out forever. Most of the landscape is quite flat, punctuated only by fields, farmhouses, the village and pylons infinitely receding to the horizon. On this occasion, the winds were strong and brought with them massive cumulous clouds, which were awe inspiring as they hovered overhead. Within an hour, these would transform into one grey mass, which would bring forth a storm seen in the middle distance but not quite reaching the Downs themselves. For the briefest of seconds, a rainbow

The same approach was repeated on another canvas, this time reserving areas for the cloud formations which appear in bright orange patches.

Pale blue-grey was also blocked in above the horizon, establishing a distanced sky. Once this background layer was established, white was then scumbled loosely on the paintings, roughly blocking in cloud formations.

Blue, white, black and a small amount of Raw Umber was mixed together to create a light grey. This began to be loosely applied to the base of the clouds, creating some of their mass. Some of this grey was also worked into the space above the horizon, neutralizing the intensity of colour that was there.

would describe its arc across the sky before fading away.

It seems like a very sensible idea to start with the sky. Working from the top of the painting to the bottom, blocking in the biggest shapes with the biggest brushes, working rigorously and gesturally before refining and controlling the marks, slowing down and being more considered in approach. There would be very little happening in the golf course sky, just a transition of hue. The sky had been the most beautiful blue with the subtlest transition of saturation toward the west. The Fulking painting was much more dramatic with the big clouds and distant storm.

Produce your own *alla prima* painting on a large canvas prepared with an orange ground, using large scale brushes.

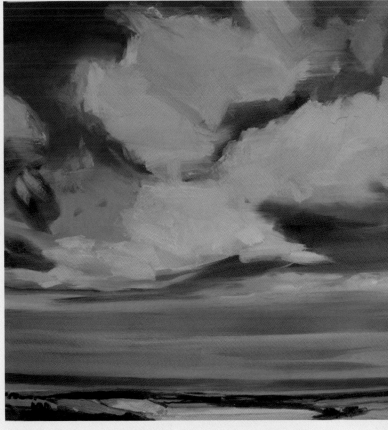

The depth of tone was increased, giving more form to the clouds, trying to keep the mark making direct so as not to lose the vitality of each brush stroke. A mid yellow was added into the mix, creating nuances of hue within the cloud.

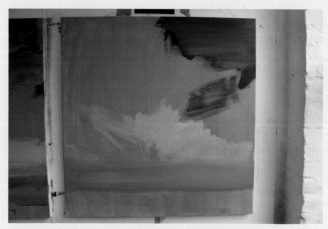
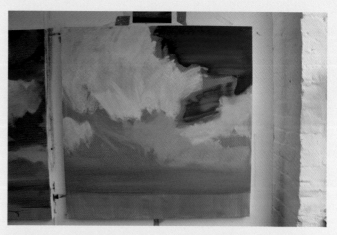

Like the previous two, the painting started with a thin coating of Cadmium Orange in acrylic, creating a bright, luminous coloured ground, which would act as a complementary contrast to the predominant blue-greys to be executed over the top. This was mixed up quite thickly and applied with a large decorator's brush onto a wet canvas, which would make it easier to cover the large area. The initial impulse was to cover as much of the sky as possible with broad marks. Working with a pale blue-grey into this, a wet in wet cloud was created using a combination of Titanium White, black and Raw Umber, trying to establish the darkness at the base of the cloud, which ended up becoming a more gestural series of painting marks. It was important to retain the vitality and direction of these marks as it created a dynamic movement for the sky.

More white was added to the top left, creating an illuminated cloud mass, blending between the two zones of colour working wet on wet to show the sense of soft edge form. Working down toward the horizon, areas of pale blue were worked into the horizon, creating an area of light moving the brush backwards and forwards, trying to create a fairly even transition of tones hitting the horizon line and revealing a recessional space.

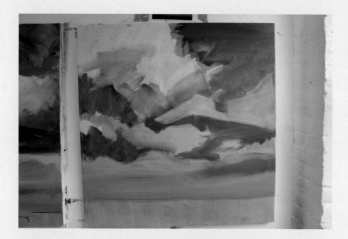

Now yellows were mixed into the pale blue-grey: Lemon Yellow, Cadmium Yellow and Yellow Ochre, each creating different greens, which were initially blocked in with large singular gestural marks using the edge of the decorator's brush rather than the width, and as the base of the painting approached, the width of the marks increased and so too the saturation of the colour.

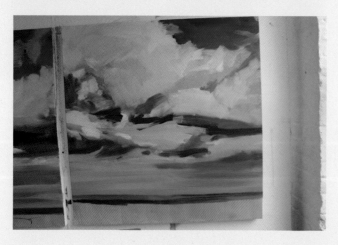

While the painting was still wet, one of the final parts of the session was to work into the paint with bright, sharp strokes of paint to identify structures which exist within the landscape. It was important to establish these loosely without drawing too much attention to themselves otherwise they would become distracting elements within the whole pictorial scheme.

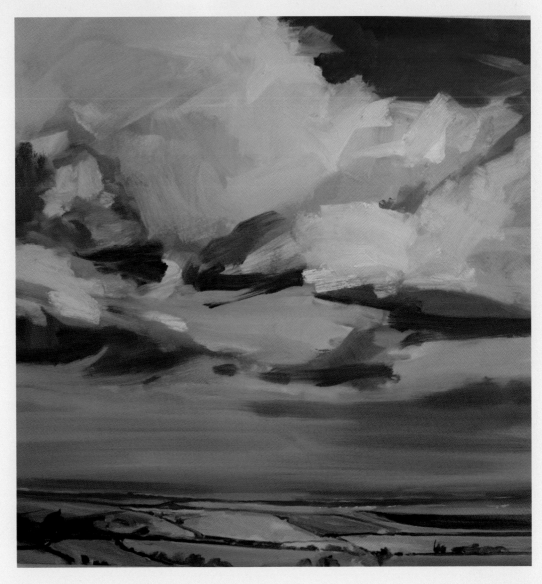

This painting began by preparing a board with another Cadmium Orange ground as with the previous examples. A pale blue was mixed up and applied as a row of dots or dabs of colour. Above this another row was applied, somewhat more saturated and this process continued, working toward the top of the painting, changing the hue with each stage, adding more Ultramarine and also increasing the size of the mark, like a mosaic.

As the painting progressed, more of the gaps were filled. Once the sky was created, attention was given to the clouds, establishing their position and tonality. This was built up quite quickly, modifying the colour decisions once they were on the painting.

Next came the sea and the landscape at the bottom. In this approach, we come toward an understanding of Van Gogh or André Derain, placing slabs of colour next to each other. When one is working with oils, the inherent problem is that the layer of paint that had just been laid is still wet and will mix with any colour placed on top. So instead of doing that, placing the colour side by side avoids the intermixing or significantly reduces it.

Finally the land is developed and the balancing of colour is resolved.

Pointillism

Developed at the end of the nineteenth century by artists, like Seurat and Signac, pointillism was a response to the fragmentation of the world through the theory of quantum mechanics by Max Planck. The atom, as a small constituent part of the whole, became a dot of pure colour, which, mixed optically together in the eye, created a purer sensation of colour, more luminous than mixing colour together.

Produce your own pointillist study. You can decide whether you want to work with oil or acrylic, and if you want to layer your colour quickly and not muddy the colour underneath.

The use of digital software to fragment the image into pixels helps you to visualize the approach that you might take. You can even separate the channels where you can see the yellow layer, magenta layer and the cyan layer, as if you were a human photocopier. Whilst the size of the brush in a pointillist study is small, the technique utilizes the placement of colours side by side as well as overlaying one colour on top

of another. Using Acrylic does speed up the process, as you can overlay faster, but it can be incorporated in oil. This is a labour-intensive technique, though.

By increasing the size of the brush and mixing other hues the technique of dabs and dashes can be explored.

Dabs and dashes

You might consider the idea of painting small wedges of colour placed side by side balanced in terms of their hue and tonality. As you work across the surface, producing a mosaic-like configuration of dabs, each segment of the colour can be considered in terms of planes. Look at Van Gogh's painting to see how this technique has been used. This will differ from sweeping marks overlaid on top of previous wet areas, which again would differ from scrubbing a thin veneer of colour across the surface of the support.

The Norfolk landscape has been painted in a pointillist style.

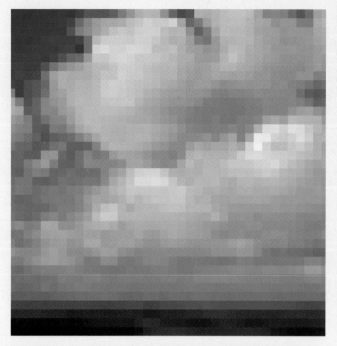

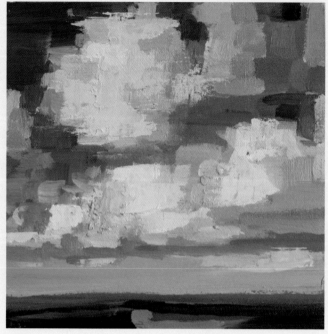

As we have seen in the chapter on composition, the landscape can be photographed and these in turn pixellated in design software, or even by reducing the size of the image on screen and taking a screen snapshot. These pixellated images are much easier to translate into pointillist studies or indeed dabs and dashes.

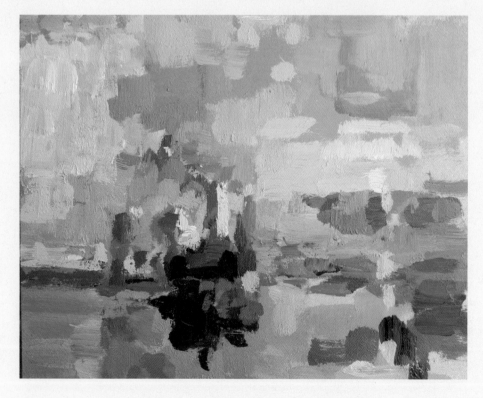

This study of *The Fighting Temeraire Tugged to her Last Berth to be Broken up*, 1839, by Turner, was made in dabs and dashes, utilizing the compositional device of juxtaposing warm and cool colour contrasts.

LESSON 41

Scumbling

Scumbling is a technique that works particularly well with acrylic. The fast drying nature of the medium means that it can be very difficult to achieve subtle colour blends without the addition of a medium which will cause the colour to dry more slowly (a retarder). As acrylic touches the surface of an absorbent ground, it dries almost instantaneously. If the paint is scrubbed onto the surface, the action of the arm causes the paint to go on really thinly, making for an optically porous surface (the ground comes through). If another colour is applied over the top of the first in a similar way, then the visual effect will be that the colours appear to mix, whilst, in fact, they are separate.

More colour layers can be applied, and subtle sfumato type effects can be created.

Whilst acrylic lends itself to scumbling, oil can be used in the same way. The only difference being drying time, the paint needs to be applied and left until it is dry before the next layer is applied on top. It was said of Sickert that he would start a new painting on each day of the week. By the following week he was then able to put a new layer on his Monday painting, then next day on his Tuesday and so on. Surface can also play a key role and Sickert used a very coarse canvas, so working on a textured board, hessian, might be interesting to investigate.

Make your own scumbled study using acrylic. Experiment with the use of dark grounds.

Distemper

Distemper is rarely used as a medium today, although it was quite prevalent during the medieval period. Soft distemper is where pigment is mixed with an animal or vegetable glue but is not permanent. In hard distemper, the pigment is mixed with casein, linseed oil or hot rabbit skin glue size which was the medium that Vuillard used and Bernard Dunstan still employs.

The inspiration for this painting came from a late evening walk. The sun was setting and the landscape was caressed by low lying mist. Landmarks were ill defined, amorphous and the technique was chosen to enable this misty quality to be rendered. Whilst a board had been prepared with a black ground, it became immediately apparent that the whole image was about light, so white was scumbled over the top half of the support.

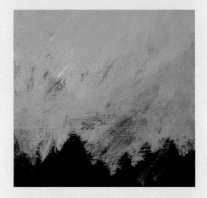

Colour was added, with white being added to the majority of the background colours, whereas the foreground had no white. This meant that the black ground would play a part in creating a dark foreground, which had some aspect of luminosity and colour richness to allow it to come forward, whilst the background needed to recede and have a veiled density.

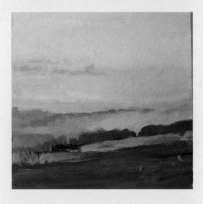

More layers were built up from scumbling, working colour over colour, defining features but at the same time keeping the edges of forms soft.

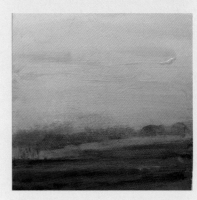

When sufficient work was done with acrylic, a white scumble was applied over the entire painting with water soluble oil paint. The initial layer was far too opaque (having used Titanium rather than Zinc) so the paint was wiped back with a kitchen towel and then Tonked, where a sheet of absorbent newsprint was pressed into the surface of the paper, which in turn takes off some of the paint. This leaves a slight texture in the paint, depending on the texture of the paper used. This final layer created the final ethereal atmosphere that was being sought after.

LESSON 42

Drybrush

Where the action of applying paint in scumbling is a physical one, the paint literally scrubbed onto the surface of the support, the action of drybrush is a much more controlled one.

In John Ruskin's *Elements of Drawing*, Ruskin describes a use of watercolour that was practiced by the Pre-Raphaelite brotherhood; having established large washes of colour, they then proceeded to use watercolour in a dry brush manner, carefully dragging almost dry pigment over the surface of the paper which created a fine network of hatching and cross-hatching marks. This enabled the Pre-Raphaelites to create incredible detail and surface nuance in their watercolours, which often had the same kind of intensity as their oil paintings. It is worth experimenting with both of these techniques, finding control over your media.

A brush is dipped in paint and much of it is then removed by wiping the brush on a kitchen towel or on paper or board. The residue of paint left on the brush is then dragged over the surface of the painting. Andrew Wyeth described drybrush as his beautiful mesh, and his watercolours as well as his egg tempera paintings are full of those tiny dragged marks, which enables him to create these optically complex surfaces.

Experiment with your own drybrush studies. Acrylic works much better than oil due to faster drying time.

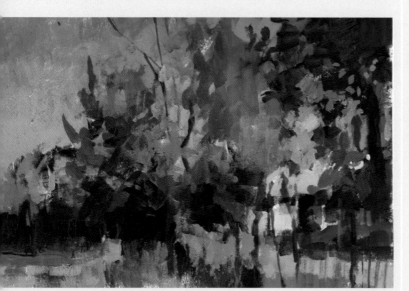

LESSON 43

Glazing

A glaze is a thin application of transparent paint applied over the top of a painting. This can be done as a way of modifying the colour or tonality of an underpainting. This is used frequently at the last stages of a painting, achieving depth of tones and colour quite different to solid colour application. With glazing, you are thinning down your tube paint, so with acrylic you can add water to your paint to make it more fluid. There are many different kinds of acrylic medium which will affect the surface quality of the paint as well as its drying rate. There is a vast array of oil painting mediums which will significantly extend the potential of the paint. Oil mediums will usually involve the combination of oils, waxes, solvents and resins.

The application of transparent layers on top of transparent layers of each other clearly is directly linked to watercolour, but acrylic and oil can be used in the same way, thinly applied, with tremendous luminosity being achieved. In these instances, it is usual for the artist to utilize a white ground so that there is a ground that can reflect the light. Whilst many layers can be built up, the transparency of the medium means that light penetrates through these layers, hits the white ground and is reflected back.

Richard Whadcock's paintings are dark and atmospheric visionary images of landscape. At the heart of his practice is glazing, the use of oil and to a certain extent, monotype too. With monotype, the range of tones is achieved through the application of black ink or oil paint onto a metal plate which is then wiped away. The different densities of black yield different tones. With Whadcock, many layers of colour are built up and he uses different kinds of medium mixed with his oil paints to achieve different drying rates.

Work over some of your acrylic studies with oil glazes. For simplicity, experiment with mixing oil with Liquin, but other glaze recipes can be experimented with too.

ALTERNATIVE WAYS OF MARK MAKING

Not all the painting is done by brush. Rags, newspaper sheets, etc. are used to make marks or effect marks already laid down. My training in printmaking also comes into play to shape the way a painting is evolving. I will hand wipe a painting in the same way as hand wiping and etching plate. Use the approach of monoprinting to remove paint from the surface. Removing paint is just as important as adding paint.

– Richard Whadcock

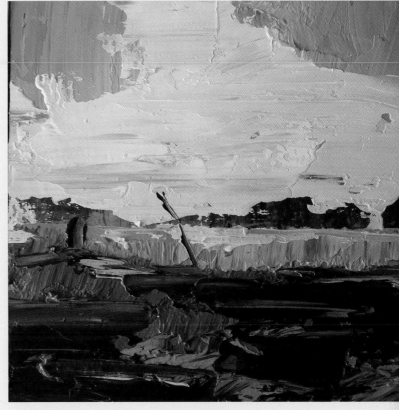

The initial painting was done with a palette knife and acrylic.

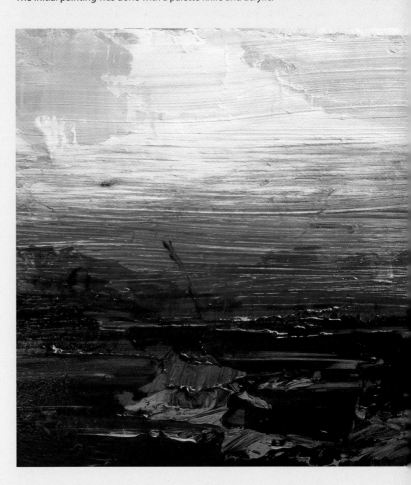

The whole painting was then glazed with Ultramarine and Liquin.

LESSON 44

Impasto

Impasto means thick paint. From the moment artists like Matthew Smith, David Bomberg or Frank Auerbach started trowelling the paint onto the surface of the canvas, impasto has implied Expressionist responses to the subject, the physicality of the material as a metaphor for the physicality of the subject.

One has to be very direct and determined with impasto, sure of one's direction. Indecision leads to a muddying of the waters and a brown mess if one is working in oil. A palette knife as well as a stiff brush can be used to apply the paint, but in terms of oil it can also be used to scrape away paint. When the surface becomes too clogged, it is easier to take the paint away rather than battle with the quagmire.

Impasto oils take a long time to dry, years in fact, but acrylic impasto dries very quickly. However, the surface becomes almost impenetrable and reworking will involve sanding back the paint, otherwise the peaks and troughs become difficult to navigate.

Of course, it should be remembered that if the whole painting is painted thickly then the textual quality of this image will cause the pictorial space to flatten. It might therefore be advisable to consider the creation of pictorial space, smooth thin layers in the background, and more textural in the foreground.

Experiment with making your own impasto studies, using both a painting knife and a stiff hog hair brush.

A thick layer of paint is applied directly to the board.

Some white and a darker blue is now added to establish the dome of the sky and the clouds.

Now the darker edges of the clouds are placed in short dabs.

The land and tree line are now worked up and so too the yellow light of the setting sun.

Mix and match

You need to experiment with technique, material, scale and process in order to discover a way of painting the landscape that suits your character, but also suits the nature of the subject matter. Techniques as well as materials can be mixed and matched and utilized to enable you to deal with the complexities of the landscape. You might also need to consider that this complexity is one of the inherent problems, you cannot, nor should not paint everything. You need to analyze the landscape and decide where is your area of focus, what are you trying to say about that place, that time or the

A gestural grisaille in acrylic on panel.

A verdaccio study made with Yellow Ochre, black and white.

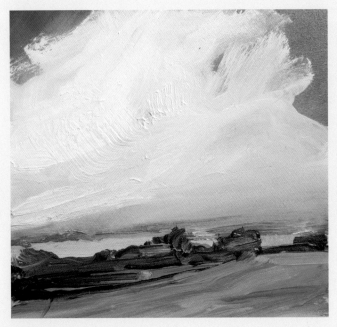

The verdaccio has been crudely glazed.

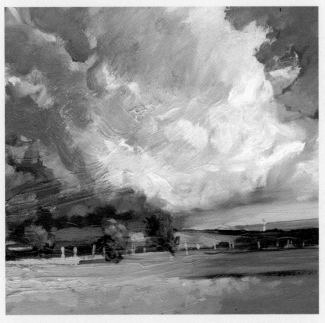

A lot more refined work has been done with glazing and scumbling the colour over the underpainting.

memory that this light evokes? Sometimes the answer is deceptive and you might need to make a lot of different studies, using a wide range of material or techniques before you begin to understand what to include and what to leave out. This may take time and effort but all of your experimentation will pay off. You will learn from your mistakes, the errors, the false starts, the moments of utter despair, but you will also have happy accidents, moments of lucidity and you will learn a lot about yourself too in the process. Someone once said that winners lose more than losers. Remember that when you go into a gallery to look at an exhibition of an artist's work, or buy a monograph on them, you only ever see the ones that worked, but these images were only able to be made by knowledge gained from all the works that ended up in tatters on the studio floor, were painted over or burned in a pyre.

Plein air painting

With the development of tube oil paints towards the middle of the nineteenth century, artists were able to take canvas and paints into the landscape and work directly from the landscape. Previously, artists had to grind their own paints, keeping them in small leather pouches to take on location. For the most part, artists made studies in nature as preparation for their studio paintings and these paintings were never considered to be finished pieces in their own right.

With the birth of Realism came the idea that direct observational painting from nature could be considered to be a practice in its own right and the reverberations of this would be felt in many coastal villages such as Staithes, Lamorna, St Ives, Walberswick and Newlyn, as well as the Barbizon commune in Northern France, that practiced this broad brush technique.

Today the standard idea of landscape painting is *plein air*, going into the landscape itself to make a painting directly from nature. Of course, it does have romantic connotations, but standing in a field in the pouring rain with freezing hands and wet palette can sometimes seem not so glamorous.

One has to consider the idea of travel (where and how far) and what you are going to take with you: supports, paint, working space, and you also need to think about your own physical protection from the environment (umbrella, rain coat). Wearing layers is a good idea, fingerless gloves can be a practical solution to wanting to control the brush but keep the hand warm. Do you want to sit down? In which case, a lightweight camping chair as well as lightweight foldable easel is an absolute essential. Some paint boxes also double up as an easel, holding your brushes, paint, boards and some even have legs which come out of their body. Some have

Plein air painting.

Time is limited and you have to work quickly.

a screw mount at their base which attaches to a standard camera tripod.

Taking part in this year's Sky Arts Landscape Artist of the Year 2016, it became very apparent that most people brought far too much stuff with them, carting trolleys of art materials to the location of Scotney Castle. It is much better to travel light and keep everything simple. The landscape changes constantly, so it is better to work on small panels rather than one large painting. Although it was immensely exciting and challenging to work on a 1m square canvas on the day.

You should prepare boards or canvas in advance. Preparing coloured grounds, making up some marouflage boards, so that way when you go into the landscape, you can make full use of your time.

Being in direct contact with the landscape, experiencing the cold heat or rain has an immediate physical effect upon you, which is transferred to the painting. The fact that the landscape changes so quickly creates an urgency in the work

A small 20 × 20cm
oil study.

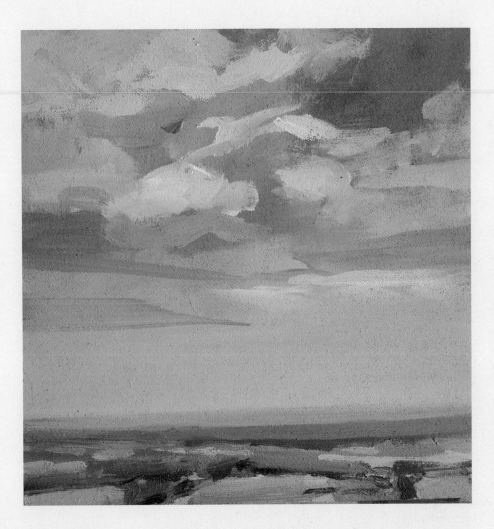

that is difficult to recreate back in the studio. *Plein air* is an exciting adventure but also frustrating, especially when the wind blows your easel and wet oil painting face down onto the grass. Oliver Akers Douglas has a great approach, driving his van directly into the middle of a field and using the side of the van as his easel, but not all of us have that kind of access to landscape.

It is not surprising that one sees the value of watercolour painting as it is a lot easier than a car full of oil painting materials. When you return back to your car with wet oil paintings, you are presented with a simple problem: what do you do with these wet paintings? A pochade box enables you to store your wet oil paintings and you can also buy bespoke wet painting carriers that clamp the edges of your boards in place, but a very simple and inexpensive solution can be made by hand with foam board. Cut out foam board panels with a very sharp scalpel, three centimetres wider than the width of your panels (but the same depth). Cut 1cm wide strips of foam board. Glue these two deep in between each panel, so that you make a series of small shelves. Your wet panels can be stored safely on these and they will not rattle around.

However, the challenge offers so much, it is difficult to weigh up the positive aspects against the negative. Patrick George still continued to paint into his nineties, though he was very fortunate that the subject matter of a lot of service paintings was at the end of his garden.

Even if you find that these studies are not as successful as the work that you do back in your studio, you bring with you a wealth of experience that has impacted on all of your senses that is difficult to replicate. This significantly improves the work that you do back in the studio from your research.

DID YOU KNOW?

You can download image-making software onto your mobile phone, like PicsArt, which presents you with an infinite amount of colour, varying brush sizes and effects which can be manipulated in terms of hue and saturation.

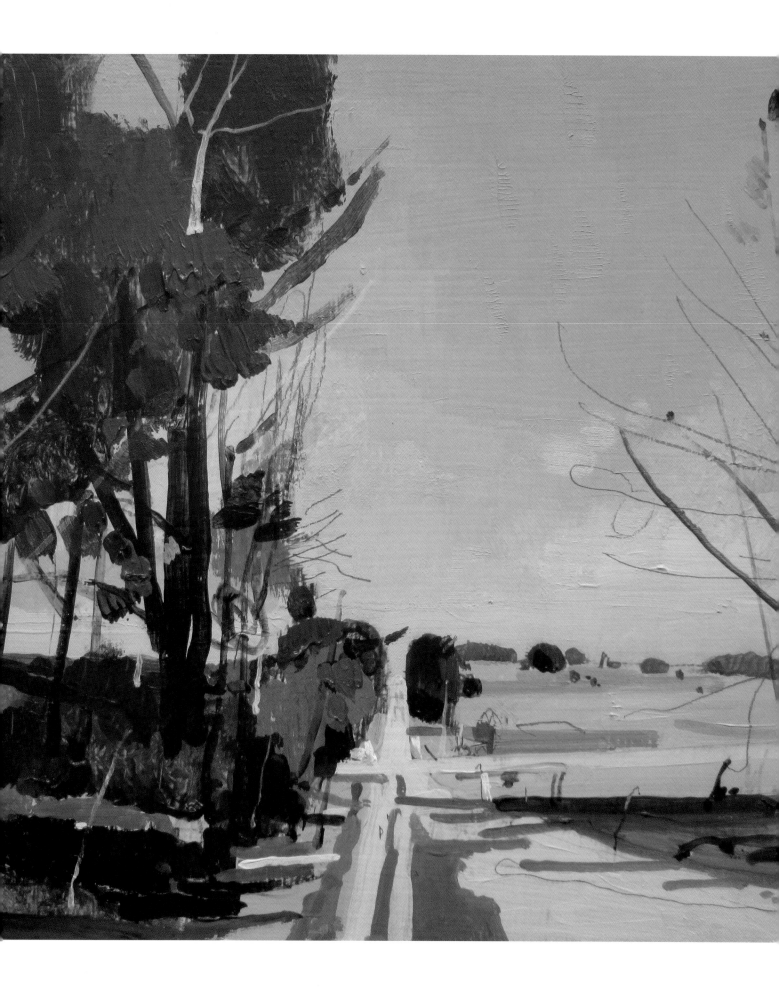

Colour

> *We were always intoxicated with colour, with words that speak of colour, and with the sun that makes colours live.*
>
> – ANDRÉ DERAIN

Why is the sky blue? Is that blue the same blue in the rest of the world? What colour is grass? In much the same way that one might ask how do you mix flesh colour, the answer to these questions is not so easy to pin down. Colour is relational, in that the appearance of a hue depends on the colours that surround it, the colour underneath it and to a certain extent, the way in which that colour is applied. A thin layer of colour will appear to be different to the same colour applied thickly, which again differs from a more textural version of the same hue. When we talk about colour, we need to think about it in a number of ways.

DEFINING COLOUR

Any discussion about colour requires us to define the language explicit to it. *Hue* is another name for colour. When you see student quality paint referred to as Cadmium Red hue, then the colour you are using is not a Cadmium Red at all but a colour that looks like Cadmium Red.

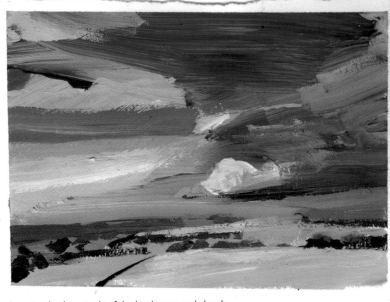

A gestural colour study of the landscape and clouds.

Harry Stooshinoff, *March Road.*

Any colour can be defined by three things:
- Value (the relative lightness and darkness of the colour)
- Hue (the family of colour that it belongs to)
- Intensity (saturation or chroma)

Hue

Value

Saturation

The sun creates energy through the nuclear fusion that takes place at its centre. This energy emanates outwards toward the planets circling its orbit, of this radiating energy (of which infrared and ultraviolet are part) our eyes can perceive a small part, which we call visible light. Isaac Newton demonstrated in his *optics*, that when passed through a glass prism, this light could be split into a range of colours, a spectrum: red, orange, yellow, green, blue, indigo and violet. These form the range of discernible hues and the subtle mixtures in between. Newton also demonstrated that this spectrum, when passed through another prism, reformed itself into white light. So white light contains all colour, but within this spectrum there were three colours which did not contain any other colours in them. These three primary colours could be put together to create all the other colours. These primary colours are known as the additive primaries because their addition creates all light and these are red, green and blue light. The addition of red and green light produces yellow light, the combination of red and blue magenta light and the combination of blue and green cyan light. The cathode ray colour TV had just three colour guns, each one relating to one of these three hues. The use of the three colours and the projection of these as tiny dots of colour allowed the brain to mix these colours in our eye (and brain), creating the sensation of all colour. Our eye has light receptors in the retina, which are sensitive to these colours as well, so that we can interpret these visual experiences.

When the sun's light reaches us, it is scattered by molecules of gas (mostly nitrogen and oxygen) in the air. These molecules are much smaller than the wavelength of visible light, and causes white light to be sent off in many directions depending on its wavelength. Where the shorter wavelengths (the blues and violets) are scattered the most. Overhead, the light is scattered the most and appears blue but toward the horizon, the light gets whiter.

In late evening, when we look at the horizon, we see light at its most direct; as most of the blue light is scattered away, we are left with orange and red light.

Grass is not green, it is all the colour apart from green. The chlorophyll in grass absorbs blue and red light and reflects green light, so our retina receives the reflected light from the grass as well as experiencing the light that has been filtered through the grass. Of course, the colour of an object is determined by the light it receives; on a bright summer's day, the light emanates from the sun, causing colour to be fully saturated. On an overcast day, light is much duller, causing the landscape to become more desaturated. As the sun drops from the sky, its colours change. If we only see red light, and there is no green light to reflect then grass will appear black. The quality of light varies considerably; in northern Europe, we look through about 80 per cent moisture, which means that many of the colours we experience are very desaturated. If you ever wondered why artists move south, to places like Cornwall, it's because the light there is more intense and colour therefore becomes richer. When looking at books on painting, it is usually easy to spot artists who are working in different countries, because of their more exuberant and fully saturated palette.

In this country, we specialize in greys, but what beautiful greys. Look at Sickert's palette and consider his use of tones, or other Camden Town painters and their use of colour. One of the real challenges of landscape painting is the fact that the light changes continuously. On a bright summer's day, a cloud passes overhead, casting its shadow over the land and all the colours change. Not only do you have to develop working at speed, you will also have to allow for changes

to your painting. Patrick George worked directly from the landscape. His working process was to work from the same section of landscape over a period of months, recording the changes in colours that he experienced. What he produced is an exquisite painting based on the constantly evolving landscape, fixed only by key elements of the landscaping itself.

As you make paintings from the landscape directly, it is useful to have a number of small paintings on the go at the same time, taking a lesson from the Impressionists. As the light changes, you can work on one study and once the light condition alters, you can start another; that should accommodate the varying different possibilities at that time, keeping each study short between half an hour to an hour and a half. This allows you to capture that particular period of time whilst realizing that as the sun moves at arc across the sky so the quality of the light changes.

When we print a colour image from our computer, we do not have red, green and blue ink. In fact, the colour we have is the same as the colour created by the two additive primaries. Our yellow, magenta and cyan ink also mix together optically in the eye, creating the illusion of a full range of colour, but we supplement these colours with black to add depth to colour areas. The addition of these three colours does not produce white. It is the absence of colour that does that (the white paper). These primary colours then are referred to as the subtractive primaries.

So what of painting? As already identified, paint is neither light nor digital printing. So the paints that you buy from the art shop, or the colours you find in your watercolour set are your ingredients. What you have to do with them is turn them into recipes. As with many things, it is better to understand what you can do with limitation, understanding the possibilities of a few ingredients before you start to add more complexity.

Paint is stuff, material that has the ability to absorb light and reflect a part of that light back. Pigment has a colour bias and not all brands or batches of paint are the same. So a colour called Sap Green may vary considerably from brand to brand.

The colour wheel

Materials
- Titanium White, Mixing White, Lemon Yellow, Cadmium Yellow, Cadmium Red, Crimson, Ultramarine, Phthalo Blue
- Two water pots
- Palette knife
- Small brush
- Kitchen roll

You cannot buy three primary colours that will allow you to make all the colours that you desire. Instead, you need to buy six colours, where each 'primary' colour has a warm and cool bias. Colour can be *warm* or *cool* in terms of their blue content, so a Crimson may be cool in comparison to a Cadmium Red. Whilst the theory states that there are only three primaries, in practice yellows, reds and blues have different relational temperatures. To achieve the maximum scope for mixing the best range of colour without buying every tube of paint in the shop, then it is certainly useful to have a warm and cool of each. A good standard palette would be Lemon Yellow (greenish), Cadmium Yellow (orange-ish), Cadmium Red (orange-ish), Crimson (violet-ish), Ultramarine (purplish) and Phthalo Blue (greenish) or Cobalt Blue. Of course, a white is vitally important and occasionally black can be useful too.

There are many options to choose from and some colours may even be called primary. Only experimentation and budget will help you decide which to use. This is what is referred to as the co-primaries.

Warm and cool colour wheels
Take a compass and draw three circles. Using the radius, mark off equidistant points around the circumference of each. Using a ruler, draw through the opposites dividing your circle into six pizza slices.

Using a painting knife into circle number one, place a patch of Lemon Yellow, Crimson and Phthalo Blue at equidistant points around the circumference so that they occupy a slice each.

Place a patch of Cadmium Yellow, Cadmium Red and Ultramarine at equidistant points around the circumference so that they occupy a slice each in the next circle.

The mixture of two primary colours produces a secondary colour. Into the adjacent slices in between each primary colour, mix the two colours next to each other, so that Lemon Yellow is mixed with Crimson, Crimson with Phthalo Blue and

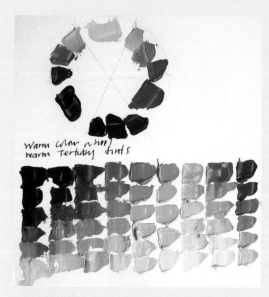

Using three warm primaries (Cadmium Yellow, Cadmium Red and Ultramarine), a set of secondary and tertiaries are created on the colour wheel. To each, white has been added, creating secondary and tertiary tints.

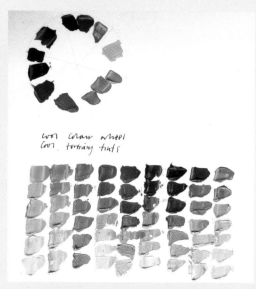

The same is done for the cool primaries (Lemon Yellow, Crimson and Phthalo Blue).

Phthalo Blue is mixed with Lemon Yellow. In the next circle, mix Cadmium Yellow with Cadmium Red, Cadmium Red with Ultramarine and Ultramarine with Cadmium Yellow.

Make three versions of each hue, so that you have a yellow-green, a mid green and a blue-green, a yellow orange, a mid orange and a red-orange, as well as a red violet, a mid violet and a blue-violet.

Tints, shades and tones

The vocabulary of colour is complex to understand. As Derek Jarman said in *Chroma*, 'I learned colour but didn't understand it.' You can learn the vocabulary of colour but true understanding comes from using it.

Take your basic co-primary set of hues, a Lemon and Cadmium Yellow, Cadmium Red, Alizarin or Crimson, Ultramarine and Phthalo Blue. Using a palette knife, take one of these hues and create a series of pure colour blocks on a sheet of 220gsm paper. To each block, add a small amount of Zinc White or Mixing White, repeating this a few times, making your colour patches lighter each time. You will note that as you add white, you might need to add a bit more white each time to make the same difference. You have created a series of tints.

Repeat this with Titanium White and note the differences.

Here, Titanium White and Zinc White have been added to Lemon Yellow and Cadmium Yellow. Each lightens the hue, but Titanium tends to bleach out the colour quicker as it is an opaque white rather than a transparent one.

Shades

Now clean your palette knife and apply a number of patches of pure colour to your paper again. To each add black in very small amounts. You may find it useful to use a very small brush to do this. As you progress, add a bit more black each time, seeing how the hue changes with its addition. You have now created a series of shades.

Tone

Now create a puddle of grey paint, mixing black and white together. Make three greys, a light, medium and dark. Add these to each of your co-primaries and paint these onto your paper too. You can add more or less to each, but consider how much grey is added to each colour as well as the nature of the muted colour produced.

Once you have mixed up a number of secondaries, add white to each to see the tints that they make.

A colour test looking at Lemon Yellow mixed with greys.

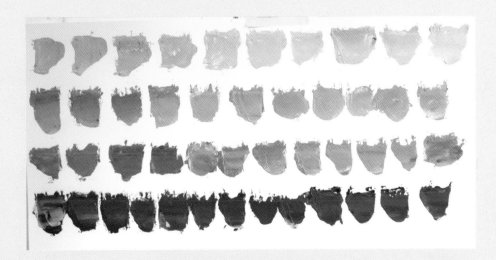

A colour landscape using Daler-Rowney Primary Blue, white, black and grey.

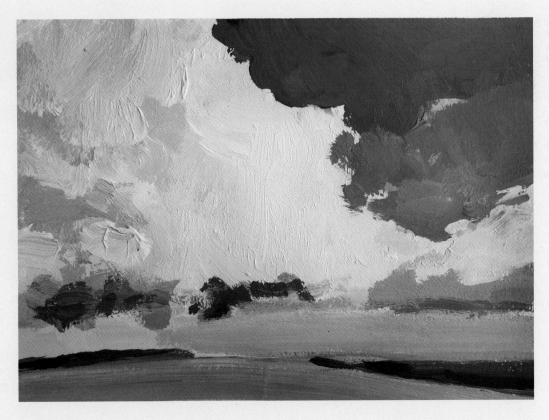

Limited colour landscapes

Using just white, black, grey and yellow, make a series of small scale landscape studies in your sketchbook. Do separate studies for your Lemon Yellow and Cadmium Yellow.

Experiment with these studies on a white ground, a black ground and a grey ground.

Colour landscapes 2
Now using your palette knife, paint a series of tint blocks, using your range of paints and you can also include some of your browns and greens in this test.

Consider these to be skies in a series of experimental landscapes.

Beneath each tint, mix some tones of each colour and paint these beneath the corresponding tints, creating the

land. In between these two colours, paint a band of shades. These small colour studies will make you consider the mood that each colour creates. From this, think about making a series of landscapes which utilize the same dominant colour. So a red painting may actually use a whole range of other colours, mixed into the red, making it warmer, cooler, lighter, darker, less saturated, to really push your understanding of the potential of a colour and to question the notion of what colour the landscape should be painted in.

The more you play with colour now, the quicker you will be able to match what you see in nature.

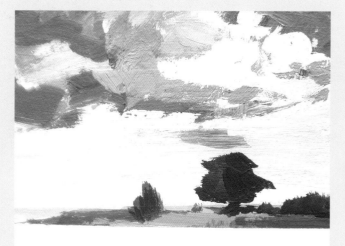

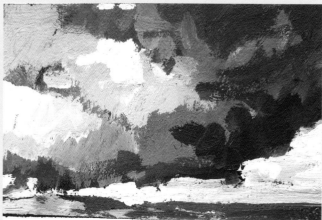

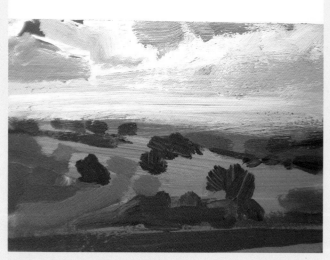

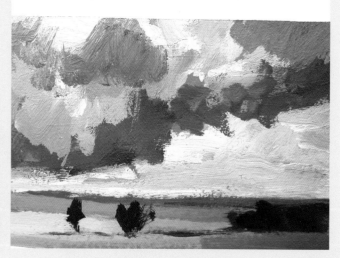

Two studies using white, black and Lemon Yellow.

Two studies using white, black and Cadmium Yellow.

Saturation

Yellow and red make orange but with two sets of primaries, you have the potential to make four oranges.

- Cadmium Yellow and Cadmium Red
- Cadmium Yellow and Crimson
- Lemon Yellow and Cadmium Red
- Lemon Yellow and Crimson

Repeat this exercise with the following green combinations:

- Lemon Yellow and Phthalo Blue
- Lemon Yellow and Ultramarine
- Cadmium Yellow and Ultramarine
- Cadmium Yellow and Phthalo Blue

And the following violet combinations:

- Ultramarine and Crimson
- Ultramarine and Cadmium Red
- Phthalo Blue and Cadmium Red
- Phthalo Blue and Crimson

If each hue has a particular colour bias, Lemon Yellow Yb (yellow with a tiny bit of blue), Cadmium Yellow Yr (yellow with a tiny bit of red) Cadmium Red Ry, Crimson Rb Ultramarine Br, Phthalo Blue By, then in all of these combinations there is only ever one pair where you are just mixing two colours together which will produce that fully saturated colour. In all the others, three hues are being mixed, which will have the effect of muddying your colour and slightly desaturating it.

In northern Europe, most of our colours are desaturated, making these colours vitally important, understanding the different kinds of greens we can make with our co-primary palette and how the amount of one colour mixed with another alters both the value and the temperature of the hue.

Before you run to the art shop to buy some tubes of green paint, it is important that you learn to see what colours you can mix with your co-primary palette, what happens when you add white to colour and the difference between an opaque white (Titanium) and a transparent white (Zinc), what happens when you add black and what happens when you add grey.

Of course, there is a world of difference between a green that has been mixed to a pigment that is green, in terms of intensity, luminosity and transparency. Experiment with the following colours, tints, shades and tones: Yellow Ochre, Naples Yellow, Sap Green, Viridian, Hookers Green, as well as what happens when you mix blues, yellows and reds into these colours.

When Lemon Yellow is painted as a glaze on top of a Cadmium Red, a different orange is produced than when Cadmium Red is painted across Lemon Yellow. This simple chart gives you a quick understanding of the impact of glazing transparent colours on top of each other.

Using any of your paints, take each colour out of the tube and dilute it so that you produce a transparent glaze. Paint a strip of this colour down your page. Repeat with all the colours on your palette to create a series of columns.

Once dried, repeat the same exercise, this time painting a row across each column.

Repeat the same exercise, only this time your columns should be an opaque colour.

A balanced colour wheel.

Analogous colours are those colours adjacent to each other on the colour wheel. These might be regarded as belonging to the same family.

The colours opposite each other are the complementary colours.

A balanced colour wheel

Place your co-primary palette out in the following order: Lemon Yellow, Cadmium Yellow, Cadmium Red, Crimson, Ultramarine and Phthalo Blue. Using a painting knife, place into one slice on the top left corner a patch of Lemon Yellow, into the top right Cadmium Yellow and in the middle of the slice, mix both together. Make sure your knife is thoroughly clean while you are working around the wheel clockwise. Leave a cheese slice free and then on the left hand corner

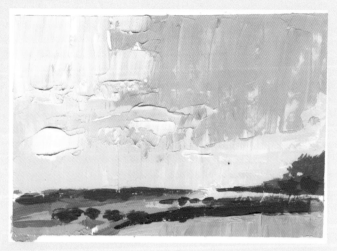

Analogous colour landscape.

Cad Red, right corner Crimson, mixing both together in the middle, miss another slice then add Ultramarine and finally Phthalo Blue so that it is nearest the yellow slice with a gap in between. Look at one of the slices. Mix a small amount of Phthalo Blue to Lemon Yellow, to create a mid green (you will need much less blue than yellow) and place this in the middle of the slice, then add to half of your mixed puddle more Lemon Yellow. Place this in the corner nearest lemon and the other half more Phthalo Blue, placing this nearest blue so that you have created one secondary colour and two tertiary colours. Repeat for oranges and violets, using the two co-primaries that are adjacent on the palette, and then for Cad Yellow and Cad Red, Ultramarine and Crimson.

Now draw a smaller circle and repeat the radius trick around the circumference, only this time draw an equilateral triangle. Using a radius larger than half of one side of the triangle, mark off an arc above and below this line. Do this from the other end of the line, so that you can find the centre of this line. Draw a line from the centre of this line to the apex of the opposite angle. Now cut this out and using a paper fastener, attach this to the centre of the colour wheel.

Colour vocabulary

The colours next to each other on the colour wheel are known as the analogous hues.

The colours opposite each other are the complementary colours.

When the eye stares at a colour for a long time, it will generate the complimentary colour in the eye, this is called an after image. When placed side by side, the complementary will affect each other, boosting each other's chroma or saturation. Mixing complementary colours together has the effect

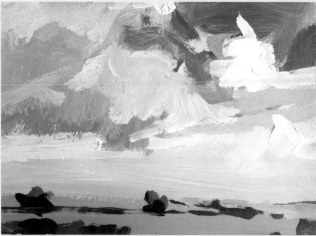

Complementary colour study using Daler-Rowney Phthalo Green and Primary Red.

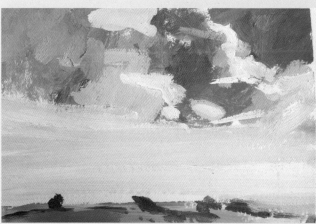

Complimentary colour study using Daler-Rowney Leaf Green and Vermillion.

Students usually darken a colour with the addition of black. This has the effect of darkening the colour, but also modifying its hue. By making a chromatic grey, the colour can be darkened much more subtly without altering its hue.

of desaturating the opposites. So red becomes darker and gradually loses its redness, green the same. If exactly the right pairs are mixed together, the result will be a chromatic grey, if not, the result will be brown. So what happens when you mix Cad Red to Sap Green, Viridian or to any green that you create with your co-primaries? What if you use Crimson? What happens when you add white to these mixtures? Controlling the saturation of your greens, being able to subtly change the temperature, tonality or chroma of your landscape is central to the problems you will face in front of the motif.

Experiment mixing your complementaries, seeing if you can achieve a chromatic grey, but at the same time, see all the brown that you will create, which will be very useful to identify for your landscapes.

Make a series of landscape paintings using just red, green and white. Experiment with the use of mixed greens as well as premixed greens, thinking about warm cool mixtures. Experiment with these on different grounds too.

DARKENING COLOURS

Students usually darken a colour with the addition of black. This has the effect of darkening the colour, but also modifying its hue. By making a chromatic grey, the colour can be darkened much more subtly without altering its hue.

Combining colour

Whilst the theory can seem overwhelming, there is no doubt that you are faced with a simple problem: how do you match the colours you see in the landscape? However, the exercises you have explored suggest an alternative solution. How do you make a painting that uses the landscape as a starting point but expresses itself through colour beautifully?

The colour wheel reveals a map, a simple colour model. Whilst the map is a simple one, it offers some solutions, the simplest answer is three.

If you paint directly from nature, you have already realized that colour changes constantly. If you work from photographs, the film stock, camera, phone, software, monitor, each has an impact on the way in which the colour is conveyed to the viewer and each individual looking at the image have different colour sensibilities anyway.

A well-known phenomenon in the colour darkroom is that some people have a warm colour eye and some a cool one. Colour blindness is a misnomer and it is better to describe it as colour deficiency, not all colours are perceived in the same way. For the landscape painter with colour deficiency, seeing the colour of a landscape offers a real challenge but it also allows one a certain degree of liberation. What colour can the sky be painted in? What colour could grass be?

Within an art historical context, there is only a small window where artists were actively seeking to record nature as they saw it. Most landscape artists filtered their vision and included only those elements that they needed to convey their ideas. Gauguin painted his grass red in *Vision after the Sermon*; after all, as we will see in the next chapter, a painting has to have its own internal logic. So a painting has to stand its own ground.

Some people have an innate sense of colour and understand what colours go together, it's as if they can visualize the result. Other people put colours together and hope for the best. In this instance, it is the ability to change and alter the relationships that allows for the solution to be found. This notion that the image is hard won is central to the artists in the following chapter, the journey to discovering the image is the exciting adventure.

Painting is a distillation of a whole raft of ideas, often taken from different locations and events and then pruned down and re-ordered and mixed up with other thoughts. Most of my paintings start out as one idea and very quickly mutate into something quite different. The older I get, the less I want to know in advance what the final image will look like. Sometimes you can make an image stronger by putting it through chaotic processes.

But there are some strategies that give some solutions to the problem of putting colour together.

Colour harmony
Triad
Three equidistant colours in the same colour wheel balance each other out. For many, this triad is red, yellow and blue. In the hands of someone like Piers Ottey, the co-primary palette offers everything.

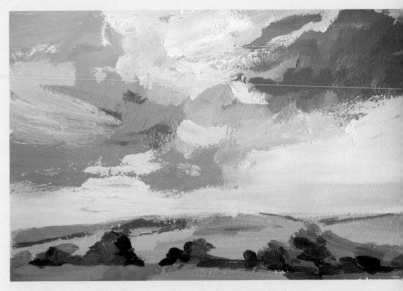

Split complementary study using a warm and cool green and red.

Another harmonious way of using colour is to look at the colour wheel and instead of choosing two opposite colours, choose one of the two colours either side of one of the complementary pairs. So you might use a yellow with a red violet and a blue violet, or a red with a yellow green and a blue green.

By investigating a warm primary palette and a cool one with the addition of white (if one is working with opaque colour) a lot can be done. As Aftab Sardar once said, 'Colour is on the palette.' For a primary triad to work, it has to be mixed.

Moving the triangle unveils more alternatives, a secondary palette, a tertiary palette too; each is worthy of further investigation. How would you paint the landscape using orange, green and violet?

Simultaneous contrast
The same red can appear cold if it is placed on a white background than if it is placed on a black background and its tonality will appear to be different too. This is called *simultaneous contrast*, so a tree surrounded by the sky will look very different than the same one surrounding the landscape. The red itself will appear to be radically different when placed on an alternate-coloured background. The following experience explores this phenomenon in more depth, making you consider the importance of relational colour and the power of three.

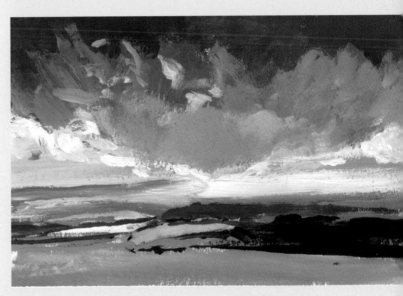

If you desaturate one of the complementary pairs, and then use a very small amount, a highly saturated complementary creates the zing effect. This can be used to great effect to create a visually exciting result.

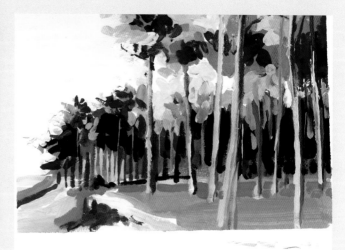

When you look at the colour wheel, the hues at the top are lighter than the hues down the bottom. Each hue has a relative lightness and darkness. If you change this normal tonal order, making a dark orange, a pale green or violet (for instance), placing this next to a fully saturated colour, this is called colour discord and is often the way that colour is used in Indian miniatures. Harold Gilman and Fairfield Porter both used this device in their paintings.

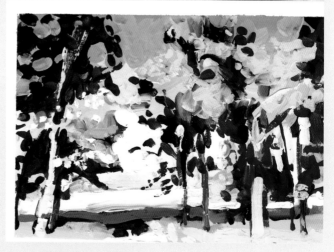

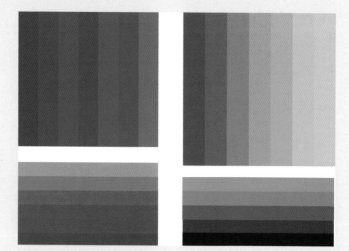

Colour discord study.

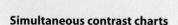

Completed chart.

Simultaneous contrast charts

Because oils take so long to dry in order to move on to the next part of the exercise, it is much better if you do this exercise in acrylic.

Stage one

On a large piece of 220gsm cartridge paper, paint a strip of colour (any colour will do) and make it at least 15cm long. Next to this, paint another strip so that the colours meet using a slightly modified version of that hue. You will find it easier if you mix up a lot of the first colour with a soft flat and add a small amount of the new colour to it with a little brush.

Continue this process until you produce a series of adjacent strips. As you progress, you can introduce a third colour into the mix, but the important thing is to keep the admixtures simple and small so that you train your eyes to notice the subtle differences between each hue.

Stage one: a series of coloured bands, each one subtly modified from the previous hue.

Do this a number of times where you experiment with different colour palette families: blues, greens, oranges. Once you have painted these sufficient strips of colour, it is important that you allow these to dry fully before you proceed onto the next stage.

Stage two B C D: dabs

Now mix a new colour, once again, it doesn't really matter what this colour is, but it is important that this new colour is opaque (mixed with Titanium White).

Apply a dab of this colour across the top of each one of your strips. You can decide whether you wish to place the same colour on all of your strips or keep one colour to one family of backgrounds and a different colour to a different family. Whatever your choice, once you have painted this first dab across all the strips, make a small modification to this colour and lay a second dab beneath the first. Continue to repeat this exercise, keeping the colour mixture simple and subtly modify the transitions of hue. There shouldn't be too great a jump as this will help train your hand and eye to mix subtle colour transitions, but you will also see that sometimes a dab on one strip may do nothing at all but with the tiny addition of another hue, it may become alive.

Once you have painted a series of variable dabs across each of your backgrounds, you need again to wait for these to dry before you introduce the third colour into the families.

Stage two. B: a small dab of colour is applied to each band.
C: each dab is modified so that it creates a simultaneous contrast.
D: the dabs fill the space.

Stage three. E: your third colour is introduced.

Stage three E: the all-important third colour

You have created a series of colour families with striped columns and dabs which move across from top to bottom in rows. Your third colour is now going to be applied downward across each of these different dabs on the same column, so that a third simultaneous contrast is created. As you fill in the first column, you will then modify this slightly and proceed onto the next column. It is this third colour that makes all the difference and creates real visual rhythm and movements across the families.

These small samples chart simultaneous contrast, but the colour relationships that you create are lodged in your visual memory for you to be able to draw upon another time.

The idea of this third colour is an important one. A blue sky can be painted as solid colour and be modified as it reaches the horizon with a second colour, but something magical happens when a third colour is applied over the top of the first, such as that the initial colour shows through the secondary layer. Two colours placed side by side may make an interesting relationship but another colour over the first two can bring them alive. This can make you aware of really invigorating your skies or landscapes.

LESSON 49
Coloured landscapes

Take a sheet of 220gsm cartridge paper. Divide the paper in half along the vertical plane using masking tape. Divide each of these spaces in half and again so that you have made eight columns.

As you complete the charts, clean off the excess paint onto spare paper. These will create other possible colour combinations that you can use at a later date.

These were quite
extensively reworked and
glazed into a series of
forty-eight idea paintings.

You can create your own
rules, but they will yield
new colour configurations.

Now divide the sheet, the horizontal plane, into three and then each of these in half so that you have six rows. You now have forty-eight little spaces to make a series of landscape studies. Give each column a letter: a, b, c, d, e, f, g, h and each row a number: 1, 2, 3, 4, 5, 6.

Mix a green with a yellow and a blue and make enough to paint the landscapes of each forty-eight rectangles. On the last column (h) make a transparent version of the hue and paint that instead in all the boxes.

Now using the two primary colours that were used to make the green, paint a row of yellows (1) and a row of blues (2). With each column you are to modify the hue.

- Column (h) tint (add white)
- Column (g) shade (add a small amount of black)
- Column (f) tone (add grey)
- Column (b) add red
- Column (c) add blue
- Column (d) add red and blue

Now that you have painted the first two rows you are now to paint the next three rows a row of reds (3).

- A row of oranges (4)
- A row of violets
- A row of oranges (5) and finally
- A row of greens mixed with black and yellow (6)

Once you have completed the sky and the land, you can now work back into these landscapes, intuitively mixing colour to use in the colour landscapes. Create new colours on your palette and add these to some of your backgrounds, a tree here, a line of forest here, the odd cloud there. Each time, think how simultaneous contrast will modify your experience of that colour. Use intuition, risk and serendipity to create little jewel like landscapes. Consider the use of different painting techniques and tools, drybrush scumbling, sgraffito, impasto, dabs, dashes, glazes.

Some mobile phones will allow you to take a negative photograph. This will yield the complimentary version of these colour frames, giving you new ideas.

Colour choice

Whilst the theory can seem overwhelming, there is a key message to be had in this chapter, and that you learn colour by using it. As time goes by, you begin to refine your own colour choices, preferred palettes and key colours that are always returned to. The artists in this book have some interesting thoughts on the subject.

Experimental colour landscapes.

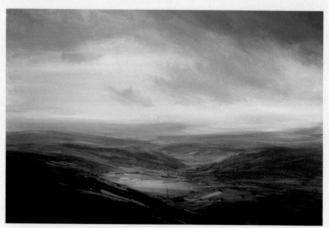

James Naughton, *Dusk Clouds*, oil on board.

'Titanium White, Naples Yellow, Yellow Ochre, Cadmium Yellow pale, Cadmium Orange, Vermillion, Cerulean Blue, French Ultramarine, Sap Green, Viridian, Burnt Sienna, Raw Umber, Ivory Black… These are colours which I have used for so long because they have always felt natural to me, now and again I have mistakenly bought other hues and thought I'd use them so as not to waste the paint but other hues always seem to jar.' James Naughton.

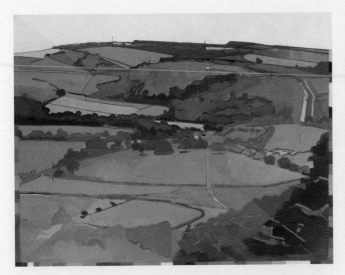

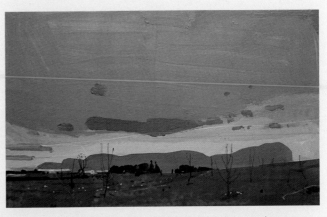

Evening Comes, acrylic collage on thin birch panel. 'Colour is the great mystery. Through its interaction a quality of life must somehow be created, through trial and error. I don't so much aim for realistic colour, but a sense of wholeness and rightness to the whole composition. I tend to be a tonal painter; an illusion of depth is often created by the positioning of lights, middles, and darks. I use a great range of greys and most often these are mixed by adding two complementaries, or approximate complementaries. My blacks are also made by mixing two opposing colours, for example, Ultramarine Blue and Burnt Umber create a useful dark. While there are certain colours I favour, I do not necessarily see them as essential. Rather, I have a system of relating and opposing colour to create space, contrast, and harmony. I buy colours of many different brands and find this prevents a certain homogeneity or predictability of effect. Almost every colour used is mixed. I use Titanium White because it has great covering power. I use a variety of blacks for mixing certain greys and greens, but one must always be careful that black is optimizing rather than killing colour. That said, black is useful and should not be avoided. I use Cadmium Yellow and Cadmium Red for certain under washes. They have great strength for mixing a great variety of warms. I love unbleached and buff titaniums. Ultramarine Blue, Permanent Blue light, Prussian Blue, Ultramarine Violet, Viridian Green, Hookers Green, are useful colours for mixing with many other tubed colours less pure or intense in their formulation. Many of my colour effects are achieved by over painting a few layers.' Harry Stooshinoff

Lone Beech, Arundel Park. 'Well, that's very interesting because we've all got a very strong colour personality, but in my teaching and with me, I try to get everyone to add another colour to their palette at least once a year and recently, I've been using a very peculiar blue which is Windsor Blue, which has got an unusual character,… And if you mix it with white you instantaneously know the particularities of a colour. Mix a bit of the colour with a teeny bit of white and it clarifies the nature of the colour, especially if you use one of the lead whites; silver white like Cremnitz or Flake White, not Titanium because that's a colour killer really, but mix one of the lead whites with it and you suddenly see it. This Windsor Blue, it's not like Prussian or Ultramarine, its odd, and I'm using that in a painting so I've got these colours that I always use but I try to question them. I can't really paint without Alizarin, I can't really paint without French Ultramarine, I can't really paint without Cadmium Lemon or Windsor Lemon and I can't paint without Raw Umber. Raw Umber is a fantastic colour, Permanent Green is the most gaudy colour on the planet but as a mixer that's really great,. I just love colour but often I won't use any Permanent Green. I can't really paint without French Ultramarine and Cadmium Red.' Piers Ottey

Here are some other palettes you might want to experiment with:

- Titanium White (with watercolour, the paper acts as the white)
- Titanium Buff
- Cadmium Yellow (medium or dark)
- Cadmium Red
- Burnt Sienna
- Raw Umber
- Prussian Blue
- Payne's Grey (not essential, but useful)
- Cadmium Red Light
- Yellow Ochre
- Raw Sienna
- Burnt Umber
- Ultramarine Blue

Whistler's palette
- Lemon Yellow
- Cadmium Yellow
- Yellow Ochre
- Raw Sienna
- Raw Umber
- Burnt Sienna
- Vermilion
- Venetian Red or Indian Red
- Rose Madder
- Cobalt Blue
- Antwerp Blue (a weak pigment inferior to Prussian Blue)
- Flake White
- Ivory Black

Big and Little Tree, Oil on canvas. (Courtesy of Browse and Darby Gallery)

'Cadmium Green, Terre Verte, Raw Umber, Yellow Ochre pale, Light Red, Ultramarine and White Titanium and sometimes a cool red like Rose Madder or Crimson Alizarin.' Patrick George

THE PALETTE

Palette for the B road paintings: Cobalt Violet, Prussian Blue, Kings Blue, Indigo, Burnt Umber, Chrome Orange, Naples Yellow Reddish, Sap Green, Olive Green dark, Bright Green, Lemon Yellow, Zinc and Titanium White. Because I am painting the stroboscopic light falling through lush spring tree growth onto the damp tarmac of the country lanes near where I live.

– Nick Bodimeade

B 182 Hamsey, oil on canvas. (Courtesy of Nick Bodimeade)

Winslow Homer's palette
- Flake White
- Burnt Sienna
- Prussian Blue
- Light Red
- Yellow Ochre
- Black

Anders Zorn's palette
- Flake White
- Yellow Ochre
- Vermilion
- Cool Black (Ivory + Cobalt Blue)
- Warm Black (Ivory + Burnt Sienna)

Singer Sargent's palette
- Blanc d' Argent [sub. Permalba White]
- Chrome (pale) [sub. Cadmium Yellow Light]
- Transparent Golden Ochre [sub. Transparent Gold Ochre]
- Chinese Vermillion [sub. Cadmium Red Light]
- Venetian Red
- Chrome Orange [sub. Cadmium Orange]
- Burnt Sienna
- Raw Umber

Rembrandt's palette
- Lead White
- Ochres
- Bone Black
- Vermillion
- Siennas
- Raw Umber
- Burnt Umber
- Lead-Tin Yellow
- Cassel Earth

When it comes to painting your landscape, it is important to consider that your response may be an emotional or intellectual one. You are trying to convey your understanding of your experience, through the tools at your disposal: colour, paint technique, drawing mark making. You are creating an image which has its own internal logic.

As we proceed to our final chapter, you will see that this notion is very firmly in the minds of all the artists making work in response to the landscape.

THE PALETTE

My palette is rather simple, and has stayed fairly constant for some time. It consists of a couple of blues (always Ultramarine, plus a greenish-blue, often Cerulean), a range of earth colours, and lots of Titanium White. I like Flake White too but it's pretty hard to get hold of these days. I love the idea of painting the land using pigments ground from earth itself, and I like using earth colours to mix a range of off-whites and chromatic greys. I don't use a lot of green but I sometimes use Sap Green or Olive Green, or I'll mix a degraded green from Yellow Ochre and a tiny amount of black. I do have a few high-chroma colours – Lemon and Cadmium Yellow are also useful for greens, while a tiny amount of Cadmium Red is sometimes needed. Generally I like to mix a range of subtle colours from a limited number of pigments, and I feel that a painting is more likely to 'tie together' this way rather than using a wide range of chromatic colours which are harder to harmonize.

– Louise Balaam

Louise Balaam, *Applecross Blue Day*, oil on canvas.

THE PALETTE

Because my work often references earth, air and water, I use a basic range of warm-to-cool oil colours – mostly I reach for Yellow Ochre, Vermillion, Magenta, Ultramarine, Viridian, black and white, supplemented by more exotic pigments when needed. (I have no problems including black.) I rarely use pure colour direct from the tube.

– David Hayward

Shipping Forecast 4. (Courtesy of David Hayward)

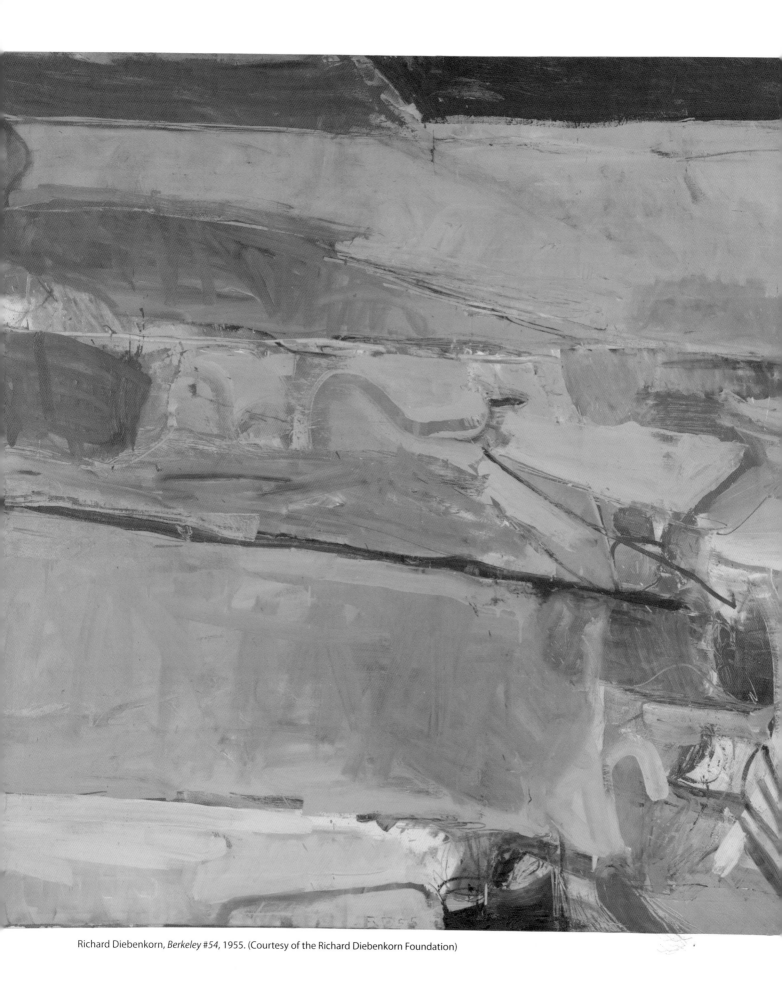

Richard Diebenkorn, *Berkeley #54*, 1955. (Courtesy of the Richard Diebenkorn Foundation)

CHAPTER 9

Ideas

> *The painter should paint not only what he has in front of him, but also what he sees inside himself.*
>
> – CASPER DAVID FRIEDRICH

RICHARD DIEBENKORN

At the start of the twentieth century, painting had undergone a major transformation with the advent of photography. Cubism had fractured pictorial space, breaking free from perspective. Expressionism had taken its cue from fauvism and released colour from the constraints of representation, making it a vehicle to communicate emotion. Surrealism had tapped into the depths of the subconscious and drew inspiration from Dada in its use of chance, order and risk-taking, to produce imagery of other worlds.

Early abstractions emerged out of an engagement with landscape. Kadinsky's fauvist interpretations of Murnau became a series of brightly coloured shapes, before disappearing into geometry. Mondrian had moved away from Impressionist interpretations of the Dutch landscape before embracing a fauvist palette. Cubism would take him on a different journey, deconstructing the landscape into the primary forces and his quiet contemplations of the land and the sea would see a gradual synthesis towards a geometric abstraction and its interplay of primary colours. Malevich had abandoned figuration altogether and before any of them ventured into pure abstraction, Hilma af Klint had created spiritual geometric internal landscapes.

The various threads of modernism would come together in America, a country hungry to form its own visual identity. Abstract Expressionism became a fusion of all of these

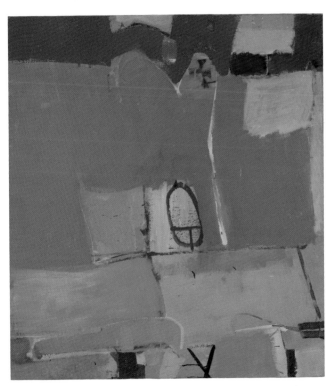

Richard Diebenkorn, *Albuquerque #4*, 1951. (Courtesy of the Richard Diebenkorn Foundation)

ideas. There had been artists already working in America, the notion of a spiritual engagement with the landscape was certainly evident in the Hudson River School; work had a great deal to do with the scale of the American landscape but also relied heavily on the European tradition. Abstract Expressionism would have a massive impact on the art world with its connotations of freedom, scale, ambition and high ideals overshadowing many of the contemporary art movements of the time.

The depths of human psyche would be plundered as artists sought to find form to their ideas, emotions or exaltations,

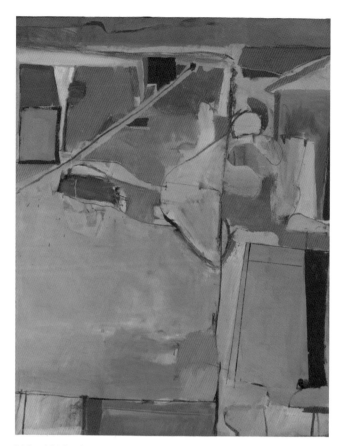

Richard Diebenkorn, *Urbana #5(Beach Town)*, 1953.

One thing I know has influenced me a lot is looking at
landscape from the air... Of course, the Earth's skin itself
had 'presence' – I mean, it was all like a flat design – and
everything was usually in the form of an irregular grid.

– RICHARD DIEBENKORN

to make a truly abstract art. Some found it in the gesture, the
signature writ large, where the painting acted as an arena to
record the actions of the body. Some sought a more contem-
plative solution, something that would act like a portal to the
spiritual self.

At the same time in England, a similar chain of events
would make for an avant-garde art based in St Ives, and
elevate its artists onto this same international scene. The
light was more intense, being the southernmost point of
the island, the affordability of studio space would account
for a migration of artists there, who would seek to gather
together to discuss these new ideas. Abstraction would be
embraced but one definitely informed by the landscape.
Barbara Hepworth (1903–1975) and her husband Ben
Nicholson (1894–1982) drew inspiration from Naum Gabo
(1890–1977) and Russian constructivism, while Patrick Heron
(1920–1999) would take a leaf from Matisse and push colour
to its limits. Roger Hilton (1911–1975) and Peter Lanyon
(1918–1964) would seek a more visceral attack on the canvas.
There were exchanges, Mark Rothko (1903–1970) coming
over to meet Hilton, Lanyon and Heron.

Although in its original form, Abstract Expressionism
sought to move away from figuration altogether, artists like

Arshile Gorky (1904–1948), Willem De Kooning (1904–1997)
and Franz Kline (1910–1962) could never stray too far away
from drawing. Elements of the observed world would creep
into their vocabulary of forms. For a younger generation of
artists, floating in the wake of Abstract Expressionism, they
would either turn their back on this approach to painting
altogether, seeking a more conceptual approach to art mak-
ing, or they would continue to embrace it as the way to paint.
The second generation Abstract Expressionists would not be
frightened of referencing landscape in their visual language.
This was certainly the case of Californian painter Richard
Diebenkorn, working alongside one of the original Abstract
Expressionists Clyfford Still (1904–1980). Diebenkorn would
make his mark on the art world by drawing upon his expe-
riences of the land seen from the air. As a cartographer, the
landscape presented itself as a patchwork of colour abutting
each other, on a flat or shallow space.

With Diebenkorn, the desert mesa would suggest earths,
reds, desaturated green, dirty colour, paint that was mixed,
scraped back and mixed again. These images would evoke the
empty space of New Mexico. This phase of his career saw him
make a physical dialogue on the canvas, with mark making
and colour fused together to create evocations of the land-
scape seen from above. The titles of these works were based
on the places he lived: Albuquerque, Urbana and Berkeley.

Midway through his career, Diebenkorn became a
figurative artist but this notion of the transformation of the
painting was still part of his visual language, figures appeared
and disappeared, rooms became seasides and landscapes and
back into rooms again. The history of his paintings are often
concealed behind gloopy layers of paint but in the last stage
of his career, he began to make a series of paintings that were
a cross between Monet and Mondrian. A thin linear grid
records some of the visual experience of the Ocean Park area
of Santa Monica. These paintings were delicately executed
in thin transparent layers of oil paint as well as charcoal. The
changes to the image, the indecisions and the fluctuations of
colour suggest different horizons, edges of a distant horizon
edge of a building catching light. This notion of the history
of a painting, the humanity of the work made beautiful and

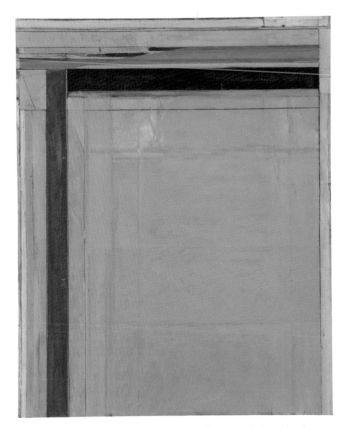

Richard Diebenkorn, *Ocean Park #87*, 1975. (Courtesy of the Richard Diebenkorn Foundation)

sensual landscapes. Diebenkorn's many paintings of the *Ocean Park* series suggest an approach. Rather than trying to solve a whole load of complicated problems for one painting, why not make a whole load of paintings to solve one problem by exploring compositional issues, colour combinations, mark making, and so on.

Richard Diebenkorn's *Ocean Park #87*, 1975, utilizes the division of the painting with both horizontal and vertical lines. Whilst this could potentially create a very static image, it is the grouping of these lines, which creates visual interest. Placing a stacked series of lines close to the top of the painting and the far left leads the eye upwards, toward a series of alternative horizons. Broken by an implied acute triangle, slicing a diagonal division of coloured rows, with saturated blue bands to the left (suggesting the sea) and as well as a block of green to the right (a prominence jutting out).

The empty spaces in the painting are large and never completely devoid of content, instead, there tends to be the residue of reworked images, ghosts of lines, some diagonals, areas of paint veiled over previous decisions. The palette is predominantly light in flavour, creams, pales, everything slightly chalky with a subdued light. Strong contrasting areas of colour and tone take the eye through the painting.

Diebenkorn had moved to the Ocean Park neighbourhood of Santa Monica in 1966 and it would dominate his visual language for the next twenty years. Painting after painting which beautifully manipulated the variables of line, colour, horizontal, vertical, diagonal divisions of space, evoking the sense of light and space of his locale.

Living on a peninsula, Lanyon would experience an altogether more vertiginous landscape; the land, the sea, the differences in height would suggest a more perceptual space of proximity and distance, hole and edge, the crashing sea never too far away.

LOUISE BALAAM

Louise Balaam gained a degree in Fine Art at Kent Institute of Art and Design, Canterbury, and her Masters at Canterbury Christ Church University.

For those artists growing into their careers during the mid 1980s, Abstract Expressionism offered one pathway, minimalism and conceptualism another. The influx of bad painting was yet to take hold (although there were murmurings at Glasgow School of Art). It is not surprising then that Louise Balaam's paintings have the hallmark of gestural Abstraction upon them. One can sense something akin to Diebenkorn's *Berkeley* series or de Kooning's *Long Island* works, but these

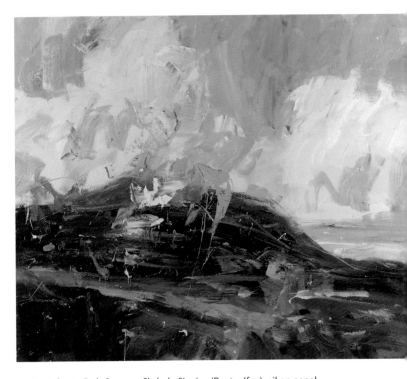

Louise Balaam, *Early Summer, Skylarks Singing* (Pentre Ifan), oil on panel. (Courtesy of John Carvana)

Soft Cloud, Pembrokeshire Sky. (Courtesy of Louise Balaam)

paintings are actually embedded with a response to place. Balaam makes drawings and watercolours on the spot; like Constable, these sketches are not meant to be seen, but they become the private investigations and musings of the artist making sense of her experience. The camera may record a great deal, but inherently the camera records everything. The unblinking fool puts everything into sharp focus, captures every detail in high resolution. For Balaam, the process of making a drawing is different.

In both drawing and painting I'm aiming to put down my response to the place I'm in. For some artists drawing may be an intuitive, spontaneous response while they see painting as more considered and planned, but I try to keep that same immediacy in the painting as well. I'm not interested in perspective or precise notation, but I'll draw with a range of media (pencil, charcoal, watercolour, pastel or oil stick), each of which tends to focus on one aspect, for example on tonal or colour relationships.

My practice is to draw outside and paint in the studio. This is because I find my painting can become too literal (for me) if I'm working directly from the motif, or even directly from a drawing. I find the drawings are essential as source material but I prefer not to work from them.

Back in the studio, these aide-memoires are used as jumping off points, like the great American painters – there is a point where conscious thought is lost, paintings become a series of actions and reactions, getting lost in the process but somehow in this hinterland, a sense of the self emerges.

I find that by painting in the studio rather than plein air I can allow memory and imagination to play more of a role, and the painting can take on its own life, rather than becoming a copy of a drawing. I can also paint on a larger scale, for much longer, and in series, all the time aiming to paint intuitively and keep a freshness in the way I put the paint on. There don't seem to be many words for this but

I find I need to get into a kind of right-brain zone, where I'm completely absorbed in what I'm doing, not thinking or judging, just painting.

What becomes immediately apparent is that painting the landscape is not about copying what you can see, but filtering that experience, making decisions about what is important, identifying the subject within the landscape.

I see myself as an intuitive, gestural landscape painter. What I'm trying to do is to convey the emotional impact of landscape, through the way I put the paint on – so energy and expressiveness are much more important than topographical accuracy.

I try to use the paint to suggest, for example, the space and activity of a sky, but without ever painting a cloud or a bird as such. I'm trying to evoke sensations rather than describe physical features… I find there's nothing like being outside – the changes in the weather, the sky and the light are endlessly fascinating and engaging for me. I love the idea of a multi-sensory experience – being extra-aware of smells, texture, sometimes the taste of salt on the breeze, as well as sound and sight, all coming together as part of that particular place. I aim to communicate these different aspects somehow in my paintings.

DAVID ATKINS

David Atkins was born in Greenwich, London, in 1964. He studied painting at St Martins School of Art and Winchester School of Art, gaining a First Class Honours Degree in painting.

After leaving college, he returned to London, where he taught part time and continued painting. He exhibited regularly throughout the UK and in 1999, began showing at the Albemarle Gallery in London, with his first solo show in 2002. He has been awarded numerous prizes including the Horan Prize for Painting at the NEAC Exhibition in London and the Façade International Prize for Painting at the Discerning Eye Exhibition in London.

He now lives and works in Dorset.

The physicality of paint becomes a vehicle to hold onto emotion as well as the presence of the artist. David Atkins's work also reveals a similar use of thick gestural painting.

I'm a painter who's very much interested in the use and application of paint. I love the marks, texture and feel you get from different qualities of paint and I particularly enjoy and get inspiration from using it in a very gestural and abstract way.

As a painter, I would describe myself in the romantic tradition of English painters such as Turner and Constable. I'm very much inspired by the landscape and it was the English tradition that first got me hooked into becoming a painter. My work fundamentally deals with the issues that concern being in the landscape and the dialogue that happens in the process of making a painting. I'm very influenced by painters painting, in particular those who use marks and the language of paint to fully express one's concerns as a human being.

There is something very special about the landscape, especially when one considers the idea of heritage. For the artist growing up in the city, the oppressive nature of urban sprawl can be quite oppressive.

I moved about twenty years ago from London to Norfolk, having fallen in love with the landscape up there. It was so vast. I remember standing on a beach on the North Norfolk coast and just being in awe at the sheer vastness of the landscape in front of me. It just did something, which I find hard to put into words. It was like looking at a Mark Rothko painting, it seemed to go on into infinity.

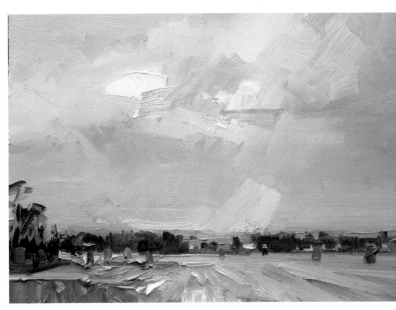

David Atkins. *Harvested Field near Chipping Campden, Gloucestershire.*

David Atkins. *A Clearing Sky. Looking Toward the Malverns from Fish Hill. Chipping Campden.*

With Abstract Expressionism, there was a sense that the image was not arrived at easily. Paintings would go through a process of transformation. Shapes and colours would appear and disappear, motifs might emerge and fade, compositions change. Like a process of excavation, artists would be scraping away layers in order to discover the treasure. In Diebenkorn's *Ocean Park* series, some of the history of the work is revealed and so too with contemporary artists like Atkins.

When I am painting outside, I respond quite quickly to different situations as things are in constant change and this excites me. Things change constantly, providing new and exciting possibilities.

My process in painting starts by applying a variety of marks to plot where things are almost in a topographical way. That gets me involved and into a dialogue with the work. Then my progression is a mixture of many different responses, mainly acting, intuitively adding and erasing marks and colours, reducing the detail to the bare essentials, continual looking and decision making. An outcome never comes easy.

I work to a point in the painting where I begin to have a meaningful dialogue with the subject, keeping a level of interpretation, investigation and energy going throughout. Sometimes I am not quite sure what I have ended up with, some I have been stopped too early, at other times I have overworked it. More often than not, it's the work that I am really unhappy with, that one I think I've messed up, that proves to be the most successful. The last part of the thought process is when you bring them back into the studio to see what you've really done. There are a lot of failures and a few successes.

I suppose within the landscape I'm always looking for a subject for a painting that will express or reflect something about myself, about the way I think, make sense of and see the world. I tend not towards making any type of illustration or any narrative in the work, it's about discovering perhaps the poetry within a subject, and conveying that in a painting. As with all paintings, they become timeless, you can look at them, again and again and see new things in them. They grow with you, they're alive. That is what I am aiming for.

The light in the sky starts to fall and the landscape becomes transformed. What had been luminous, a golden glow, begins to fade, a darkening blue. Trees that had seemed afire in light now silhouettes of blue-black, amorphous sentinels.

Walking into the woods, within a few moments, the space closes in a series of tree line tunnels, a break in the path and routes seem to offer themselves up, inviting inspection, but do you continue to travel that same well-trodden path, or venture into the unknown, getting lost, finding dread ends, but with the knowledge that if you do venture into the unknown, you will learn more about this mysterious place?

RICHARD WHADCOCK

Richard Whadcock paints beautiful atmospheric landscapes of the South Downs and East Sussex coast. Having studied fine art painting and printmaking at Bristol Polytechnic, he completed his Masters at the Royal College of Art. He now works from his studio at Phoenix Brighton.

If Balaam and Atkins explore gesture, then there is altogether something quieter and more contemplative in Richard Whadcock.

The South Downs have always been the main location and source for the work for the last twenty years or so. It meanders from Winchester in the west to Eastbourne in the east, tracing a path just in from the coast. It isn't that it's a craggy snarling landscape, more undulating, but it does rise to peaks such as Chanctonbury Ring, Devil's Dyke and Ditchling Beacon.

I will spend time walking in the landscape and recording as I go using a camera. Plein air painting has never been something I've wanted to venture into. The experience and memories of the walk or even a drive start to form the basis of a work. Already the camera is used to compose elements from the landscape instead of being just simple snaps. They are more often than not then converted to black and white on a computer. This starts to remove some of the information that isn't necessary in some ways and starts the process of paring down the image to really get to its bare bones and the reason behind the photograph in the first place. Any information removed can always be referred back to at some future point anyway.

The physicality in Whadcock's work is altogether thinner, more ethereal.

It is the 'stuff' in between us and the landscape that I am interested in capturing. The atmosphere, light, morning, dusk, rain, mist. All are transitions of time and place. These are the elements I am aiming to paint and perhaps the landscape is just a back drop, reference point, a vehicle with which to render the elements. It isn't very often a piece is named after a specific place. Some are, but it isn't important to me or the work itself and in actual fact, can add barriers to the way someone can view the work and can define an unwanted framework that the painting should conform to. I keep coming back to the landscape as it is never the same. It can change from day to day, hour to hour, right down to minute to minute. You never know what to expect and quite often get something you didn't. To me it is the way it can morph in to a different state within minutes. As it follows the coast so closely it can be clear one minute and then capitulate to a weather front that sweeps in from the sea and rapidly change the look and feel of the landscape. Known geographical detail can be expunged by a coastal mist, smudged away by a downpour or bleached out by intense low morning or evening sun. It is these transitions from one state to another that the paintings are dealing with, small periods of time, not really a singular moment as such. This is what draws me back.

Revision and indecision play their part too in Whadcock's practice.

Several canvases, panels etc are worked on at the same time. Firstly due to drying times of oils but also because one painting can naturally lead to another and begin to feed off each other. As the works progress on, they each start to develop within themselves as paintings. Allowing them to create a landscape of their own in some way. The initial ideas are drawn back into the paintings as well to bring back solidity to them. Layers can sometimes be sanded back and start to reveal layers beneath in a way that is not completely in my control to throw up other possibilities within a painting.

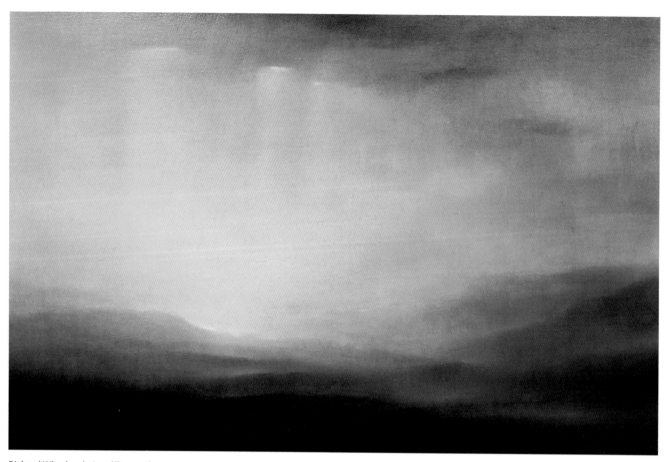

Richard Whadcock, *Land Trace*, oil on canvas.

Brook, oil on canvas. (Courtesy of Richard Whadcock)

Abstract Expressionism had put forward the idea of the image discovered on the canvas, through an internal dialogue with the artist. It is clear from Whadcock talking about his work that location is not as important as the act of painting itself. The landscape offers motifs and jumping off points but ultimately, one is only left with the work itself and the emotional response one has to the encounter.

JAMES NAUGHTON

James was born in 1971 in Bolton, Lancashire. He enjoyed drawing from an early age and was introduced to printmaking by Bill Dyson on the Art Foundation course in Bolton (1989–1991). This passion for print continued, on the Graphic Arts degree at Leeds University, under the guidance of Phil Redford and Jack Chesterman (1991–1994).

James became a professional painter in 1998 and has exhibited widely in the UK and internationally ever since.

Whilst it may not seem that apparent at first, James Naughton's works looks like *plein air* paintings, but they too go through a similar process of discovery.

My process does not normally involve any preparation, sketching or photography. In order to get the most from the material I start with a very vague notion of subject, usually linked to a combination of colours but the instant I start, even that first loose idea is challenged as I want to be open to the potential of what has just happened, the paint moves and I respond repeatedly.

In his paintings the clouds sweep into the valley and seemed to rise up, over the hills, swirling in on themselves, creating a kind of vortex, a cone to funnel one's eyes into the distance. The clouds break apart suddenly and shards of light seems to hit the ground, bringing forth a luminescence, a patch of light. James Naughton's paintings are beautiful, of that there is no doubt. Thin semi-transparent veils of oil paint overlap each other, the hand of the artist evident in their movement and decisiveness. Yet these marks transform, become cloud, grass, hill and light. Naughton performs a conjuring trick, a space unveils itself, but never fully revealed. One is reminded of the great nineteenth century painter John Martin (1789–1854), the great day of his wrath, as the earth is thrown up into the sky closing up and around the sinners to bring them down into the bowels of the earth to wreak their atonement. Standing on some high promontory looking down at the landscape below, watching rain clouds empty themselves into the space, ethereal wisps of vapour falling upon the ground, it is easy to think in this drenched state of all the miserable days, all the negative thoughts, but Naughton never gives you this. Instead, there is hope and

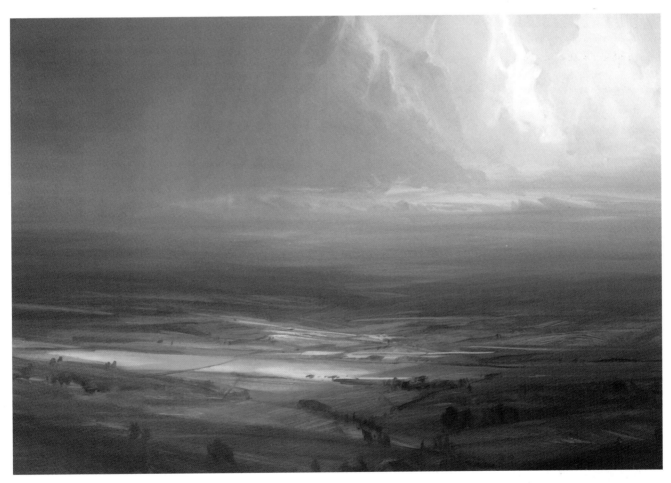

James Naughton, *Clouds Drift.*

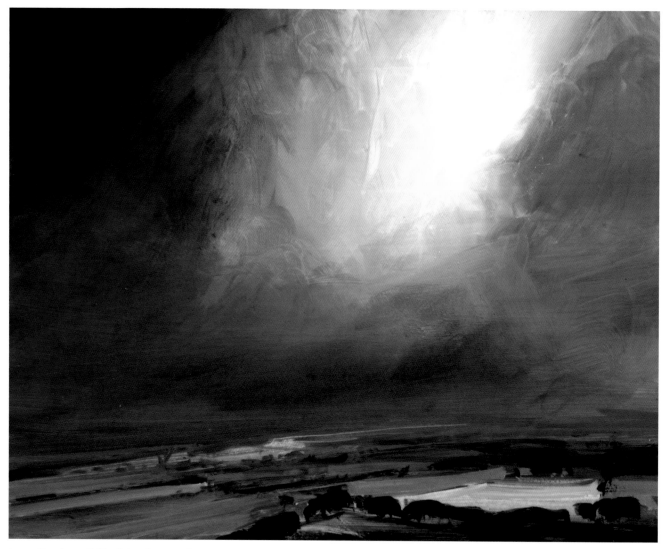

James Naughton, *Golden light*, oil on panel.

exaltation, a spiritual dimension to his painting. Like his paintings, Naughton's drawings seem to rise up out of nothing, solid forms, an edge of a cliff, a distant vista appearing out of the blank page. His drawings demonstrate his process, a gathering of information.

Direct observation is a traditional way to respond to a landscape but I am also interested in depicting the interplay between what we see and our imagination, making links between experience and mythology.

I suppose my real subject is rather indefinable and rather romantic – it's about the spiritual elements of landscape, and the effect that has on us as human beings. I suspect

that this is important to many people even though we may struggle to talk about it explicitly… I think many people still find a deep, instinctive meaning in their relationship to the natural world, and in my paintings I'm attempting to tap into that and to evoke the viewers' own emotional response.

We have such a close connection to landscape because we recognize the fleeting beauty of life in it. Again this isn't something that I give much thought to, in a conscious way, when I am painting. Most sessions are a blur of activity but with similar moments of the recognition that something incredible has happened or is just about to.

NICK BODIMEADE

Nick Bodimeade trained at Northbrook College and Wolverhampton Polytechnic in the 1970s. He is currently represented by St Anne's Galleries, Lewes, Zimmer Stewart Gallery, Arundel and the Porthminster Gallery, St Ives. His work is held in many public and private collections including the Contemporary Art Society, The Landmark Trust and the Government Art Collection.

Whilst many amateur artists see painting as the production of a one off, a record of direct visual experience, many professional artists work in a series, where the singular painting is merely part of a much bigger body of work. Richard Diebenkorn identified this themed body of work through his titles. Diebenkorn produced *Ocean Park* paintings and numerous supporting works including monotypes, etching, works on paper. Diebenkorn did not do what many successful artists do, find a formula and stick to it: constants and variables, change and reorder a small number of elements. Instead, he continued to reach out and draw from his immediate surroundings the inspiration to inform his paintings, his language evolved over a long painting career. Nick Bodimeade does not stick to one thing, either, he also works serially and as a painter, he is drawn to many things.

The medium and its manipulation is the most important thing. 'It ain't what you do, it's the way that you do it.' Different paintings often require different pictorial languages, what is communicated is bound up with how any given paint language is employed.

With many of the artists in this chapter, we see that at some point in their careers they have worked formally.

For many years I was an abstract painter, very interested in process and material and concerned with the idea of not directly picturing the world, but making an equivalent for it in paint on canvas. Now as a representational painter, it is this background that I call upon every day.

It is clear that in the twenty-first century, artists employ all sorts of resources to aid them in their working practice.

I am a studio painter reliant upon digital photography, computers, printers, projectors. to help fill the information gap that exists when not confronting the subject directly as a plein air painter might. I am also fascinated by the secondary exploration where the photograph becomes the subject and one enters it through the use of the computer, often finding information that was invisible to the eye at the time the photograph was taken, landscape explored twice and then a third time through painting.

Colour plays a vital role in Bodimeade's work and this is most clearly evident in his *Beach Bathers* series which often utilize negative paintings with intense coloured grounds. There is something in the slab like application of rich colour in the bathers (perhaps a reference to the high level of pixellation in the images they are derived from) which is quite different from the *B Road* series as they have a much greater openness and dynamic energy, similar to the *Long Island* De Kooning

Nick Bodimeade. *Fire Mountain 1 NB020314,* oil on canvas.

Nick Bodimeade, *Sedona Wind NB210714*, oil on canvas.

paintings of the 1960s. These expansive paintings look like they have been painted very quickly with large brushes using a very limited range of saturated colours.

In the *Fire Mountain* series, there is a more subdued use of colour, with much more evidence of layering with thin semi-transparent glazes applied over the top of more opaque layers. The trees seem to have been created out of calligraphic scrawls as if one was looking at a Cy Twombly (1928–2011) varying in scale and density.

In the winter of 2014 I travelled across the southern states of America, mostly hugging the Gulf of Mexico, but longing for some mountains, I headed north for a while and explored the snow dusted, fire and wind ravaged, Ponderosa Pine forested hillsides near Sedona, Arizona. Finding in the landscape there, qualities glimpsed before, but not taken advantage of, in New Zealand and

Australia. It was something to do with how the landscape seemed to be somehow a drawing of itself, in the way a tree can often look like both a tree and a diagram of a tree, or scaffolding a drawing of the building to which it is attached. The subject seemed to have done much of the work for me, all I had to do was move my hand in response to it. This relationship between a thing and its representation is a central concern, and one constantly explored through the to and fro between my interests in process based abstraction and photographically derived representation. The Fire Mountain and Sedona paintings sitting firmly in the middle of these approaches.

The processes of wind, fire and snow having their equivalents in the layering of brushing, spraying, scrubbing, blotting and drawing that make the work.

JULIAN VILARRUBI

Julian Vilarrubi studied painting at the Royal Academy Schools where he won the Richard Ford Award for travel in Spain. He has made landscape paintings based on the travels of writers and artists in Europe and Russia. He works in *plein air* as well as in the studio and drawing underpins all his work. In the last four years, he has focused on working on the iPad as a drawing and painting tool and he now considers this approach to be as valid as any traditional method. For him, the iPad offers a whole range of exciting possibilities for the artist. He lives in Brighton where he works in his studio, undertakes commissions and teaches drawing and painting from the figure and the landscape.

At the end of the nineteenth century, artists like Bonnard (1867–1947) and Vuillard (1868–1940) had taken a cue from Gauguin (1848–1903), radically moving away from perspectival space. Colour became much more significant and with it, the embellishment of the painting creating decorative surface. As colour becomes much more intense, the pictorial space of the image becomes flattened. Bonnard would stop time in his painting, working from his immediate surroundings, the bathroom and his wife bathing in it, or the landscape out of his window, as if he was holding onto that very moment. His wife never aged in his paintings, the landscape was always in bloom; for Bonnard, the motif provided a structure onto which he could hang the most beautiful arrangement of colour, layered and jewel-like in their vibrancy. Vuillard would tread a similar path for a while, but his work would move away from the flattened image in later years. Julian Vilarrubi's work clearly shows his interest in this interplay between flat and illusory. Whilst some artists use the immediacy of their emotional response to the landscape and attempt to capture this

fleeting moment in physical paint, Vilarrubi works over a very long time, building up layers and layers of thinly applied oil paint, consolidating and encapsulating this resonant experience.

Time passing, isolation, the mark and effect of man in the landscape. All these things and more probably are implicated in most landscapes. I think most people will react in different ways and respond according to their own interpretations. Hopefully they'll have their interpretation of what they are seeing.

When asked if there was a particular landscape that kept coming back to him as a motif, Vilarrubi said, 'For years it was Italy and in particular Umbria. Now it's Catalonia in Spain.'

I really like to travel and explore new landscapes. I think it's because I like space, light and colour so much that I respond to landscape. I find it very exciting and the natural urge is to record the experience somehow. Clearly a photograph is inferior as there's no real sense of scale and experience and the colour can change so much. The sense response is limited with a photo. It's a representation after all. An over-representation.

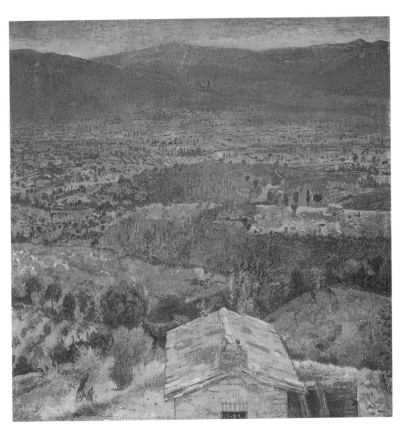

Julian Vilarrubi, *Italy Valleys of Umbria*, oil on canvas.

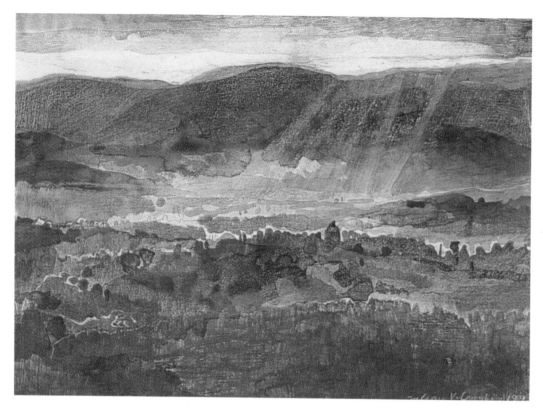

Julian Vilarrubi, *Italy Valley Blue*, oil on canvas.

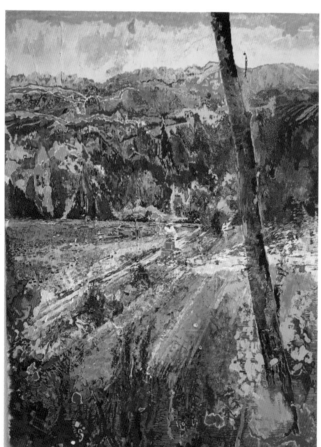

Julian Vilarrubi, *Sunflower Field*, oil on canvas.

As I move through a landscape I see so much but usually I respond to the same things, just in different landscapes. All the formal elements are activated in me but also association and history can play their part too.

The urge is to rise to the challenge and understand pictorially what I am responding to. Sometimes it's hard to know until you're in the process and it feels right to try and make sense of it. In a sense you possess it somehow and as a result experience it deeper by seeing it.

Howard Hodgkin once discussed the idea of waiting, not impulsively taking the emotion of the moment and applying that to the canvas, but instead allowing sufficient time to recapture the emotion generated by a particular encounter, a meeting, a sunset, the passage of light from a time long gone.

Vilarrubi's work has a visual beauty that comes from paying attention, looking at and working the surface of the painting until every square inch vibrates with a colour sensation.

PATRICK GEORGE

Sean Ferguson once suggested that each artist had their own nervous system. This might seem strange, but it's certainly true that the characteristics of the individual are born out in the paintings that they make. It takes someone very brave to destroy and rebuild a painting – scraping back and excavating layers of paint to try to find some sense of self. There's a certain kind of bravado in Louise Balaam's paintings, a gestural energy, an ebullient excitement with the stuff of paint that has the same kind of excitement one sees in a David Bomberg and Frank Auerbach, the relentless desire to find some kind of meaning out of a quagmire of paint marks. There is a different kind of mindset at work in the paintings of Richard Whadcock and James Naughton, a quiet whisper, a sense of foreboding, the spirituality of the landscape coming through the paintings' ethereal glow.

Patrick George, *Hickbush, Snow Scene with Hare*, 1979, oil on canvas. (Courtesy of Browse and Darby Gallery)

Patrick George, *Hickbush Landscape II*, early 1970s, oil on canvas. (Courtesy of Browse and Darby Gallery)

Patrick George, *Pippin Tree Blossom*, oil on canvas. (Courtesy of Browse and Darby Gallery)

In the work of Patrick George there is an altogether different mindset. Patrick George was born in Wilmslow in 1923 and started painting at the age of seven, where he was taught by Maurice Field and met William Coldstream. He met Lucian Freud at Bryanston, before he went on to Edinburgh College of Art, where he studied for a year (1941–2) before going into the Navy during WW2. After the war he went to Camberwell School of Art, where he was taught by Coldstream, and eventually received some teaching at Slade following Coldstream's appointment there as Principal in 1949. At the end of the 1950s George would go on to become Professor of Fine Art and Director of the Slade, before retiring in 1988.

For artists going back to art school after the experience of war, there was a strong sense of resolve to get it right, to be truthful and earnest in one's approach. The 1950s saw an emergence of a Kitchen Sink School at the RCA, but also an emerging sense of the real and everyday in film and theatre. George painted what he saw; the simple act of recording the view became a compulsion to revisit the same location again and again to pin it down.

In *Hickbush Snow Scene*, the landscape almost disappears and becomes a series of horizontal lines just below the middle of the picture. Subtle luminous colour seems to give light to the overcast sky of the winter day. For the briefest of seconds, one notices a hare dancing through the field, and George records this fleeting act.

In *Hickbush Landscape II* one encounters a series of strong vertical divisions of the painting. The trees stand their ground against this strong rectilinear composition. George's vision removed extraneous detail and reduced the necessity to draw every detail, paring the tree branches down to their very core.

There is something timeless about George's paintings, as if a whole series of experiences in front of the landscape have been distilled to this one moment, and yet they also belie their history and the changes that have taken place over a period of months and years. In the same vein the Spanish artist Antonio Lopez Garcia would also return year after year to the same location, and record more of his visual encounter with the subject.

PIERS OTTEY

Piers Ottey works in studios in Hackney, London and in Arundel, Sussex. Much of his work derives from visiting places at home and abroad. He has worked on images from the mountains of Switzerland to city paintings of New York and London. His work continues to be concerned with colour as well as with the relationship between natural space and flat surface geometry.

His are not hurried paintings, but carefully plotted out in luminous colour thinly applied, synthesizing his experience and reducing the scene to its essence. His paintings might take years to make, recording the seasonal changes and shifts of colour in a single painting. Many of those Euston Road painters took time, considering every element of the painting as a vital part of the whole, but also editing out superfluous detail. Piers Ottey is part of this continuing dialogue too, taught by one of Coldstream's students in the 1970s at Chelsea School of Art. Ottey's work has a fascination with surface, colour and geometry.

> *So that painting there (pointing at a work) is about history. Turner's spot that he painted on; Battersea Church where William Blake got married; ultra-modern architecture by one of the most famous architects in the world (Richard Rogers). It is about the geometry of the canvas with that diagonal shooting up which echoes the diagonal in the building and so on.*

Ottey works in lots of ways to achieve his imagery.

> *I'm searching. I don't want to be cast in any particular vein. I don't discount anything at all, anything. I'll work from a photograph or a drawing or on the spot; I don't like to get into a habit. If I do too much working from photographs, then I'll get a great big canvas and strap it to my back and paint outside. If I'm working very big for too long, then I'll work very small. A bit like my mountain paintings, I stopped doing them because they were selling very well. I loved them but I got to a point where I did not know whether I was doing them because I loved them or was doing them because they were successful. I stopped doing them because there's plenty else to do that I love. It was all passionate, but I think it had run its course. If I carried on it would have been for the wrong reasons. I love mountains so I haven't stopped doing mountains but stopped doing those particular mountains.*

Piers Ottey, *Evening Cervo, Zermatt.*

Piers Ottey, *Andalucia.*

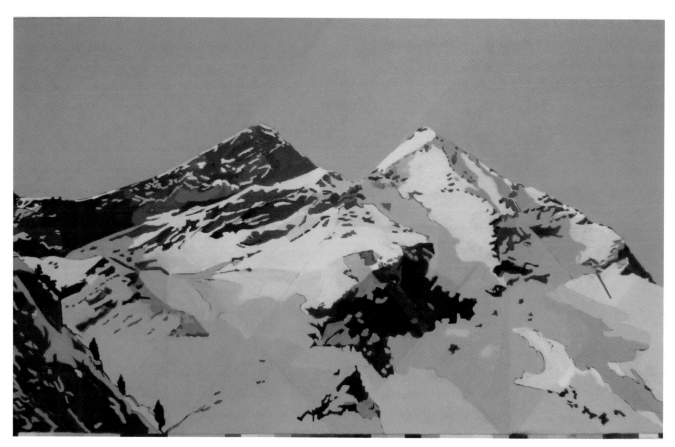

Piers Ottey, *Big Snow*.

Like Diebenkorn and Bodimeade, Ottey doesn't confine himself to one subject matter. When asked is the landscape your major preoccupation, he said:

> *It is from time to time, it's a constant interest, but then I've got other constant interests as well and I can only do one thing at a time, so I go through phases of doing London paintings and phases of doing figure paintings, but they're all constants in my life, so I'll never not do landscape ever, but it's not relentless… I wouldn't define myself as anything. I'm an explorer.*

When asked what he is searching for, Piers responded:

> *I'm not sure; if I knew I'd probably stop painting. I suppose I'm searching for the perfect language to express my feelings, I don't want to keep repeating the same old stuff.*

> *I love Sussex for instance, but then I went to work in Greece and I did a whole lot of paintings about Greece; the heat and the beauty and the colour, and then I went to Denmark and that blew my mind; the kind of light… And in September I'm going to paint in France and I've never painted in the south of France, I've got a feeling that it will be special again. I suppose it's the newness, I'm looking for the newness, new places, new adventures, new emotions, to express. I don't think landscape is just about a view. It's about the emotion that looking at it and being there creates.*

TREVOR SOWDEN

Trevor Sowden trained at Cardiff College of Art and at the University of Wales. As a mature student, he took an advanced diploma in Ceramics at Goldsmiths College, London. He is a member of the Gainsborough House Printmakers and now lives in Suffolk.

Although strictly speaking a printmaker, his work goes through a similar process of reduction and simplification.

When I started printmaking seriously I produced editions, often with complex printing processes, time consuming and uneconomical but a good learning curve. This gradually developed into simpler but much more considered designs, often adding other media, the image being more important than the purity of the process. Now I produce the line block design from lino or, recently, solar plates; the resulting prints can be cropped and recomposed, parts enlarged, recut, sometimes collaged and hand coloured.

I find that the clarity of the drawn line is nothing compared to the cut line using a scalpel on lino… I am indebted to a small book by Claude Flight called Linocutting and Printing, Batsford (1934) where he describes a wide variety of printing methods. Also examples of beautiful work by himself, Lill Tschudi (another Swiss, must be something in the air!), Cyril Power and Sybil Andrews. All added to the pot. Finally I must not forget the hundreds of youngsters that I introduced to simple printmaking whose efforts on occasion produced gems and proved that rules are made to be broken.

Like so many artists in this chapter, the interests in the formal relationships of the image are paramount.

I owe a particular debt to the work of Jean-Pierre Schmid 'Lermite', a Swiss landscape painter whose work showed me another way.
My discovery of Lermite in the early 1970s coincided with a holiday in Wiltshire where the long lines of the landscape with isolated trees like notes on a stave and the patterns made by cloud shadows were perfect for the development of a new, for me, way of looking at things. At this time I also tried to create ceramic sculpture from the same starting point. Even as a sculpture student I was fascinated with line and the interlocking of facets to show volume. It was not a success, however, a shame as I think that there is mileage in the idea still. Perhaps small scale – not enough time in the day.

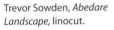

Trevor Sowden, *Abedare Landscape*, linocut.

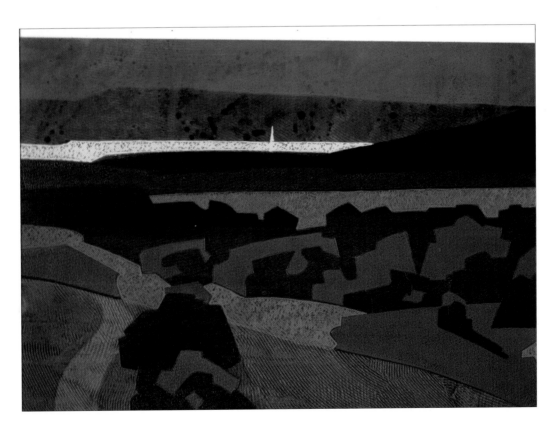

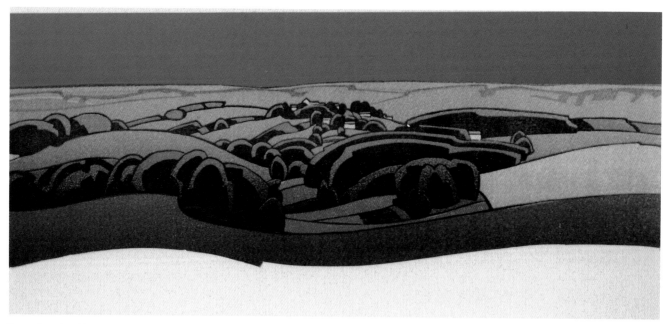

Trevor Sowden, *Linocut*.

Lermite's work evolved slowly toward a hard-edged abstract interpretation of the landscape by the mid 1960s, echoing many other European modernist solutions: Nicolas de Stael (1914–1955) revealed a similar although somewhat more painterly approach.

Sowden prints reveal a fascination with movement and rhythm. The landscape is simplified into a series of interlocking shapes that dance across the pictorial surface. These shapes and the negative spaces in between originate in nature, but through drawing become more curved and fluid.

How the image is developed depends on the possibilities it offers for simplification (often complex!) and pattern making and a strong linear structure.

I frequently return to sketch books of decades ago and rework ideas and I now see printmaking as an image making tool with the possibility for multiple images, each with different elements and outcomes (lots of failures and the occasional jackpot).

There is a quality in Sowden's line that is almost calligraphic, moving across the landscape, dancing around the forms as if he is composing a Haiku, simplifying the landscape to its significant forms.

The nature of lino printmaking is certainly instrumental in the visual solutions. With multiple block printmaking, a lot of decisions need to be made at the outset. The vision of the final work made at the start and the deconstruction of that image into a series of flat coloured planes should be calculated. Of course, chance plays a role and one can never fully predict the outcome. Sometimes one can never have the time, space, resources to do exactly what one wants, but limitation can be a very powerful tool in creativity. Within it, Sowden creates space, through layering and the saturation of colour as well as the odd trick up his sleeve. He also creates beautifully poetic landscapes. 'For the past twenty years circumstances have dictated that my work has been mainly two dimensional, the greater part being relief prints and the subject matter apart from landscapes includes a long-term interest in figures and ships in a variety of combinations.'

HARRY STOOSHINOFF

The landscape has been my major subject for the last thirty years or so. There have been earlier avenues as well. For a time I painted narratively, telling stories of my past, from fiction, and from dreams and imaginings. Various areas of art history influenced my training. For example, abstractionists such as Miro are still as important to me as people like Soutine, Cezanne, or Corot. There was a time when I made abstract landscapes based on what I experienced the previous day. I still make non-representational or semi-abstract pieces as well as portraits and still lifes. But for a long time now, I have turned to the landscape as a primary subject, and dealt with it in a representational way.

There is a real immediacy to the work of Stooshinoff, and this comes from the limitations of his process.

I want to make something every day. There are exciting visual problems to solve by remaining involved and interested; good things will happen as a result of genuine engagement. I want to use my perceptions and reactions to the world to fuel my daily tinkering sessions with paint

HARRY STOOSHINOFF

Harry Stooshinoff received his Bachelor of Fine Art in Painting and Drawing from the University of Saskatchewan, Saskatoon, followed by a year at the Banff Centre working with a variety of visiting international artists. He completed his Master of Fine Arts in Painting at the University of Calgary in 1982, and taught Visual Art at Trinity College School in Port Hope, Ontario for twenty-six years. He has maintained a painting practice throughout, now producing daily landscape paintings, documenting and interpreting the terrain south of Peterborough, Ontario. Harry Stooshinoff's works show his interest in interplay of flatness and illusion. The landscape presents itself as a motif which can be interpreted in a formalist way. Many artists in this chapter have embraced the lessons of modernism but take from it only the parts that serve their own purpose.

Harry Stooshinoff,
Storm Over Little House,
acrylic on paper.

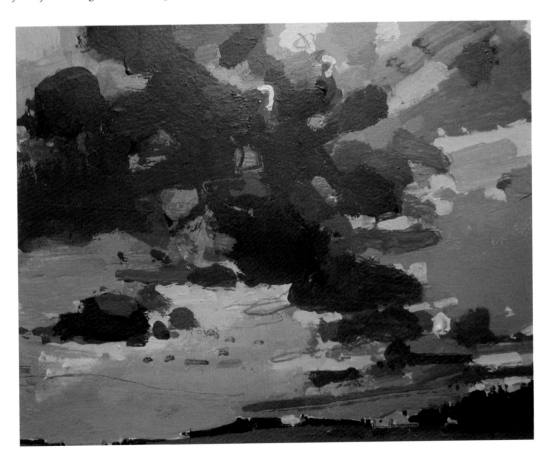

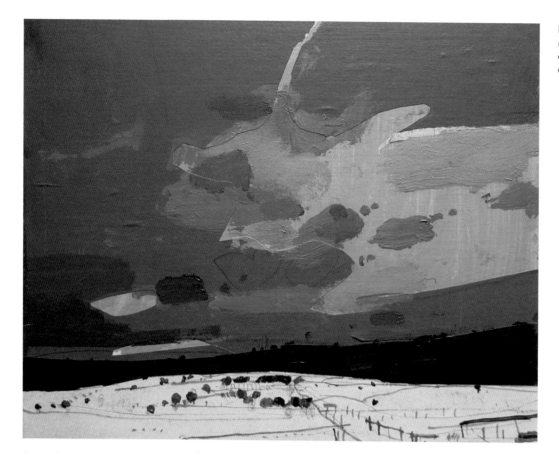

Harry Stooshinoff, *Pasture, (January 26)* acrylic, collage, on gessoed cradled birch panel.

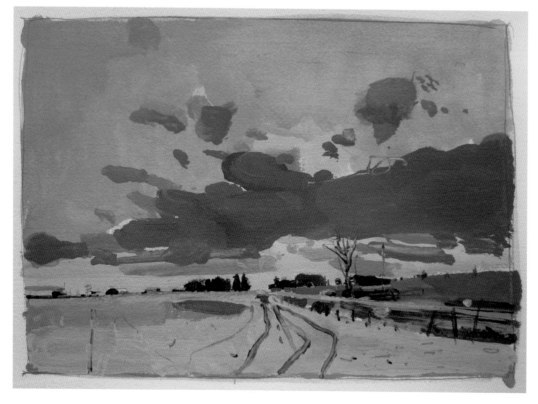

Harry Stooshinoff, *March Horse Trail*, acrylic on heavy, unprimed Whatman paper.

and paper. There is always a satisfying solution waiting once I commit to spending a few hours making something. I make small paintings, partly because it is a way to easily maintain this daily practice in a very free manner. To make some record of living in this world seems like a necessary thing. If a day goes by without a new picture to consider, it feels like an opportunity has been lost ... an opportunity that can never be reclaimed. I leave grand ideas aside ... it is enough to deal with one's own real and valuable experiences of living. I want to make things to the very end.

I suppose I paint 'home'! I wander perhaps fifty miles in any direction (travelling by car), but the vast majority of my pieces are based on daily walks that take about forty-five minutes to two hours. It is very important to me that I have a certain feeling and response to the few miles around me. I visit certain locations repeatedly in all weather conditions, times of day, and seasons. They change in both appearance and mood through all this. Lost Dog Hill, is one such place ... I may have painted it over a hundred times. My favourite places have a certain look, but they also have a specific 'feel' to me. The feeling of a place draws me as much as any formal characteristics related to making a painting.

The urge is to rise to the challenge and understand pictorially what I am responding to. Sometimes it's hard to know until you're in the process and it feels right to try and make sense of it. In a sense you possess it somehow and as a result experience it deeper by seeing it.

Stooshinoff likes to use acrylic as his preferred medium of choice.

I paint in acrylics and have for a very long time. The medium determines how I do things and the approach I take to painting. Everything I do is completed in one sitting so drying stages need to be quick. I often work in layers, and fast drying media are helpful in this regard. There was a time when I painted directly outdoors, or in the front seat of my car, and overly fast drying was sometimes a challenge in those conditions, but I seldom paint on location these days. I also work in collage made with thin papers previously covered in acrylic.

There are a few requirements I place upon the work. First, a painting should be made every day. The world is experienced every day, so there should be steady work continually referencing that experience. Second, each painting should be completed in one sitting. I have always worked in this fashion and it suits my temperament. Whatever needs to be said should be stated simply and freely. A number of years ago I started working with a small format (9 × 12 inches or smaller) and this habit is still with me because it allows each work to get made in a reasonable time frame (within two to three hours). There is also a secretive quality about smaller work that encourages an adventurous approach ... anything can be tried. My paintings are small but they are not sketches for larger work. Each piece I finish is separate and complete. The subject matter comes from my movements during the day, most usually from my daily walks, and from my drives.

Whilst the landscape may be a reoccurring motif, the challenge for any artist is to keep the subject interesting.

The moment the results begin to seem predictable or repeated my energy diminishes, so change and a freshness of approach are built into the practice. At the same time, I do not reject any of my results. I love them all and they are all kept. Making a picture is at least in part, a design problem, subject to the workings of the elements and principles of art, so I know in advance that there is a solution to the set visual problem. It takes complete attention and a certain ease of manner to find this solution, but the solution always comes. I find it is important to keep moving, to not stop. Working in this way prevents me from over-thinking. I never go back to a picture after the work session. The piece stands on its own as evidence of an experience in a particular time and place.

But the landscape offers much more than just a view.

It's always about self-portraiture. There is the world, and there is one's response to everything in it, and the two are closely intertwined. The painting is always as much about me as the place that's depicted. You cannot paint yourself out of the picture. And yet there are no people in my pictures, but the places are all created through their interaction with people. My places are not wild places. They are man-made, manicured, and they will become less treed and less green as the decades pass. The world remains a very beautiful place, but underlying it all is the real worry of what it will eventually become.

David Hayward, *Luxembourg II*, encaustic on panel.

DAVID HAYWARD

David Hayward spent his childhood in rural mid Wales. He studied art at Cheltenham, Canterbury, Brighton and the Royal College of Art followed by a lengthy teaching career. He has held senior posts, including Professorships at The University for Creative Arts and at Canterbury Christ Church University. He resigned from academe in 2009 and works full-time in his studio in Kent.

David Hayward's work takes this flattening of pictorial space to an extreme.

I would describe myself as a speculative painter. The older I get the less I want to know in advance what the final image will look like. I purposefully keep planning to a minimum because I want the act of painting to generate visual surprises and prompt unexpected associations. I have always liked the idea of the artist as a 'prospector' because it suggests a methodology that is informed as much by intuition and chance as it is by knowledge and planning.

When asked whether landscape was his major preoccupation, he replied:

There is no doubt that my approach to painting has always been strongly influenced by my love and interest in landscape. Even my most non-figurative paintings have an underlying feeling of 'somewhere' and I will often give them titles that hint at specific locations of personal importance.

When we look at landscape we are looking at a complex visual lexicon of form, space, colour, tonality and texture – it is highly physical and highly optical. Add to this the transient, qualities of light and shadow, weather, seasonal changes and traces of human endeavour. Then add the powerful psychological responses that landscape can trigger. No wonder landscape enthralls and challenges so many artists.

David Hayward, *Weather Report # 1*, encaustic on panel.

David Hayward, *Shipping Forecast 1*, encaustic on panel.

David Hayward,
Undercurrent 2, encaustic
on panel.

In Hayward's hands, the landscape become synthesized,
pared down to its essence. 'I am particularly drawn to shore-
lines with their shifting delineations of air, water and land
and the transience of weather, erosion, tides and the detritus
of tidelines.'

Like Diebenkorn, location plays an important role.

*Two specific locations recur in my work – Covehithe in
Suffolk where coastal erosion had caused an entire village
to fall into the sea, leaving only tiny fragments of peoples'
homes now disappearing among the sand and stones
– and Dorset's Jurassic Coast where erosion and fossil
remains provide a wonderful array of structures. Both
places speak eloquently about the passing of time.*

Hayward deals with an unfolding history, the notion that a
painting goes through a process of transformation over time
and we are left with the layer that the painter/archaeologist
has unveiled, whereas Diebenkorn revealed all the different
histories of the work, beneath his transparent layers.

Conclusion

As I walk through the landscape and see the veils of rain obscuring the view, leading me to think about what lies beyond those trees and stand in awe as the landscape opens up before me, a bright shard of light illuminates some patch of ground. I think myself lucky to be here, savouring the moment, thinking about my life, those that I love and those that are no longer with us.

When I stand in front of a painting, I try to take myself back to that moment, try to remember all of those things, those memories, those feelings and hope that somehow they will be encapsulated by my attempt to paint the view.

As a young artist, I believed I had to discover a solution, a formula, to a way of working, many of those abstract artists that I looked at at the time seemed to have this identikit approach to painting. As time has gone by, the most interesting artists evolve their pictorial language, developing either a greater complexity or simplicity in their work. It took me a long time to realize that the central problem is not how to paint or draw the landscape (although that is an important foundation) but to understand why you are drawn to the landscape. Are you having some spiritual or emotional response to a particular place? Are you more concerned with the conceptual, the history or geography of location and the way it has been altered by man's presence within it (Bodimeade, Hayward); the landscape of property, possession and wealth, or agriculture and farming, nature's larder sustaining us, or the way in which the industrial revolution caused mass migration out of the villages and into the new towns and cities?

It is interesting to remember that this is the 300th anniversary of Lancelot 'Capability' Brown (1716–1783), the landscape architect who literally rebuilt the English countryside in the form of Italian painting.

Casper David Friedrich (1774–1840), Johan Christian Dahl (1788–1857) and Peder Balke (1804–1887) communicated a more elemental landscape that could invoke a sense of awe. A similar sense of the sublime can be found in Whadcock's ethereal evocations. This is the landscape of memory or a romantic idyll, which also seems to be at the heart of Naughton's work, a landscape created out of the mind rather than the eye. Both artists share something of Balke's technique, wiping paint away, like the process of etching or monotype to create luminosity.

Light plays a key role in Atkins and Vilarrubi, the glow of sunset or sunrise with the former or the glare and heat of the Mediterranean in the latter. In both there is evidence of the hand, the mark of the artist; with Atkins it is writ large in the gestural swathes of paint and in Vilarrubi it is the surfaces that he creates.

Light seemed important to George as his work seems to have an internal illumination. He also displayed a concern for a formal compositional aesthetic; he responded to line, shape, placement and of Suffolk, cataloguing a system that mapped the colour choices made in a single work. Once again, parallels can be drawn between him and Diebenkorn, removing unwanted details to find a patch of colour, a line or division of space that made sense. For Ottey too there is this fascination with the grid and bringing order to the world, particularly with his use of gridding and the.

Are you interested in the landscape as a vehicle to express emotion? Balaam certainly does and her paintings reveal the way in which her whole body is involved in the process of making the painting.

Artists invariably set themselves complicated problems, whether it's emotional, philosophical or conceptual, they challenge their understanding of the medium. This becomes ever more complicated with an understanding of the historical precedents of landscape painting and the notion of being a painter in the early stages of the twenty-first century using a seemingly outmoded form of representation.

Not everyone wants to be an artist, though, and challenge themselves in this way. You may be content with sitting in front of 'this ravishing scene' and losing yourself for a few hours in an attempt to capture some part of it.

Like a cookbook, you may wish to dip into the recipes and the approaches in the text to enrich your vocabulary of possibilities which will give you a greater understanding of how you might tackle the visual problems with which you are presented.

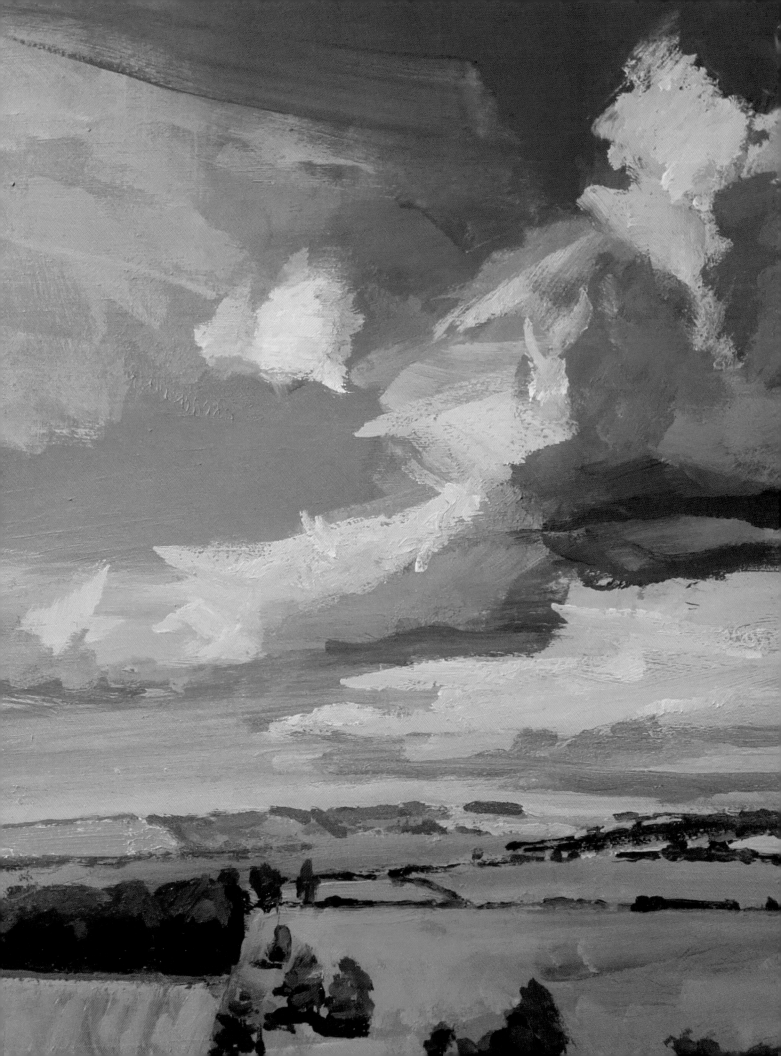

ARTISTS' WEBSITES

Louise Balaam
www.louisebalaam.co.uk

David Atkins
www.david-atkins.com

Richard Whadcock
www.richardwhadcock.com

James Naughton
www.jamesnaughton.com

Nick Bodimeade
www.nickbodimeade.co.uk

Julian Vilarrubi
www.julianvilarrubi.com

Harry Stooshinoff
www.harrystooshinoff.com

David Hayward
www.david-hayward.com

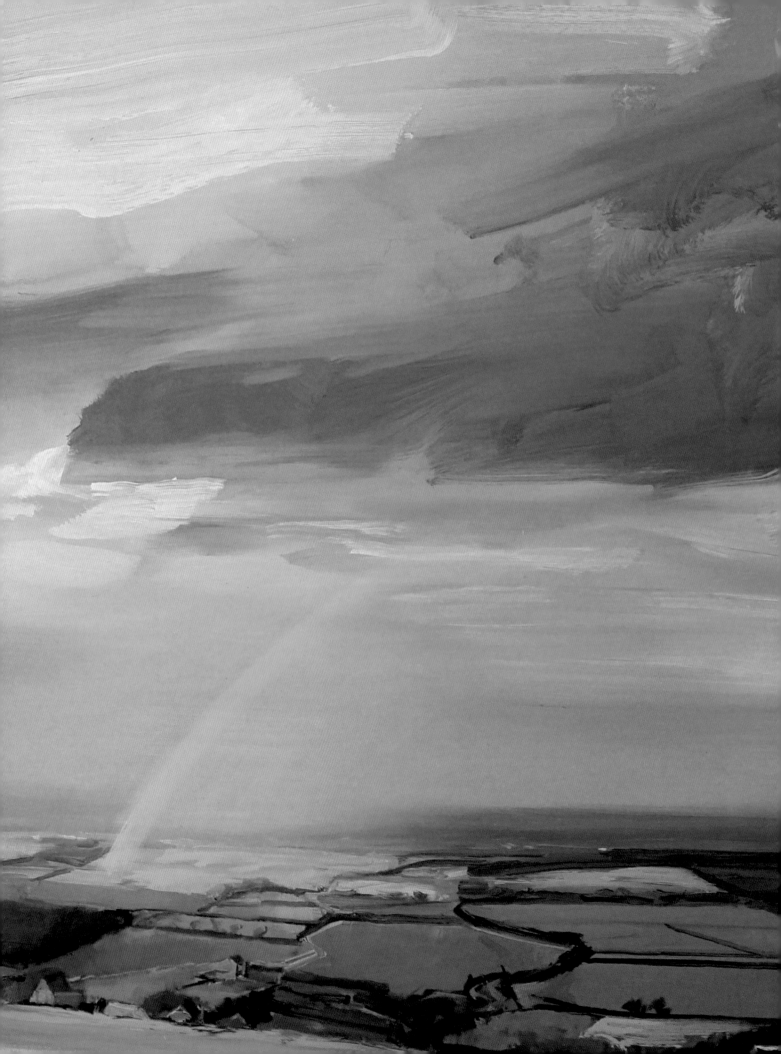

ACKNOWLEDGEMENTS

A book like this does not get made on its own and I would like to take this opportunity to thank all the artists that have contributed their time, their work and their words to the book. My wife Louise and my three girls get a special thanks: Millie, Rosie and Phoebe, for their support and encouragement throughout this project; they have suffered the long hours of neglect, bad temper and time spent waiting for me to draw, paint or photograph the landscape on our many walks with my dog Moo, who has shown me pieces of Sussex I never knew existed.

A massive thank you goes out to The Richard Diebenkorn Foundation for letting me reproduce his work, as well as Antonia Johnson and all at Browse and Darby Gallery for helping arrange my visit to Patrick and to Susan Engledow for the soup and the technical support when I needed to get a bit more information about Patrick's work.

I would also like to thank the University of Brighton for their support and encouragement, and allowing me the research time to undertake such a big project.

FURTHER READING

Albala, Mitchell *Landscape Painting* (Watson-Guptill Publications)

Barringer, Tim *Opulence and Anxiety* (Compton Verney)

Berger, John and Overton, Tom *Landscapes* (John Berger on Art 8, November 2016)

Brooker, Suzanne *The Elements of Landscape Oil Painting: Techniques for Rendering Sky, Terrain, Trees, and Water* (Watson-Guptill Publications)

Brutvan Cheryl A. *Antonio Lopez Garcia* (MFA Publications)

Clark, Kenneth *Landscape into Art* (Read Books)

Corn, Wanda M. *The Art of Andrew Wyeth* (Fine Arts Museums of San Francisco)

Cuming, Fred, and Tyler, Christian *A Figure in the Landscape* (Unicorn)

Diebenkorn, Richard *Richard Diebenkorn: Paintings and Drawings 1943–1976* (Albright-Knox Art Gallery, New York)

Dimbleby, David *A Picture of Britain* (Tate Publishing)

Evans, Mark *John Constable: The Making of a Master* (Harry N. Abrams)

Gill, Robert W. *Creative Perspective* (Thames & Hudson)

Heron, Patrick *Ivon Hitchens* (Penguin Modern Painters)

Jeffrey, Ian *Chasing Sublime Light (Ar Drywydd Goleuni Ysblennydd)* (David Tress West Wales Arts Centre)

Lambirth, Andrew *Patrick George* (Sansom Ltd)

Leopold, Rudolf *Egon Schiele Landscapes* (Prestel)

Livingston, Jane *The Art of Richard Diebenkorn* (Ahmanson-Murphy Fine Arts Book)

Nolde, Emil, and Urban, Martin *Emil Nolde: Landscapes* (Praeger)

Ruskin, John *The Elements of Drawing* (Wiley)

Schama, Simon *Landscape and Memory* (Vintage Books)

Simpson, Ian *The Challenge of Landscape Painting* (Collins)

Speed, Harold *Oil Painting Techniques and Materials* (Dover Art Instruction)

Speed, Harold *The Practice and Science of Drawing* (Dover Art Instruction)

Spring, Justin *Fairfield Porter: A Life in Art* (Yale University Press)

Vicat Cole, Rex *Perspective for Artists* (Dover Art Instruction)

Vicat Cole, Rex *The Artistic Anatomy of Trees* (Dover Art Instruction)

Wyeth, Andrew, The Helga Pictures (International Arts & Artists)

INDEX